DORSET COUNTRY POTTERY

The kilns of the Verwood district

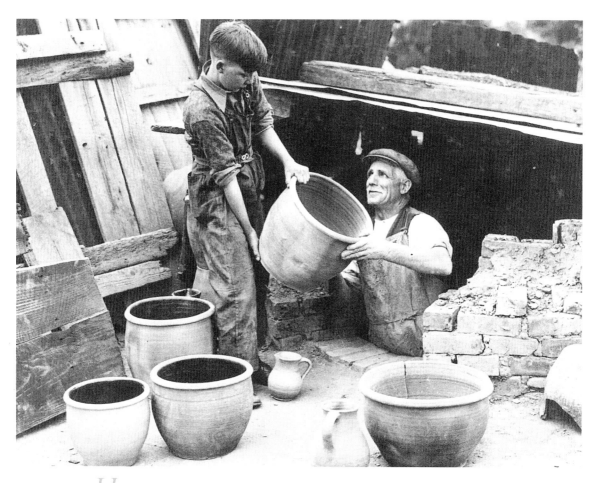

U nloading the kiln at Cross Roads in 1938 – Mesheck Sims actually in the kiln passing pots to the apprentice Fred Thorne. Several sizes of bread bins (one cracked) and a jug can be seen.

DORSET COUNTRY POTTERY
The kilns of the Verwood district

Jo Draper WITH *Penny Copland-Griffiths*

The Crowood Press

First published in 2002 by
The Crowood Press Ltd
Ramsbury, Marlborough
Wiltshire SN8 2HR

British Library Cataloguing-in-Publication Data
A catalogue record for this book is available from the British Library.

ISBN 1 86126 514 X

Line artwork by Christopher Chaplin.

Photographs by Julian Comrie.

The Drawings
The drawings of pots on pages 31, 33, 37, 39, 40, 53, 60, 104, 120, 131, 139, 144, 148, 151 and 156 are the type of technical pottery drawings used by archaeologists. They are usually to a fixed scale, with the right-hand side showing the outside of the pots, and the left-hand a section straight through the body and the inside of the pot. Handles, etc. are usually also drawn in section so that their shape can also be seen.

Typefaces used: text and headings, ITC Giovanni; chapter headings, ITC Tiepolo.
Typeset and designed by
D & N Publishing, Baydon, Marlborough, Wiltshire.

Colour origination by Black Cat Graphics Ltd, Bristol, England.

Printed and bound in Malaysia by Times Offset (M) Sdn. Bhd.

Contents

Dedication

This book is based on several people's work on the Verwood and District Potteries (besides our own) and we dedicate it to them:

David Algar
Anthony Light
John Sims
Donald Young

Acknowledgements

We could not have produced this book without the earlier work of David Algar, Anthony Light, John Sims and the late Donald Young. The first three have also helped us by lending files and answering queries. David Algar and Tony Light have kindly read the text, and we are grateful to them for their comments, and to David for the photographs on pages 30 and 177. They drew the majority of the Horton Kiln pots reproduced here.

Julian Richards very kindly saved us from a horrible error about the pots made by Gertie Gilham, and we are very grateful to him. Our understanding of the actual making of the pottery has been greatly assisted by Andrew McGarva's book, *Country Pottery The Traditional Earthenware of Britain* (2000).

We have been kindly shown public collections at the Dorset County Museum, Dorchester the Red House Museum, Christchurch; Borough of Poole Museums Service; Wiltshire Heritage Museum, Devizes; Somerset County Museum, Taunton; Priest's House Museum, Wimborne; Lyme Regis Museum; Salisbury and South Wiltshire Museum; Hampshire County Council Museums Service; and Verwood Historical Society. We are grateful to those who helped us with these collections.

We have also been fortunate in having access to many private collections, and are grateful to Mrs Maud Brewer; the Broomfield family for access to part of the late John Broomfield's large collection; Mrs Fox; Mrs Froud; Martin Green; Peter Irvine; Michael and Polly Legg; Reginald Lloyd; Richard Percy; Mr & Mrs Pope; Julian Richards; Mr & Mrs R. Sims; Mr Wareham; Ian Waterfield; and Graham Zebedee. Most of these collectors have kindly allowed us to have some of their pots photographed for this book.

Julian Comrie has taken all the photographs of the pots for this book, and we are grateful to him for making the pots look so good. Sheena Pearce has cheerfully word-processed it all, as usual. Christopher Chaplin has helped with everything.

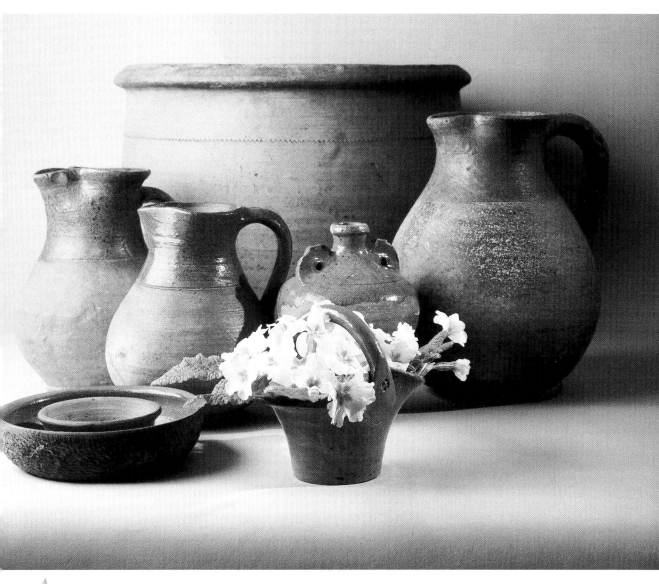

A variety of Verwood pots, utilitarian and fancy.

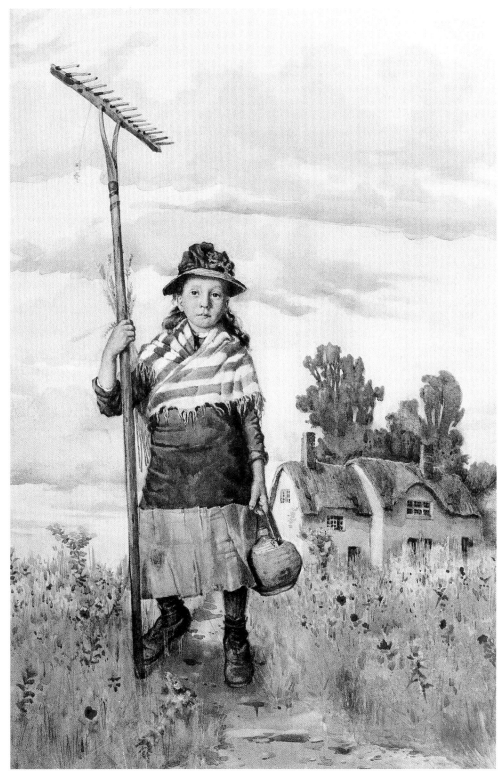

'Emily the Harvest Girl' is the original caption to this watercolour by F. Richards, painted in 1885. She holds a Verwood costrel slung from a leather thong, and holds a rake and a little bunch of wheat in the other hand. The realism of the painting – her boots, poor clothes and tired look – puts the costrel in its proper rural context. The cottages suggest Wiltshire. Her wooden rake (a smallish one) is of the type known as a hay rake, but these were also used for raking up corn and other jobs.

1 Introduction

Verwood in Dorset was one of many areas of Britain to produce simple earthenwares for local use, but it differs from most of them because it survived, still working in the same traditional way, until 1952. From 1900 it was often visited by reporters who turned out articles on 'The Last of the Old English Potters' (*The Graphic*, September 1926) or 'Potter and Clay Endure' (*Evening Standard*, May 1938). The Verwood potters went on making the same sort of pots and using the same methods as they had for centuries with no mechanization. They still fired their primitive kilns with wood, and still used local clays. *The Graphic* in 1926 sets the tone of most press descriptions:

> In the quiet little village of Verwood, in Dorset, the pottery industry has been carried on for some two hundred years or more. Within that period in most industries amazing changes have taken place because of the introduction of machinery and the progress of science, but the Verwood potters – a little band – have made no use of modern inventions in the pursuit

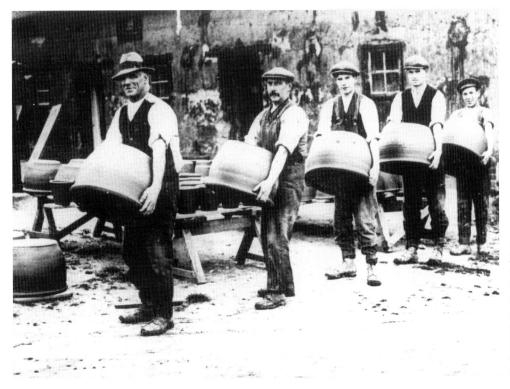

Maybe taking pots to the kiln, but maybe a set-up for the photographer. Cross Roads 1930 – Mesheck Sims, Herbert Bailey, Jim Scammel, Len Sims and Harold Churchill.

of their calling. They have been quite content to follow faithfully in the footsteps of their fore-fathers, to whose methods they continue, after all these years, strictly to adhere. It is one of the most interesting survivals to be met with in rural districts. The processes of manufacture are a never-failing source of interest to strangers in the village.

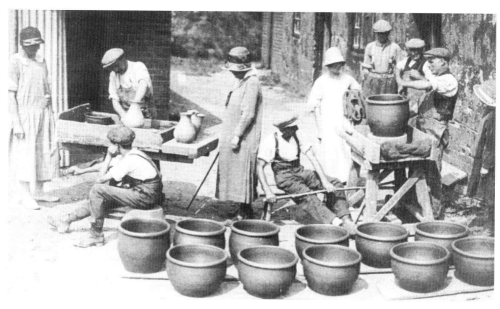

Visitors at Cross Roads pottery, Verwood; a photograph from The Graphic *article of 1926. The potters have brought the two wheels outside into the yard to demonstrate throwing the pots. Herbert Bailey (left) is throwing jugs, and Mesheck Sims (right) is finishing one of the huge bread bins. These were some of the largest pots thrown on a wheel, and were very difficult to make. Several that had been made earlier are on drying boards in the foreground. In the background is the kiln mound.*

When Michael Cardew, the distinguished studio potter, was completing his training with Bernard Leach at St Ives in Cornwall, he looked around for a traditional pottery where he could work. He visited Verwood in the mid 1920s, hoping it would suit him:

Verwood must have been one of the most primitive potteries to survive into the twentieth century. At the time I saw it, it belonged to a local timber merchant, for whom its chief merit was as a place where his offcuts, otherwise useless, could be used as fuel. There was no pugmill, all the clay being tempered by a boy with bare feet treading it out on a stone or cement floor. There were two or three kick wheels of the English or cranked type, and when they had to make big pots they undid the treadle arrangement and tied a stick to the crank of the spindle ...

The pottery was manned by two or three throwers with a boy and an older man called Meshek who managed the kiln. The kiln was perhaps the most remarkable feature of this pottery: enormous, partly below ground level, and loaded from the top ... When it was full, a temporary covering was made, consisting of old broken pots and pieces of tile. There was only one fire-mouth and it was fired with wood only ...

Here they made the usual flowerpots and washing pans and also – this was its special recommendation in my eyes – pitchers of a very fine shape, much fatter than the Truro and Fremington pitchers but, like them, free and generous in feeling ...

All these traditional pots were set in the open kiln without any saggars or other supports, but I thought perhaps I could make some arrangement with the owner and the potters, letting me work there and share the kiln, making saggars to occupy part of the kiln space. But even I could see that such an arrangement – imposing myself as a sort of cuckoo in this ancient nest – would be rather difficult.

From *A Pioneer Potter* (1988)

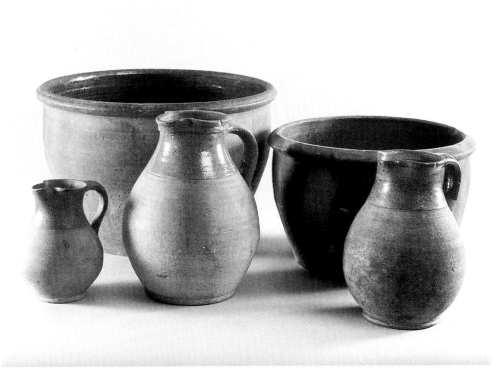

*V*erwood jugs and bread bins like those opposite. The jugs are the 'fat' pitchers admired by Michael Cardew (bread bins: Dorset County Museum, left, 320mm high; jugs: two left, VDPT; right, Ian Waterfield).

Cardew understood the primitive methods used at Verwood because he was a potter himself. Other visitors were charmed by the Verwood method of treading the clay with bare feet, but Cardew knew that every other pottery had invested in a machine – a pug mill – to do the job rather better and more easily.

Cardew was describing the Cross Roads Pottery, the only one to survive the 1920s. Because the methods used were so primitive, it was easy for visitors to believe that it was an old industry. The rural set- ting, in the heathlands adjoining the New Forest, helped the pic- turesque, folksy image.

In fact, potting in the area went back earlier than anyone then real- ized, starting in medieval times, possi- bly even as early as the twelfth century. Most of the early records are from Alderholt, just to the north of Ver- wood. Potting was certainly a wide- spread industry, existing in several adjacent parishes at different times, but because the last surviving pottery was at Verwood, the whole industry has been called by that name.

It is fortunate for the historian that potters tend to land in court for

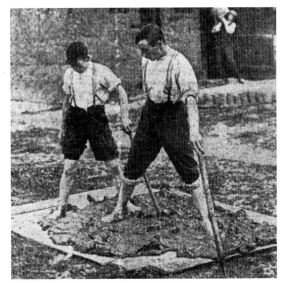

*T*reading the clay at Cross Roads, Verwood, in 1912. Fred Fry (right) and a boy are trampling it outside so that the photographer can get enough light for the photograph. They have put down a cloth. Posed in the background is a man with a bread bin.

digging pits to get their clay and then leaving them dangerously open. Alderholt potters were brought up in the Cranborne Manor Court for just this offence regularly from 1489. In 1646 it was presented that 'John Kibby digs clay for Francis Gould and others and opens pits and holes and leaves them open, near the King's Way [the road] to the great injury of all the King's liege [i.e., everyone]. They are fined 10/– each but by the grace of the court the fine is assessed at 6/8, they are ordered to fill in and make safe the pits and holes upon penalty of 40/–.' (Quite what they were to fill the pits in with, having extracted the clay or sand, is never made clear). The big fines were usually reduced to something more like the annual licence fee for digging clay which other people were charged, but the court records give us not only the potters' names, but where they were taking clay from and so on.

In the sixteenth and seventeenth centuries, as earlier, potters of the Verwood district were the main suppliers of all sorts of vessels to a wide area, but from the later eighteenth century onwards industrialization led to the growth of specialized potteries producing attractive and cheap finewares. These took over large parts of the market, until gradually local earthenwares became less important, with most of these pots going for the kitchen or dairy. Verwood continued to make jugs, costrels and bushel pans, but other potteries took over parts of even this market in the nineteenth century. From the 1880s, fancy wares were produced at Verwood to try to improve turnover, and novelty pieces were made alongside the utilitarian wares until the end of the kilns in 1952.

Apart from the nostalgic articles in the newspapers and occasional visits from studio potters, the Verwood industry attracted little attention. Every museum in the area had pots from Verwood in its collection, but no one studied them. A few people collected the pottery, and two small samples from stocks still remaining at Cross Roads in the 1960s were given to Salisbury and Christchurch Museums.

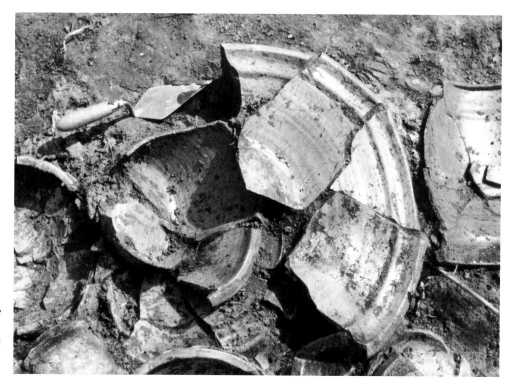

Seventeenth-century kiln wasters being excavated at Horton. All kilns are surrounded by discarded pots which either fired badly or were broken.

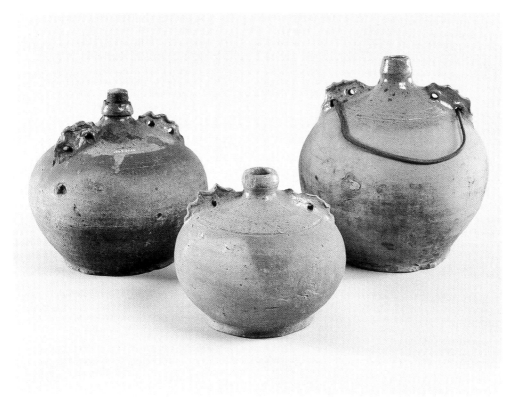

V erwood costrels came in several different sizes, and are the best-known form made at Verwood. They have been called owls and pills, the latter presumably because of their rounded shape (centre, private collection, others, Dorset County Museum, right, 224mm high).

The earliest article to be published after the closure was by T.P. Kendrick, who visited in 1959. He was very sympathetic to the industry: the Verwood pottery used rather primitive methods, but:

> there was little reason for them to change their methods. They served a fairly small, rather isolated area, and competition bothered them very little. As time went on, mechanisation and mass production came to the other potteries of Britain. Easier transportation now made it possible for these mass-produced wares to be bought in the vicinity of Verwood. This small pottery, however, plodded on, unwilling or unable to change, producing good honest pots, only to find its public decreasing. Preference was given to the sophisticated, decorated chinas and porcelains which had been beyond the means of the general public before mass production lowered their cost. The rough, rustic beauty of the Verwood pots went out of fashion; the shiny-glazed, highly decorated china and earthenware took its place. I have even seen old Verwood jugs painted over in high-gloss enamel paint with an attempt at a flower design on the front in an effort to disguise their unglazed surface.

Study of the kilns and the pots really started in the 1960s. J. Sims' thesis *Heath Potters in the Cranborne District* (1969) not only identified the potters and kiln sites from the eighteenth century onwards, but discovered huge amounts of documentary material dating back to the fifteenth century. Everyone working subsequently has owed him a great debt.

From 1972 David Algar, Anthony Light and Penny Copland-Griffiths have researched every aspect of the industry, and excavated several of the kilns. The Verwood and District

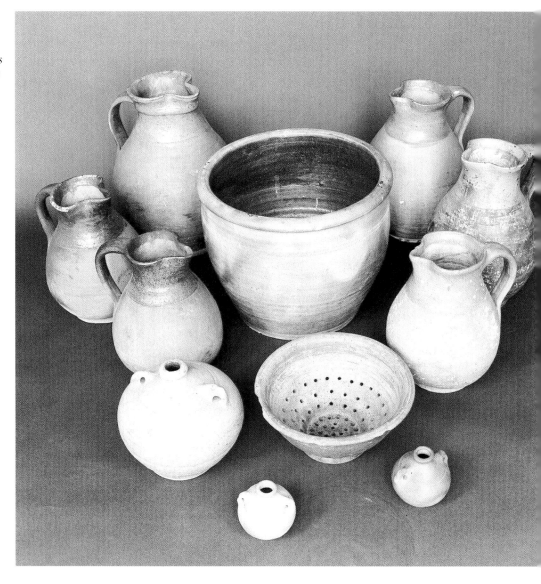

A selection of typical Verwood forms – jugs, costrels and bread bins. The jugs and bread bins were made right up to 1952, but the costrels were not produced after the late 1920s. The miniature costrels (front) were made from 1907 (all VDPT; jug, left, 317mm high).

Potteries Trust (VDPT) was established by them in 1985, and now holds probably the largest collection of Verwood pots.

Even in the 1970s Verwood was only appreciated by a few collectors and potters, and into the 1980s it was possible to buy even costrels from market stalls for a pound or less. All that has changed: earthenwares are becoming properly appreciated and sadly rather expensive. Because so few of them are marked, collectors need a good knowledge of the kilns and pots. We hope this book will provide the necessary information about Verwood, although we still do not know all there is to know about all the kilns. But that is part of the fascination.

2 The Place – Heathland and Woods

The potteries developed in an area that is unusual in several ways, all caused by the geology. The land is virtually all heathland, so it has never been the normal sort of agricultural area, with a central village and scattered farms. Verwood and Alderholt are entirely heathland except for a little strip along the river, and they were both part of the huge parish of Cranborne until 1887 – heathland was of little value and was simply appended to parishes on better soils. Cranborne had 13,000 acres (5,265ha) until 1887, but nearly half of this was moor or heathland. These wild lands often had rather wild inhabitants – lawlessness was more common on heathlands than agricultural areas. John Hutchins gives the eighteenth-century view of this unproductive landscape:

Near Piddletown [Puddletown] begins a large tract of heathy ground, which from thence eastward occupies a great part of the southern coast, and extends to Hampshire and Surrey, and to the great heaths beyond London. This is professedly the most barren part of the county; and nature, who has in other parts distributed her beauties with so liberal a hand, seems here,

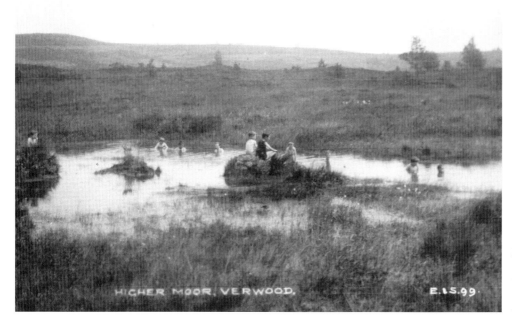

Higher Moor, Verwood, from a postcard of about 1900–10. This moor was drained in the late 1920s and conifers planted.

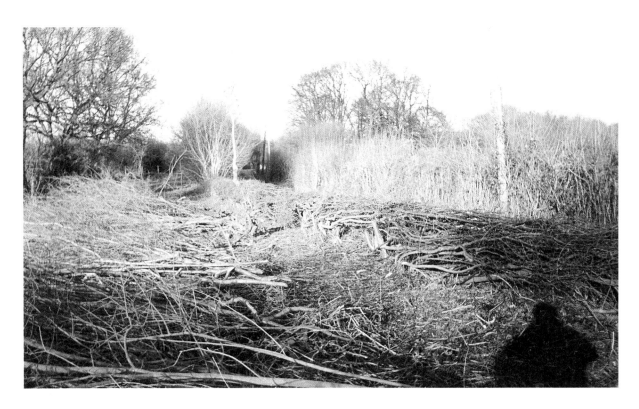

A traditional laid hedge at Alderholt in the 1990s, with the excess wood placed on one side. Hurdlers used hedge material as well as coppiced hazel.

by way of contrast, to exhibit a view of all others the most dreary and unpleasing. It supplies the inhabitants with a cheap fewel, and supports a small breed of sheep.

The land was poor agriculturally because of the underlying clays, sand and gravel, but these provided the raw materials for several industries, with the poor agriculture encouraging people to find ways of supplementing a living. The clay was used from medieval times for tiles, pottery and cob building, and the sand and gravel supported heathland vegetation which provided furze and turf for firing the tiles and pottery. Sand was used for building and mixing with clay for pottery. The clay lands also supported woods which were important, producing brooms and hurdles as well as supplying fuel for the kilns.

Cranborne Chase and the Woodland Industries

Until the early nineteenth century wood was the main fuel, used for all purposes, from cooking and heating to industry. Huge quantities were needed – Richard Henning of Alderholt had 1,000 faggots in store when he died in 1682, some for household use, some for firing his pottery kiln. Firing the smaller later kiln at Cross Roads in the 1950s took three to four lorry-loads of wood, obviously a considerable quantity. In 1618 complaints were made that the coppices in the Cranborne area were not being looked after properly, and this was causing problems because 'the country around Cranborne Chase

depends chiefly on the coppice there for fire-bote [firewood], hedge-bote [fencing], watling [internal walls in houses etc.], hurdling and spikes for thatching.'

Turf was the fuel of the poor, and was exploited a good deal. Lot Oxford, one of the hawkers who sold the pots, was told by his grandfather that in the earlier nineteenth century he had seen as many as twenty or thirty wagons all out on the common at the same time cutting turf for fuel, and every house had a big rick of turf because there was no coal.

Cranborne Chase was created in the twelfth century, one of the many 'forests' created in medieval times to encourage deer. Forests and chases were areas where forest law applied, all designed to preserve the deer and the woods they lived in. Cranborne Chase covered 15,000 acres (6,075ha) at its greatest extent; parts of it were open downland, but much of it was woodland. It was bounded on the east by the River Avon, and extended to Wimborne, Blandford, Shaftesbury and Salisbury. Alderholt and Verwood were part of Cranborne Chase. Adjoining Cranborne Chase and the Verwood area is one of the few medieval forests surviving today – the New Forest, which is on similar poor soils. Adjacent on the south was Holt Forest, yet another medieval forest.

Cranborne Chase, like the New Forest, belonged originally to the King, but in the early seventeenth century the Earl of Salisbury acquired it. The Lord of the Chase only owned

A party of Cranborne Chase deer stealers in the mid eighteenth century, drawn for the second edition of Anecdotes & History of Cranborne Chase (1818) by William Chafin. He described the odd caps as 'formed with wreaths of straw tightly bound together with split bramble stalks' like bee skips, and the jackets were made 'of the strongest canvas, well quilted with wool' to defend the deer stealers from blows given by the heavy staffs of the keepers.

some of the land, and other landowners objected strongly to the restrictions of forest law, which meant that the deer could eat their crops or young timber with impunity, and that the woods had to be maintained. Verwood and Alderholt were right on the edge of the Chase, and from the thirteenth century onwards there were attempts to have these outer edges released from forest law.

As well as being in Cranborne Chase, Alderholt also had a deer park, a completely enclosed area for deer. It was only 230 acres (93ha), surrounded by a big bank and ditch.

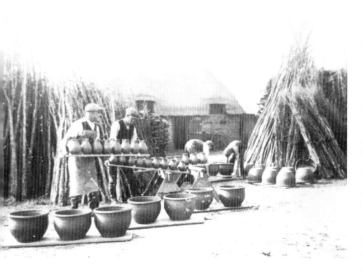

Parts of the bank still survive today, but the ditch has silted up. The park was in use in the four-teenth century, but it may date from much earlier. It was abolished in the 1530s.

Even so, as late as the eighteenth century the owners of Cranborne Chase had the right for fif-teen days before and after Midsummer Day to take 'a toll of 4d for every wagon, and 1d for every pack-horse, passing over Harnham Bridge [Salis-bury] on account of travellers disturbing the deer while dropping their fawns. At that time a pair of horns are fixed to that bridge, to give notice to travellers.' (John Hutchins, 1774.)

Deer were important in Cranborne Chase, but so were the trees. Large trees were grown for timber to be used in buildings, while smaller wood (much of it coppiced) was used for fuel. The potters and tile-makers fired their kilns with this smaller wood, right to the end of the industry in 1952.

*T*he yard at Cross Roads pottery in 1928, with wood stacked ready for use; faggots of hazel on the right, and what looks like fir on the left. The Thornes who owned Cross Roads were timber dealers, but these stacks are probably stored ready to fire the kilns. The jugs and bread bins are being laid out to dry. The old cob and thatch cottage in the background may be the building shown on the north-east corner of the site on the 1901 Ordnance Survey Map.

Hurdle-making was one of the most important industries, because hazel was easily available from the coppices and the many sheep on nearby downlands resulted in a huge demand for hurdles. William Chafin described the traditional management of the cop-piced woods in 1818:

When about fourteen, fifteen, or sixteen years' growth, they are felled, and the copse wood sold at a great price to dealers, who assort it, and dispose of it again by retail for various uses. The assortments are the following articles: poles for light scaffolding, for rails, pales, gates, and fences; hazel wood for fagoting, hedging, the making of hurdles, the cutting out spar gads for making spars for thatching, and sticks for use in gardens. ...

When the copses are felled, they are enclosed with a high wreathed fence against the deer, which none ever leap over unless pursued and distressed. On the third Autumn of the wood's growth, these hedges are in divers parts lowered down, to give entrance to the stout deer, and creep-holes are made for the fawns and weak ones; and this operation is called leaping and creeping.

On the fourth Autumn the fences are entirely removed, the substance of them made into faggots and disposed of as fuel, and the copses are laid open, and become common for the feed of all sorts of cattle except sheep. A great number of young kine are reared in the woods, many cows in the summer milked in them, and much butter and cheese produced, to the great benefit of the neighbouring Parishes to whom the rights of common belong.

Everyone had to allow the deer to feed on their four-year old coppices, and put up with the damage to other crops. They sometimes retaliated by killing the deer. In 1524 Thomas Willis, of Eastworth (part of Verwood) was presented at Cranborne court because he had 'hunted and disturbed the wild beasts of our Lady the Queen from the coppices and wood' twice that year 'contrary to the custom of the Chase'. In 1788 it was proposed that Cranborne Chase should be abolished because of the injury the deer did to the woods, and because the Chase had been:

a nursery for, and temptation to, all kinds of vice, profligacy, and immorality, whole parishes in, and adjacent to it, being nests of deer-stealers, bred to it by their parents, and initiating

their children in it, they naturally contract habits of idleness, and become pests to society. It is likewise a great harbour for smugglers, the woods being very commodious for secreting their goods, and the deer-stealers always ready at hand to give them every assistance.

Some of these 'pests to society', and indeed even wicked smugglers, lived in Verwood and Alderholt. Daniel Sims (the same surname as many eighteenth- and nineteenth-century potters) lived and stored his smuggled brandy at Verwood, in a secret underground cellar by his cottage. While he was cutting turves on Verwood Common, the Cranborne exciseman found the storage place with eleven kegs of brandy. So lawless was the area that Dan checked which house the exciseman lived in at Cranborne, assembled some of his smuggling friends and at midnight they broke down his door with a sledge-hammer while another man threatened the exciseman with a loaded pistol. They grabbed the brandy, loaded it in their carts and escaped unharmed. According to local remembrance, these late eighteenth-century thugs got away with it, and were not even prosecuted. Dan Sims died in 1826, aged sixty-seven years, killed by his horse. He was returning drunk from Cranborne, fell from the horse and was dragged some distance by a stirrup.

Heathland and smuggling went together, not only because the inhabitants tended towards independence, but simply because there were not many people about. The lonely heathland shore between Poole and Christchurch was a favourite landing ground for smugglers in the eighteenth century, and one of their routes inland led through Verwood. Bournemouth developed right in the middle of this landing area in the early nineteenth century, but by then smuggling was already declining with changes in taxation and punitive anti-smuggling laws.

Production of timber and fuel on Cranborne Chase was of great importance to the economy of the region. Everyone from the Lord of Cranborne Chase and the lords of the manor downwards was concerned with the woods and there were elaborate laws (often bypassed of course) to control felling and make sure the woods were maintained. The pottery industry was very different – it was run by small farmer/potters towards the bottom of the social scale, and in small concerns run by perhaps two or three people.

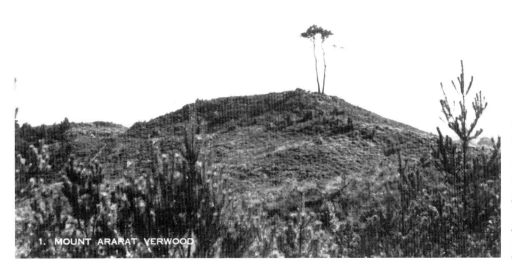

1. MOUNT ARARAT, VERWOOD

Mount Ararat, on the heathlands of Verwood, a noted landmark with isolated pines. This postcard of the 1930s shows the planted firs (foreground) starting to grow up.

The potters had no laws to help them; indeed, they often broke their tenancy agreements by taking clay, sand or fuel which they were not entitled to.

The Chase was abolished by Act of Parliament in 1830. Thousands, possibly as many as twelve thousand, deer were killed, and the landowners could do what they liked with their land. Verwood and Alderholt seem to have managed to cease being part of the Chase in the eighteenth century. Coal was becoming a common fuel in Dorset in the early eighteenth century, with the Somerset pits supplying the north of the county, and Newcastle the south, through the port of Poole, so the coppice wood of Cranborne was becoming less important for fuel. Huge quantities of hurdles still continued to be made, along with thatching spars.

Changes in the woodlands around Verwood (and on other heaths) occurred from the eighteenth century onwards. In 1815, the *General View of Agriculture in the County of Dorset* recorded that 'many hundreds of acres around Uddens Park [just to the south-west of Verwood] have been planted with firs'. the same book gives the major contemporary objection to this: 'At present, much turf is procured from the heaths, at the rate of 2s 6d per 1,000 turfs, which are conveyed many miles by the farmers for the use of their labourers.' At Ringwood, where many firs had been planted, 'the want of this article of firing is much felt and complained of by the poor'.

Sadly, conifers were the future for woodlands in the area. From 1928 the Forestry Commission took over much of the Verwood heathland, and 3,500 acres (1,400ha) were planted with conifers before 1932. The ancient bogs were drained, and the whole area transformed.

Hurdles and Brooms

Hazel coppicing was maintained all through the nineteenth century to supply hurdles and thatching spars. Cliff Lockyer recalled that the five or six smallholdings around the farm he worked on at Alderholt in the late 1930s were held by hurdle- and spar-makers who helped out on the farm at threshing time. The men who cut the timber and laid the hedges were called 'strappers'. Besides supplying the hurdle-makers, they made faggots of hazel which were used under hayricks to keep them dry, and bavins of lighter wood which were sold to bakeries for their ovens. Both faggots and bavins were tied up with twisted hazel or willow. One local man made sheep cribs as well as hurdles. When the hazel was cut by the woodmen it was laid down in long lines (called drifts) about 7 or 8yd apart.

Crendell and Cripplestyle had so many woodland craftsmen that the Congregational chapel band in the 1930s was called the Spar and Hurdle Band because that is what most of its members made. There are said to have been fifteen hurdle-makers around Cranborne in 1955, and even today there are still several.

Hurdles were made almost everywhere, although the Verwood district had more makers than most areas. A more specialized and uncommon industry – besom broom-making – was centred on Three Legged Cross, just to the south of Verwood. The heathland was vital for this as it supplied the heather and birch needed, while nearby woodlands supplied the hazel. The early history of the industry has yet to be uncovered, but by 1898 there were eighteen broom-makers listed in *Kelly's Directory*; there were only twenty-four in the whole of Dorset (and some of those probably made yard brooms, not besoms).

During the early twentieth century the craft gradually died out, but luckily one of the last makers, John Haskell of Verwood, was interviewed in 1937:

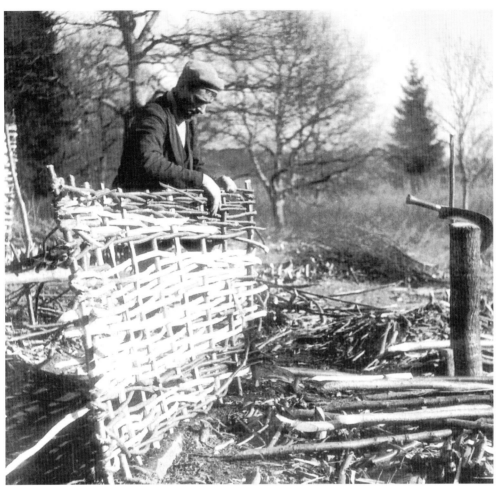

*L*en Lane making a hurdle in Alderholt in the winter of 1936/7. The larger trees have been left to grow on after the hazel has been cut. His main tool was the bill-hook, seen here parked carefully on the stump.

*H*urdles in use at South Monkton Farm, Wimborne St Giles, in 1941. They have been used to create an enclosure for the ewes who must be about to lamb. The crib (right foreground) was also made locally.

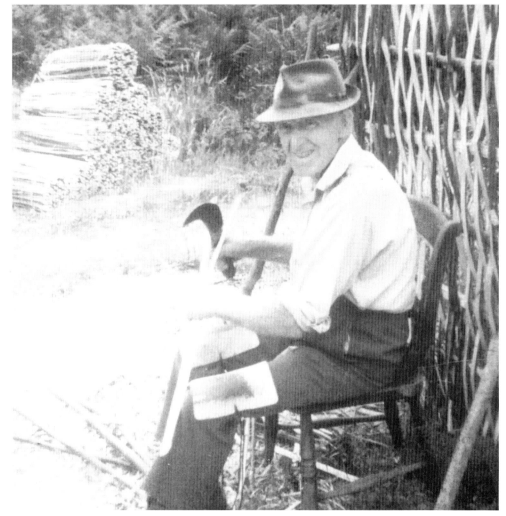

Will Foster of Crendell making thatching spars from hazel, sitting in the shelter of a hurdle. These long split hazel rods (stacked in the background) were needed in their thousands when thatch was commoner on houses, and when every farm had ricks which needed covering.

A visit to this maker of brooms is like stepping back a century, for here is no mass production but a man working alone in a thatched shed surrounded by the time-honoured implements of his trade: a wooden bench, broom sticks, an old-fashioned Dorset hook, and stacks of heather and twigs. ...

His introduction to the work came when he was ten years old for then he spent his holidays gathering bundles of heather for his father. At that time heather was commonly used for brooms but now birch is preferred. This comes from the New Forest or from Lord Shaftesbury's pheasant coppices. ...

Leaving school, Mr Haskell was taught the craft by his father. The first part of the broom to be made is the handle. A strong, straight birch branch is chosen and the twigs stripped off. The wood is then held in a vice while a 'shaver' removes the bark and smooths it before a sharp point is made at one end.

When the handle is ready a bundle of heather or birch is tied together as tightly as possible with thin twigs. Long ago 'sleets' were used to bind the broom twigs together. These sleets were thin shavings about a yard long cut from hazel sticks. To obtain them required consid-

erable skill for a slit was made at the top of the stick while fingers and teeth ran the shavings down the stick.

The next thing is to hold the bundle firm and with a wooden mallet drive the handle deep into it. After that the handle has to be bored just above the broom and a small wooden peg driven into the hole in much the same way as a spade is riveted. The broom is now finished ready for use after much thoughtful and skilful manual labour which makes the broom a real craftsman-like article.

In another 1937 interview, John Haskell emphasized the change in his lifetime from heather brooms for sweeping out stables to birch brooms for garden sweeping. Luckily, the Verwood area could supply both. In the early twentieth century, at least some of the besom brooms were sold by the pottery hawkers on their rounds, and this could have been happening for a long time. In 1937 John Haskell was also selling directly to Bournemouth and Poole Corporations.

The Second World War seems to have finished the industry in Verwood, although many local people were still able to make brooms. For example, Len Sims, one of the two last workers at Cross Roads Pottery, could make brooms, as he demonstrated to a researcher in the 1970s.

Cob, Bricks and Farming

Cob

Often referred to disparagingly as 'mud', cob was a common building material in the Verwood area right up to the 1940s. As in the old saying, if it is 'given a good hat and a good pair of shoes' (that is, a good roof and footings of brick or stone), a cob building will last for many years. The best description of local cob building comes from Heywood Sumner in the early 1920s. He was concerned that:

This traditional craft has been dying out. Mud walls should be made of sandy, clayey loam with small stones in it; and with heath, rushes and sedge-grass, or straw,

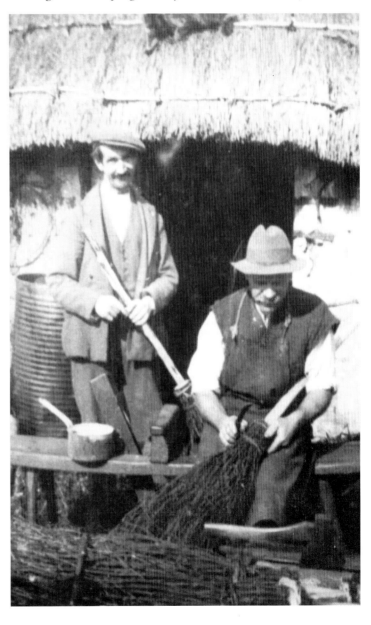

John Haskell making brooms about 1929–30. His workshop is behind.

thoroughly puddled into the mass by trampling. In the best-made mud walls this was dobbed and bonded by the mud-waller with his trident mud-prong in successive layers on the wall he was building. About two feet, vertical, were raised at a time (a 'rearing'), then left for ten days to dry before the next rearing was raised on it. Walls built thus, on heathstone or brick footings, stand well. But often they were raised without any footings, and by inexperienced 'mudders' who used the wrong sort of clay; who did not temper it stiff with heath; and who could not build a wall with a mud-prong, but trusted to board 'clamps', and thus this serviceable walling material has been discredited; most unfairly; mud walls that have been well built stand firm and impervious for generations, and provide warmth in winter and coolness in summer within the cottages which they surround, and they cost less than walls of any other material locally available. There is excellent mud-walling still being raised, and for such requirements, I should go to Verwood; to Mr Sims of Sutton Holms, Verwood, who has inherited the knowledge of his craft, and can point out this, that, and the other mud-walled, thatched cottage in his native village, as built by his grandfather, his father, or himself (to the last he has recently been adding). An outer rough-cast coating of plaster and pebble-dash fortifies the weatherproof nature of mud-walls, and veils a coarse material with a serviceable finish.

Sidney Frampton of Holtwood to the south-west of Verwood, later a builder, remembered the methods used for cob building in the 1930s:

First you prepare your foundations, you dig them and then put in concrete. Some people used to put sandstones into the foundations but this is not so good because later you tend to get cracks in the walls of the building in line with the joins in the sandstone.

Then you get a cartload of clay, or loam, and tip a cartload on to each way (where you intend the walls to be). Then you use water to make the clay wet and then tread the mixture well. You tread it first, then turn it over with a prong and tread it again. When you've done

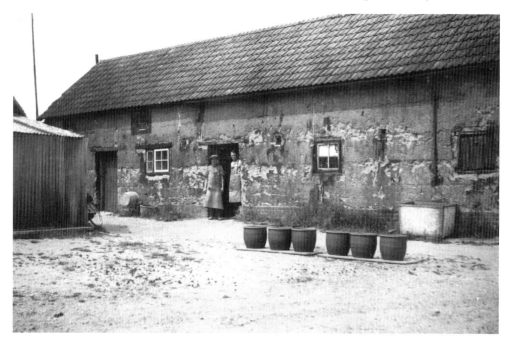

Cross Roads Pottery in 1940, with the meagre wartime production drying outside. The workshop was built of cob, and this view clearly shows the joints between each rise.

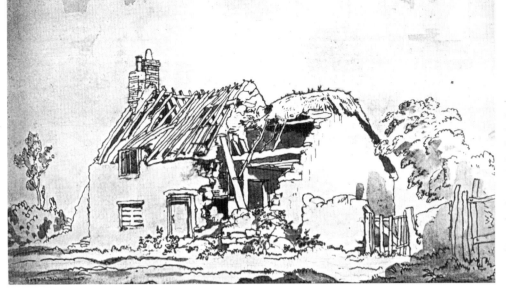

A ruined cob cottage in 1922, drawn by Gerald Summers. It had been thatched, the usual roofing material of the area, and typically is fairly small. The right-hand part was probably a workshop or store.

that a time or two you put green heather into it. Heather is good because it never rots. Then you turn it again and keep on treading it and adding more heather until the texture is right. That's until it's stiff enough to stay on the prong. Now you can start. You start by plumping it down on the wall, eighteen inches wide all the way along the wall. Then you come back and build the wall up to eighteen inches high all along. You must do this in one day. Then do another wall in another day, and so on until you have four walls at the end of the fourth day. On the fifth day, if it is dry enough, you can add another eighteen inches to the top of the first wall.

Of course, this is a job for the summer-time, you must have dry weather. So you can see that this is a long and hard job. But for warmth you can't beat a cob wall.

The pottery buildings at Cross Roads and other sites were built of cob, as were smaller workshops, besides the cottages. At Sandalholme and Prairie Farm the cob had

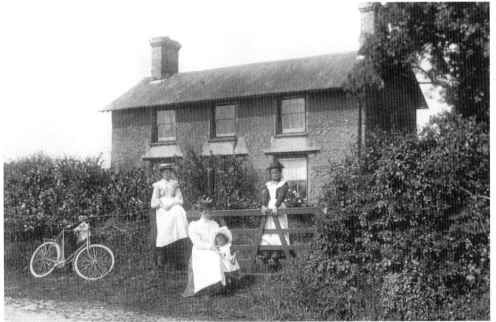

A very unusual 'villa' built in Ringwood Road, Verwood, about 1895–1900. It looks just like brick houses of the period, but the lines between the levels of cob are clear, and it has a corrugated iron roof, a strange combination of modern style and age-old materials for the walls.

occasional small pottery sherds in – very unusual. Cob is found all over south and east Dorset and the New Forest, but there is a larger proportion of cob cottages on the heathlands, probably because the heaths were poorer and had many more cottages built by their occupiers than agricultural areas where the cottages were built by large farmers and landowners. Bungalows were built of cob in the 1930s, and even earlier some 'villas' (*see* the photo on page 25).

Cob is a surprisingly good building material, but it does not survive forever, and few cob buildings earlier than the eighteenth century remain anywhere. In 1698 John and Katherine South 'being in their beds in a Ground Chamber at the west end of their cottage at three legg'd cross and asleepe …. The whole end of the said house being built with Mudd and being very old and rotten and it being a very stormy night tumbled in upon them' and they were killed. The facts are recorded in an Inquisition, and the twelve men taking the Inquisition decided that they 'came by their deaths by misfortune And that the mud walls was the occasion of their deaths'.

P art of Alderholt about 1905, showing the wide verges found on many local roads, and late nineteenth-century brick houses, the successors to the old cob cottages.

Bricks

Brick was not used in east Dorset until the sixteenth century, but they were made in the area from the early seventeenth century. In 1635 William Wigg was granted a lease for 'a piece of ground taken out of the Common and inclosed to make brick' at Alderholt. There were several small brickyards in both Alderholt and Verwood, and with the opening of the railway station in 1876 these were transformed into a large industry because the bricks could be taken out by train. Large brickworks were constructed close to Alderholt (Daggons) and Verwood Railway Stations, and by 1898 there were six firms making bricks in Alderholt and Verwood. They had all closed by 1939.

Farming

Farming in Verwood has been one long struggle against the heath. The only really fertile lands are along the river valley, but steadily farmers and smallholders have 'assarted' or taken in bits of the heathland, converting them to enclosed pasture or even arable land. This had been happening for centuries before documents survive, but leases from the seventeenth century onwards document its continuation. The Survey of Alderholt in 1666 has Richard Soning leasing 'a cottage built upon the common' and others renting land 'taken out of the common'. Field names also show their origin, for example: 'A close of arable called Great Heath Close' in 1697.

A map of the Earl of Shaftesbury's land in Verwood in 1770 shows this process happening. The Prairie Farm kiln has been cut out of the heathland with 4 acres (1.6ha) of land, but assarting the heath has clearly been going on for some time – other farms are pushing new fields out into both Horton Heath and Verwood Heath.

Even down in the river valley the farms were small. The 1770 Shaftesbury map has ten holdings as well as the pottery, and they vary from 3 to 54 acres (1.2 to 22ha). Ignoring the three very small ones (3 to 9 acres, 1.2 to 3.6ha) and the largest one, they range from 13 to 39 acres (5 to 16ha), with the majority around 22 to 38 acres (9 to 15ha), tiny holdings which must have used the heaths adjacent for grazing. It is not surprising that so many of these small farmers had other jobs as well, many of them supplementing their income by being potters, broom-makers or hurdle-makers.

In Verwood it was the farmers and small-holders who were 'improving' the heathland, but a little to the south, at Uddens Park, some of the heathland had been reclaimed 'at great expense' before 1815, and after draining it was so rich that 'it has been known to support five sheep per acre for seven months together' (*General View*, 1815). However, at the same time, 'some low moist soils near Uddings [Uddens] Park, rather of a peaty nature, seem to have been cultivated and afterwards neglected: at present they are covered with no kind of vegetation but a few tufts of various kinds of sedge, and other coarse grasses.' Even for big landowners, reclaiming the heath for cultivation was expensive and not always successful.

Cripplestyle was described in 1899:

> This hamlet is a part of the vast parish of Cranborne; anything like a village does not exist, and scarcely three houses are found together. Formerly it was the custom of the lord of the manor to lease plots of land for lives, on easy terms, and the life could be renewed on the payment of a small fine. Upon their holdings the people built a cottage, and though they may have had to toil as hard as any day labourer, there was a feeling of independence. The house, often a poor one with mud walls, was their own in a sense, and so were the fields, which they, or their fathers, had enclosed from the surrounding wastes of heath and furze. The custom does not now prevail; the little holdings, as they fall in, are attached to the adjacent farms, and the cottages are allowed to tumble down.

Three Legged Cross is similar: 'The population is scattered, and the district somewhat dreary and barren, but the people seem fairly prosperous, and have a good deal of independence, living as they do, mostly at small rentals, on their own leasehold plots, which they or their fathers enclosed from the surrounding waste.'

Ralph Wightman described the area in the early 1950s:

> West Moors and Verwood are suburbs of Bournemouth. The motor-car, between the wars, made it possible to branch out beyond the railway and there are hundreds of little villas all over this part of the heath. ... There is a strange mixture of modern brick houses with an occasional old cottage which once got a living from the poor soil. Most of these old houses are very small, built of crumbling cobb and with thatched roofs. They stand on a half-dozen acres

Looking across to the drying sheds of the Verwood and Gotham Brick & Tile Company's works, probably about 1910. This big brickyard was next to Verwood Railway Station.

of sandy soil, hardly won from the waste, and there are very few native inhabitants. Almost every holder is a stranger who was tempted by the relative cheapness of the land and the nearness of the Bournemouth market into thinking that he could grow market-garden crops. It is a heart-breaking tale. The real market-gardener knows that his job is half gardening and half marketing ... It is the man who can sell his goods who makes a living at market-gardening. Most of the little holdings in what I have called the 'Bournemouth Heath' have had a sad history of continual change of occupants.

The Verwood area with the places mentioned in the text. The dashed line is the county boundary – Dorset to the left and Hampshire top and right with the wide Avon valley. The heathlands (dotted) are taken from the first edition of the Ordnance Survey c.1810. Verwood can be seen developing as a dispersed settlement on the edges of the heaths.

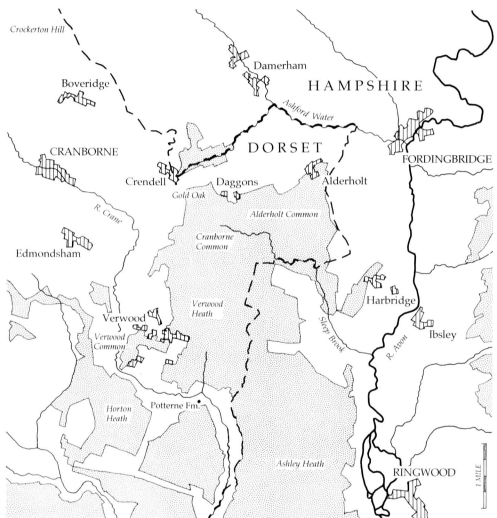

Since then, development has accelerated, with Verwood becoming a town with 11,000 inhabitants in 1996. Some of the heathland survives, and the old potters might recognize Alderholt, but Verwood itself has been transformed by the development of so many houses. H.C. Fryer, the owner of much of Verwood, writing to Freddy Sims, the potter, in 1920 notes at the end of his letter 'All the world seems anxious to have houses in Verwood, so I hope a good time is coming to the place.' Good times have indeed come, but they took rather longer than expected.

3 The Start of the Kilns

Potteries making earthenware were to be found all over the country in medieval times. Earthenware pots were a necessity, used for cooking as well as holding liquids and serving some foods. Pottery, usually broken into sherds, is the commonest find on archaeological excavations because so much was used and then discarded when broken. Luckily, although the basic forms of cook-pots, jugs and (less commonly) bowls, go on throughout the medieval period, they gradually change both in shape and in the exact clay mixture they are made from. This means that the pottery can be fairly closely dated, and in fact it is the main means of dating for medieval archaeological excavations. The pottery was made in kilns that were established anywhere there was suitable clay and the fuel to fire the kilns. Only one medieval pottery kiln has been found in Dorset, at Hermitage in the centre of the county. This produced the usual very plain cooking pots, bowls and jugs alongside tiles, during the thirteenth century. Much closer to the Verwood area are the medieval kilns of Laverstock, just east of Salisbury, which were in production in the late thirteenth and early fourteenth centuries. Ten kilns have been excavated, one of them still with jugs inside. Cook-pots, bowls, lamps and bottles were also made, but the main product was jugs.

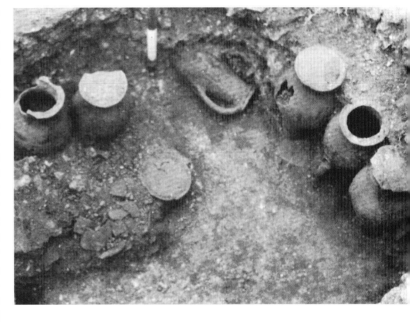

Kiln 6 at Laverstock being excavated, showing the jugs from the last firing still in position sitting on the base of the kiln. Some of the jugs had already been removed when the photograph was taken.

The most satisfactory way of knowing about medieval pottery production is the discovery and excavation of the kiln that fired it, but only a few have been found and excavated. There must be huge numbers of kilns undiscovered to account for all the medieval pottery found. Often pottery can be identified visually, or by analysis of the inclusions – the sand or other material added to the clay to make it fire better. This type of analysis has been carried out on medieval pottery from Sherborne, but the results were inconclusive for most of the wares because they contained only common inclusions.

Luckily we do not have to rely entirely on evidence from kilns to work out a dating sequence for pottery. Every excavation on sites that were occupied in medieval times has produced groups of broken pottery which have all been discarded or deposited at the

same time, and occasionally those groups have well-dated imported pottery or glass in them. Analysing the complete group, and comparing them to other published groups, produces a dating sequence for the area. Medieval pottery varies regionally, while following a basically similar development, so local comparisons are the best ones. There is also the nasty possibility that pottery found at the kilns does not fully represent what was made – experimental firings and trial pots in new shapes are more likely to go wrong and be discarded before sale than the regularly produced forms. Pottery found away from the kilns will have been sold, used, broken and discarded.

It has sometimes been suggested that the Roman kilns only 13km north-east of Verwood relate to the later pottery industry. The Roman kilns are on heathland like Verwood, and were also single-flue kilns, similar to Verwood. However, the Roman kilns were much smaller than the later ones, as were all Roman kilns, and they produced high-fired finewares and a hard greyware quite unlike the later Verwood products. Comparisons are misplaced because there is such a huge gap between the end of the Roman industry in the late fourth century AD and the start of the Verwood industry, which cannot be earlier than the eleventh century. Hardly any coarseware pottery was made in Dorset after about AD 400 and before about AD 1,000. The coincidence of the kilns being in the same area is due to the availability of clay and wood to fire the kilns, nothing more.

Some of the late thirteenth/early fourteenth century jugs from kiln 6 at Laverstock, showing a great variety of decoration, including pellets and strips, some of which have a dark brown glaze. Most of them also have a greenish glaze over the outside (Salisbury and South Wiltshire Museum).

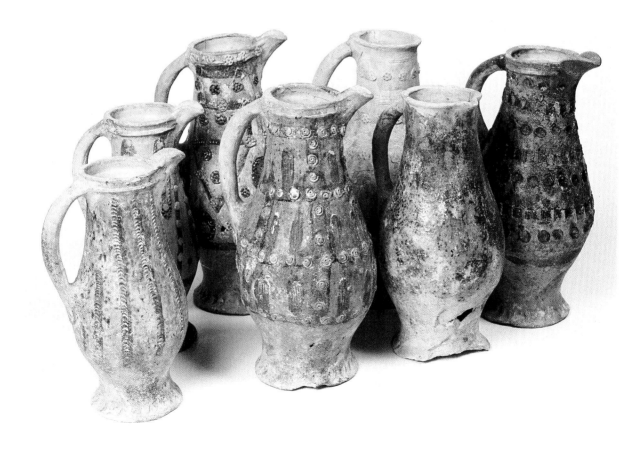

Medieval Kilns at Verwood

No kilns have yet been discovered, but it is known that the Verwood area was producing pottery in the medieval period. There are documents from the fourteenth century which prove this at Alderholt, and a farm in Verwood was known by the name of Potterne from at least as early as 1280.

Alderholt and Verwood were part of the huge parish and manor of Cranborne in medieval times and the Cranborne Manor Accounts record that, in 1337, the tenants paid fourteen shillings (a large sum then) for digging clay to make pots. In 1317 tenants at Alderholt paid a clay rent. These accounts only survive from the fourteenth century, so it is possible that the tenants had been paying this for some time, presumably for the right to take clay.

In 1489 what are almost certainly the earliest named potters occur in the Cranborne Court Roll. Robert Adale, John Shergould and Thomas Grey had permitted 'les pyttes', called 'claypyttes' in Holewell tything, to become deep, muddy and dangerous, to the injury of the whole county. They were ordered to fill them in under penalty of a 20/– fine. The first two men were recalled to the next court at the end of December 1489 and fined 1d each for not having filled in the pits. One penny seems a much more realistic fine than the huge 20/– deterrent. After 1500 the accounts are more complete, and in 1503–04 John Laurens, Thomas Grey, Henry Russell, John Gold junior, John Ride and

Bartholomew Delamont of Alderholt were fined 2d each for cutting heath in Alderholt Common to burn pots there, having no licence. They were also fined 6d for taking clay from the common next to Goldocke to make tiles. This was repeated in 1524 and 1526, the latter year not for making tiles but pots. The fines are repeated in 1530, 1542, 1543 and 1562. In 1517 John Tyler was fined 2/8d for a licence to take clay from near Goldocke for making tiles – a late example of a surname coming from occupation.

Goldocke is Gold Oak, clearly shown on the 1605 map next to the boundary with Hampshire, and the 'Pits of Potters clay' are shown just to the west. Crendell and Alderholt are both mentioned – Crendell as the source of the clay, Alderholt common for the heath to fire with and Alderholt itself as where the potters are from. Six people digging clay is a

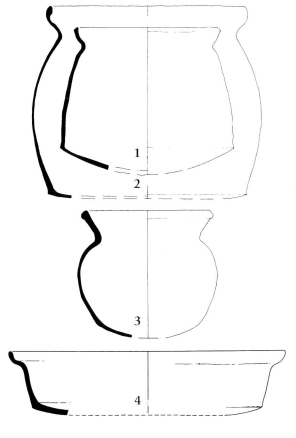

rdinary medieval cook-pots, the commonest form made and a great contrast to the decorated jugs. Three cook-pots (1–3), one with a rounded base from a thirteenth-century pit group from Dorchester, and (4) a bowl of similar date from Wareham. At about one-sixth life size.

OPPOSITE PAGE:

Sixteenth-century pottery from Dorchester (1–8) and Christchurch (9); jugs (6 & 7), a big cistern (8) with a spigot hole and a bowl (4) are characteristic forms, along with the handled cook-pot or pipkin (9). These may have been made in Verwood, and are hard, well-fired and decorated with only spots of glaze. 10 is the earliest complete vessel made at Verwood. The fabric (the body of the pot), is just like later Verwood pottery, and since it was found at Wimborne, only 12km south-west of Verwood, it seems very likely to have been made there. It was probably a container for salt, but since it is unique it is difficult to say. It can be dated to the sixteenth century by the glaze and style of the base. All at one-quarter life size.

large number – possibly some were labourers employed by the potters, but it still implies a sizeable industry.

The leases for Cranborne Manor property give an idea of the land-holdings of these early potters, and it is clear that they were small farmers as well as potters. John Vowle, fined in 1517 for taking clay, held two cottages with an orchard (6 perches) and 7 acres (2.8ha) of arable land and 'pasture being in several closes with pasture upon the common heath' in 1534. His son William's lease of 1570 includes half an acre of underwood – the source of all the fuel for the house and for firing pots. Other potters held between 10 and 40 acres (4 and 16ha) of land, with common pasturage on the heath. The potters seem to hold much the same amounts of land as other tenants.

For Verwood itself the evidence is less direct, but dates from even earlier. From at least as early as 1280, a part of Verwood was known as Potterne or Wimborne Potterne, meaning the building where pots are made. The name persists right through to today, and in medieval times gave rise to people being named after it, such as Walter de Potterne who is recorded in 1340 at Wimborne St Giles. Often such a surname suggests a potter, but here it refers to the lands he held. There must have been a pottery here in early medieval times. The date of 1280 is simply the first time the name occurs in a surviving document: it could have been used much earlier.

Crockerton Hill, to the north of Cranborne, is recorded as a place name from 1325, when it was 'Crokkerneweye', meaning the way to the pottery or the gate to a pottery. Although situated up on the chalk, it is in an area where there is clay, and medieval pottery has been found there, some of it possibly kiln wasters.

In the late fifteenth and early sixteenth century the range of pots being made increased greatly. New forms were produced, such as cups or mugs (which had earlier been made of wood or horn); chamber pots and commode liners; as well as salts, chafing dishes and so on. In addition, other types which had been rare in medieval times were now commonly produced, including costrels (which were to continue in production at Verwood into the twentieth century); candlesticks; cisterns (like huge jugs but with a bunghole towards the base); lids; handled cooking pots (pipkins) sometimes with feet to stand over the fire; and handled bowls.

These locally made vessels are found in archaeological pit groups alongside imported stonewares and even fine earthenwares from Holland and France. Cooking pots virtually ceased to be produced because they were superseded by metal ones. They had been the main product of virtually all potteries from prehistoric times, but from the sixteenth century onwards only a very few were made, usually handled and sometimes with legs.

The Seventeenth Century

We know that the Verwood area was making pottery all through the seventeenth century because there are quantities of documentary evidence and one kiln (at Horton) has been excavated. The potters continued to dig clay and sand without a licence: in 1627 Robert Symes, John (?), Dunstone W. Clarke and Thomas Attwaters were presented at the Cranborne Manor court 'for digging of sand in the common of Alderholt and not filling in their pits and for digging of clay in Cranborne Common'. They were fined 6/8d each. 'John Kibby digs clay for Francis Gould and others and opens pits and holes and leaves them open, near the King's Way, to the great injury' of passers-by in 1646. This goes on

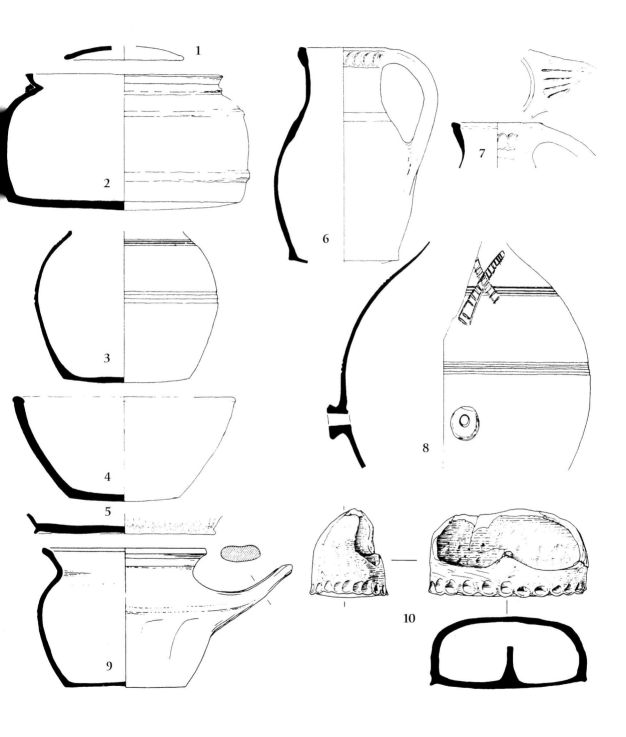

Crendell on a manuscript map of about 1605, with the 'pittes of Potters clay' clearly marked top right, close to Goldeoke. The roads run through the open Crendell Common (Crundole Plott), and the potters may have lived in the cottages shown bordering this open land. The common has since been enclosed. The first names are those of the tenants, followed by what seems to be field or area names. The area on the right has lots of woodland. (By courtesy of the Marquis of Salisbury.)

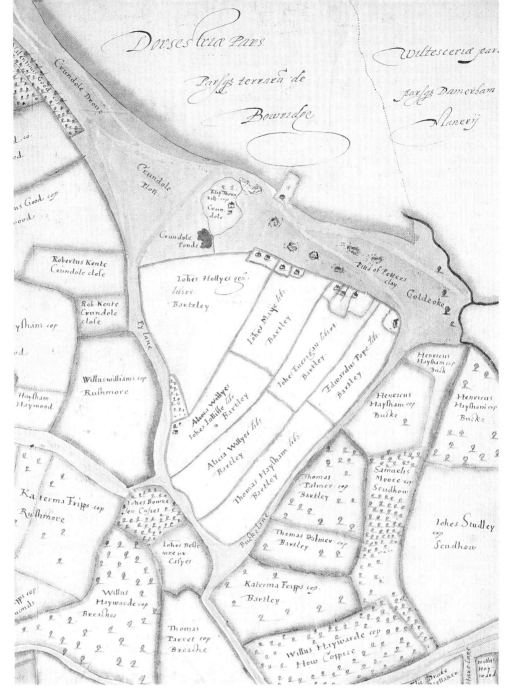

all through the seventeenth century, with the same names occurring again and again. Digging clay or sand from Alderholt or Crendell Common and cutting turves or heath from the commons and wastes are the usual offences, along with not having filled in the pits, or mended the road when told to.

Another potter, William Frost, was working to the south, in Horton: his name first occurs in the Manor Court in 1616, when he was prosecuted for digging clay in the Lord's waste. He was regularly in trouble for this up to 1635. He died in 1659, but by that time his son of the same name was also potting and he seems to have continued to work the kiln until the 1680s.

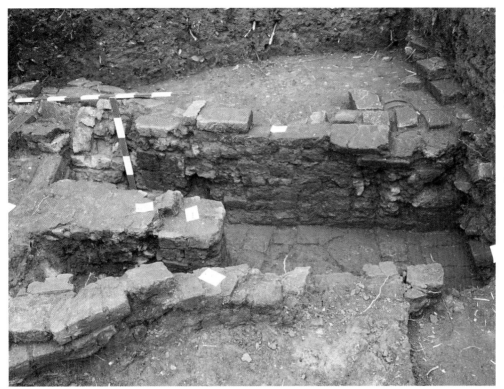

The kiln at Horton had an almost circular chamber, lined with brick. At first it only had one flue, but later another was added. The chamber was 1.5m across, and like later kilns it was fired with wood.

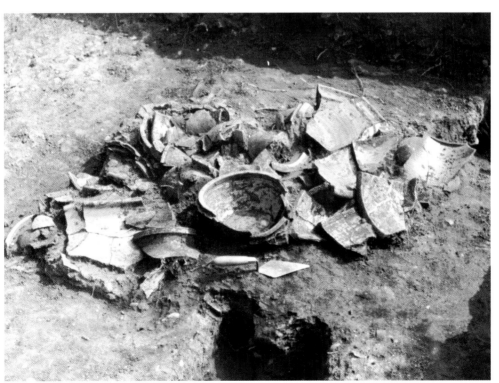

Heaps of wasters – rejected pots – are always found around kilns. These are some of the Horton wasters, mostly in the characteristic yellowy-orange glaze.

Some of the wasters from the Horton kiln during the excavation – one of the pipkins (left foreground) and a dish.

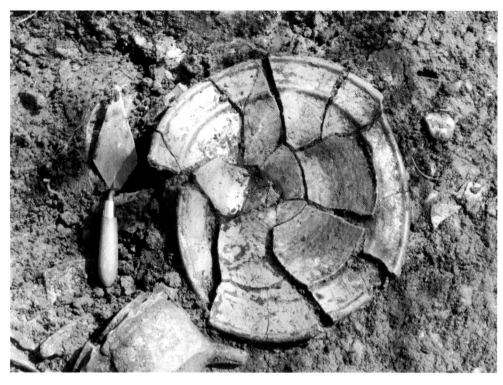

OPPOSITE PAGE:

The kiln excavated at Horton produced fine earthenwares with green glaze, including the small plates (or saucers) (1–3) and the mugs (16, 17, 18). Some fine lids (4–7) were unglazed, but the pierced ones from fuming pots were glazed (8 and 9). 10 is a little drug jar. The jugs (13, 14, 15) are typical of their date, and are the earliest Verwood jugs that we can be certain of. 11 and 12 are the earliest known Verwood costrels, another type which goes on until the end of the industry. These were found in both orangy glazes and greeny ones. Some of the cups/mugs are so large that they were probably used as jugs despite having no lip. At one-quarter life size.

The earliest will to survive for a potter is from Horton – Elias Talbot who died in 1672 left to his brother-in-law or nephew Richard Lacy 'the Boards wheele and the use of the Shop and Kilne … and also to have all my ffagott, and other great wood' at valuation, but if his widow and Richard Lacy cannot agree a price, then he can agree 'at every time of burning ware and so to pay her for the said wood within a week after every time of burning'. Richard was also left 'all my lead now in house and a pott to melt lead in'. He clearly expects trouble between his widow and the new potter. He seems to have only one wheel, so only one potter would have been throwing the pots.

By the late seventeenth century there were also potters in Edmonsham. When Stephen Foreman took an apprentice in 1669 he was described as 'potter of Edmonsham'. Lewis Kerbey or Kerly seems to have been working there a little later.

A few inventories (lists of money, debts and possession taken after death as part of proving the will) survive for potters from Alderholt in the late seventeenth century. Richard Henning died in 1682 and his possessions were valued at £83. This includes £4 4s 'debts owing on book' and even worse £11 11s 'Desperate debts owing on book', but even with these sums taken away he was a prosperous man. His house had two bedrooms, a hall or main living room, two butteries (small store rooms) and a brew-house. These were probably all on the ground floor. In his 'shop' (workshop) were 'In the materials therein belonging and the 2 wheels, and boards, lugs and plants etc. £1. The clay without and within 10s.' 'Earthenware burnt' is valued at £4 right at the end of the inventory. He also had 1,000 faggots valued at £2, brush faggots at 5s and something puzzlingly described as 'a colefire of wood' at 18s. Doubtless the household used wood for heating and cooking, but these huge quantities of faggots must include the firing for the kiln. The lead pot in the workshop is valued at 3s, and carefully

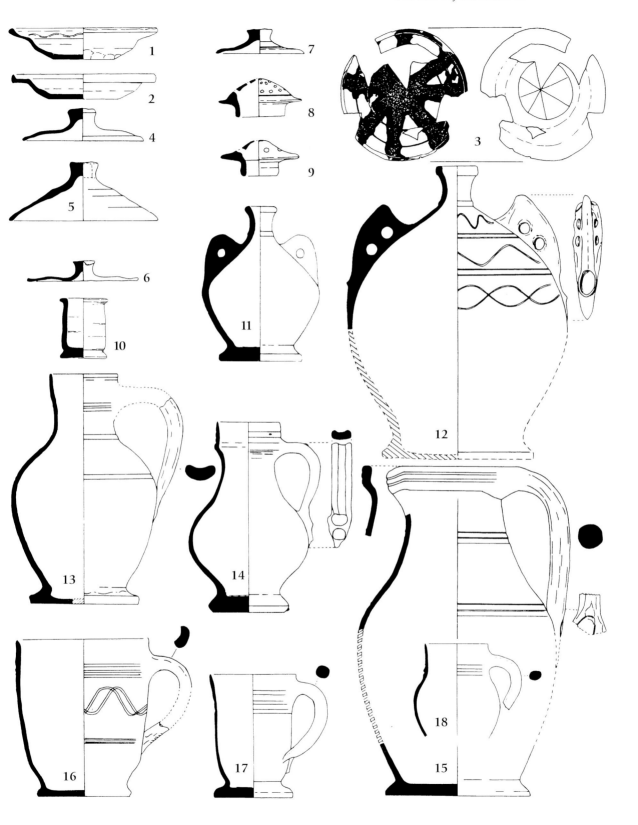

OPPOSITE PAGE:

Kitchen wares from the Horton kiln, including bowls and colanders (1, 2), handled cookpots on legs (pipkins) (3, 4), jars (5), a huge handled dripping tray (6) and chafing dishes (7, 8) used with charcoal in to keep food hot. At one-quarter life size.

stored in the house in one of the butteries was 'one hundred of lead' at 13s, which must be for the lead glaze. No kiln is valued. Henning clearly farmed as well as being a potter: he owned a cow, a young bullock and a calf, four sheep and a lamb at the time of his death.

The same man, Richard Henning, was amongst those fined for 'cutting turf and heath and having no right' in 1658, and for digging clay and making waste on the common in 1648. Although a prosperous man, Richard Henning could not sign his will with his name – he used a mark, a shaky H. William Frost, potter of Horton, also marked rather than signed his will, suggesting that few were literate.

Another inventory of 1682 is for James Thorne of Verwood, potter. He was farming as well as potting, owning two horses, a cow and calf and a pig when he died. His total is £28 2s 6d, including £10 as the value of his leasehold tenement. He only has 6s of faggots, but 'earthenware at the pottery' was valued at £4 1s, a large proportion of his wealth.

Walter Major of Alderholt, who died in 1685, was a potter whose possessions were worth only half those of Richard Henning – £43. His house had a hall (general living room/kitchen) with one room over the hall (that is, upstairs) containing three beds. No other rooms are listed except the 'Shop'– workshop – where there were goods worth £2 10s. 'In the backside' (yard) were wood and faggots worth £20 10s, or almost half of the total inventory. Walter Major probably didn't farm – the only animal listed is one horse, presumably to draw the cart listed. A second Walter Major of Alderholt, perhaps his son, died in 1692, and his inventory is very different, totalling £68, and including £2 10s worth of clay and 'money in house and ware' £20. He also had a horse and cart, and one pig. As there is no other livestock, Walter Major also seems to have been a full-time potter.

The Major family later rented a property in Alderholt held in 1697 by William Attrill, who was probably another potter as the list of his property on the Court Book includes 'a piece of land containing half an acre on which is now erected a certain building called "le Potters Shop"' (shop then meaning workshop). Attrill's buildings included a house with two bedrooms, a barn with two rooms attached, a hay house, and a barn in an orchard. At the rear was 'a backside called le Great Backside', too small to be given an acreage. He also held three pasture closes each of 2 acres (0.8ha), six small arable fields totalling 20 acres (8ha), one of which had clearly been taken from heathland as it is called Great Heath Close, and a coppice of 2 acres (0.4ha) which must have supplied the wood for household fuel and firing the kiln. The lands were probably scattered rather than being in one compact holding, but a clear picture of a small farmer/potter shows from his land and buildings. This must be the father of the man who witnessed Richard Henning's will (with a mark, not signature) in 1682, but he spelt his name William Hatrell.

The Cranborne Manor Court made its usual protest about the claypits on Crendell Common 'being not filled in and dangerous for horse and man' in 1698, but they list those responsible for the actual digging – six men, 'Henry Forman and Stephen Foreman and Devy and Edward Sims and John Harvey and John Savidge'. But this was not enough – the road itself was also 'in decay and ought to be repaired by the potters, viz John Major, William Kibby, Robert Diwy, Charles Henning, John Henning, Samuel Henning, John Miller, Thomas Symes, and Lewis Kerley and Stephen Foreman'. Only two of these ten men occur on the first list. The second list is named as 'the potters', and the other people must be their labourers. If these ten men represent ten separate kilns, as seems very possible, the industry was already huge by 1698.

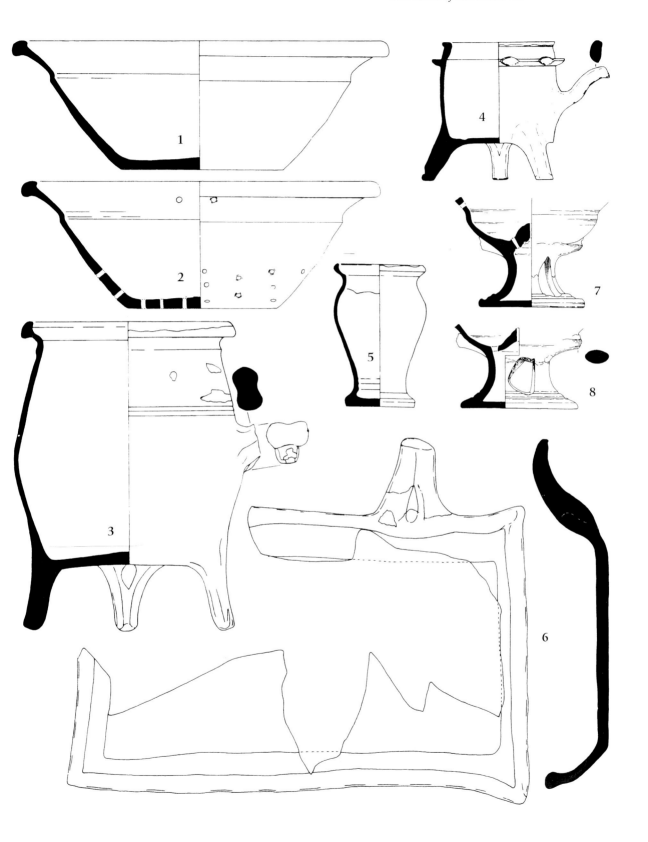

*C*ontainers from
the Horton kiln – a
commode liner (1),
a jar (2), two
chamber pots (3 and
4) and a butter pot
(5). These huge
butter pots were
commonly used in
the seventeenth
century to send
butter to market. At
one-quarter life size.

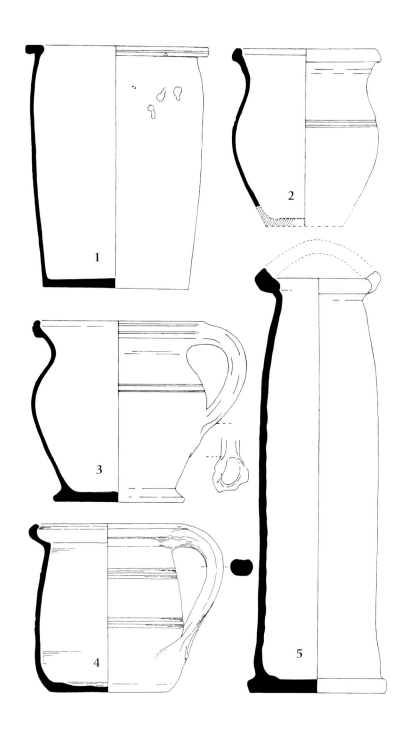

The Pots

At the start of the seventeenth century, the Verwood area kilns (like other local potteries) were the main suppliers of virtually all the pots in their district, and this was true all over the country. Developments both in the pottery industry itself and in the distribution of the pots were to change this – middlemen or merchants started to establish warehouses, buying from many potters and selling to the public. This had much more effect in the midlands and north of England than in the south, with the Staffordshire industry growing to take over huge parts of the trade.

Imported wares with attractive slip decoration encouraged the production of slip-wares in England, and kilns such as Donyatt (Somerset) and those at Barnstaple, Bideford and other north Devon towns produced large quantities of slipware from the mid seventeenth century. Verwood never used slip for decoration, and these more adventurous potteries sold their wares in the areas that had before been supplied by Verwood.

Verwood (and all the other potteries) increased the amount of glazing on their pots in the seventeenth century – earlier this was limited to fine jugs with occasional patches and splotches on other forms. From the seventeenth century virtually all pots had some glazing, although only the finer wares had it all over.

The variety of shapes produced at Verwood in the seventeenth century is vast, ranging from huge bowls and dripping trays down to tiny fine saucers and lids.

The Horton kiln is the only seventeenth-century one in the area to have been excavated. The discarded pots and sherds around it (the wasters) show that it was producing more than twenty different shapes, many of them with variants. All had a rich, wet-looking glaze which is different from the later, meaner-looking glazes.

Pots from the Horton kiln – (from left) jug, mug with manganese glaze, chafing dish, costrel and pipkin (in Dorset County Museum).

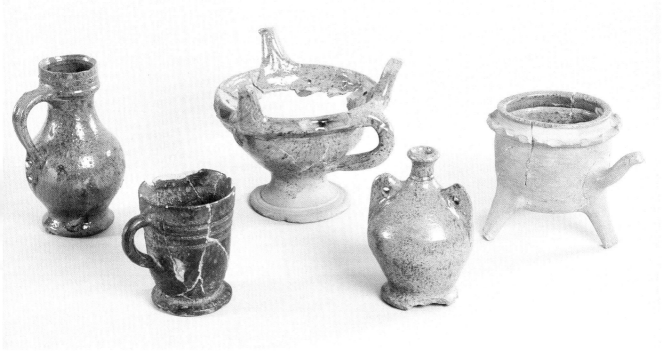

Some of the forms had been made earlier, including jugs, cups, bowls, cisterns and pipkins (handled cooking pots). The jug is the most persistent form, made from medieval times until the end of the industry in 1952. The costrel, with a tight neck which could be corked and pierced lugs to take string or leather for hanging, appears for the first time in the seventeenth century, and again goes on being made into the twentieth century. Bowls in many sizes and shapes along with the flatter dishes, handled bowls, colanders and storage jars, were produced. Strange bucket pots, with a handle over the top like a basket, were used for 'dipping' water (*see* page 104, no. 7). Immensely tall conical pots with a similar handle were made to be packed with butter and sent to market. The heaviest and largest pots were the dripping trays, easily recognized by their distinctive handles. Chafing dishes were used to cook food – they were filled with burning charcoal, and a plate was supported on the spikes on their rim. They are easy to identify because of the holes in their sides, needed to keep the charcoal alight.

A few of the forms from the Horton kiln were glazed a rich green, and generally seem finer than the bulk of the products. This was typical of the date: many kilns produced fine green or brown wares alongside their usual coarser earthenware. Specialization was yet to come.

A good many archaeological pit groups of the seventeenth century have been excavated and published, and these show the increasing amount of non-local pottery being supplied. A mid seventeenth-century group from Dorchester imported German stoneware jugs and mugs; English blue-painted tinglaze (sometimes called delft) saucers and mugs; and huge quantities of bowls, chamber pots and dishes decorated with white slip which came from Donyatt. Verwood only supplied a plain bowl, a mug and a dripping pan.

A late seventeenth-century group from Dorchester shows even more variety, with a chamber pot, mugs and jugs in a rich brown ironglaze, and one-third of the pots coming from Donyatt with slip decoration. Verwood supplied another third, including handled bowls, chamber pots, storage jars, mugs and dishes, but again stoneware and tinglaze have taken the market for the finest pots.

The situation was not particular to Dorset, but was the same all over the country. Advances in the production of finer wares in England, combined with imports (especially of stoneware), were competing with local earthenwares. The later sixteenth and seventeenth centuries saw a vast increase in the types produced by local potters, but it also saw the start of specialization and the importing of pottery which was to be their downfall.

*T*he earliest bill for pottery yet found in Dorset. The Kerby or Kerly family were potters at Edmonsham from the 1680s, so it is possible that this bill is from a Verwood potter. It has been written out by the Mayor of Lyme Regis, or his clerk, not the potter. It reads ' Recd this 10th day of Septbr 1697 / of George Kerby & his son vizt / two dos Large Dishes – halfe a dos: Pye plates – Two Pasty plates – Six dos: want one of trencher plates / whereof 2 are broken'. No prices are given, sadly. It was a big order – seventy-one plates, twenty-four large dishes and eight pasty or pie dishes.

4 The Eighteenth Century

The Cranborne Manor Court continues to record complaints about the potters all through the eighteenth century. In October 1706 John Harvey and six others (not named) were presented 'for not filling up the clay pits in Crendell which are very dangerous to the Queen's people passing on the highway'. The pits are to be filled and they are to pay 13s 4d each, and no more clay is to be dug in the winter (the worst time for the badly made roads) under penalty of £2. As usual, this had no effect, and the complaints continue – 1725 'the way [road] at Crendell clay pits in decay and ought to be mended'. This goes on into the 1770s.

In the eighteenth century the potters were also in trouble for taking fuel from the heathlands. In 1709 Richard Harvey, potter, was taken to court for 'cutting a great number of heath [heather] faggots in our common to burn his pots to the great distruction of the common and the abuse of the rights of the tenants of the manor, himself being no tenant'. Only those who were proper tenants of the manor had rights to cut a certain amount of fuel, but from 1748 there are instructions from the court that no potter is to burn turf in their 'pot houses or kilns' and in 1756 they are told not to burn turf, heather or furze. This was repeated in 1758 – no potter in the hundred of Cranborne was to 'cut turf, heath or furse to burn in the drying houses or kilns under penalty of £2 for every such offense'. And as an afterthought they were (again) to fill the sand and clay pits up.

The potters were building kilns on the Lord's waste, that is the unenclosed heathland. In 1726 Edmund Chubb was ordered to demolish his kiln which he had built on 10 perches of the Lord's waste at Crendell, or pay a fine of £20. Whether he paid or evaded the fine, or even demolished the kiln, is not clear. Given that the manor court demanded that the clay pits be filled and the road mended for 200 years with little happening, it seems unlikely that it was demolished. Stephen Bailey was prosecuted for the same offence in 1758.

In the 1770s potters found new ways to annoy everyone. In 1772 they were ordered 'not to carry out any unburnt glazed ware on any waste grounds or commons under penalty of 10s'; and in 1778 'no potter shall throw out any lead dross within the tything of Holwell and Alderholt under penalty of 40s'. The last is repeated in the following three years, and perhaps has to do with pollution, or the danger of fire on the heaths.

The number of potters paying clay rents varies between eight (1725) and twelve (1712), and the number of potters ordered to fill in the claypits likewise ranges from seven to ten in the early eighteenth century. From 1738–43 there are consistently seventeen potters paying rent, the highest number. From the 1660s until 1799 there are lists of the amount paid annually to Cranborne for potters' clay and sand. These are mostly around £1 10s up to 1701, when it increases to £2 17s 6d, and to £4 in 1741. There is a gap until 1774, when the amount has hugely increased to £34 15s, and it

A list of the twelve potters paying rent to Cranborne estate at Michaelmas 1712. The first person is Joan Henning, the only woman apart from Thomas Sims' Widow, second to last. Her name was Margaret.

Cranborn Potters

Rents for one year ended at Michas 1712

Name	£	s	d
Joan Henning	0	05	0
John Major	0	05	0
Lawrence Grubb	0	05	0
Samuel Henning	0	05	0
Robert Denny	0	05	0
Henry Foreman	0	05	0
Edward Sims	0	05	0
John Vincent	0	05	0
Stephen Foreman	0	05	0
Thomas Lawrence	0	05	0
Thomas Sims' Wid	0	05	0
John Saruvey	0	05	0
Total	3	00	0

continues at that sort of level to 1799. Clearly more money was being paid (although summary fines have to be added to the total in the seventeenth century) and more clay must have been extracted. Whether the rents exactly match the amount of clay taken is dubious. From 1776 there is a cheerful entry in the Manor Accounts: 'To paid entertaining the Clay Cutters and Potters on Payment for their clay and sand' 19s 6d. The next year it cost £1 1s.

The Cranborne Manor Court claimed (hopefully) in 1742 'The Potters Clay being all dug out of the said [Crendell] common the Potters are obliged to go elsewhere for a supply', but since the rents go on, either another supply was found, or there was more at Crendell.

In 1716 some of the potters were going further to get clay – they were told to fill in a pit 'in the Common called Dog Deane near the queen's highway leading from Wimborne to Ringwood'. The only Dogdeane place name surviving is just north of Wimborne at Colehill.

Two inquisitions of 1702 give close-ups of the lives and work of two of the potters. In January 1702 Mary Welsh, a widow, gave birth to an illegitimate child, a boy. She said that the father was John Major the younger, of Alderholt, potter. She gave birth to the child alone in her room, and it seems to have been stillborn. The body was concealed in an earthenware pot 'about 14 inches in depth and about 8 inches in breadth' under her bed.

The other death was caused in the potter's workshop. On 25 March 1702 two sons of Charles Henning, master potter, were working along with John Savage, labourer, and Richard Harvey, journeyman (a potter who had passed his apprenticeship, but was still employed rather than an independent craftsman). Richard (aged 14) and Charles (aged 16), the two brothers, were working with Anthony Henning, a relation of their father. Charles Henning junior told Anthony 'to follow his work, which he [Anthony] refused to do' and Richard took Anthony's part 'giving the said Charles Henning ill Language, and upbrading him with swaling [stealing] a White Loaf at Ringwood by telling him that he should go steal another white loaf and also giving the said Charles Henning further provocation by pelting him with bits of clay'. Charles 'was provoked into a passion and went to his brother and give him a slight kick in the side'. The journeyman and labourer were working in another part of the workshop, and didn't see the quarrel.

Charles Henning senior, the master potter, wasn't in the workshop, and perhaps if he had been this tragic horseplay would not have happened. Richard junior died an hour later, and his brother was found guilty of murdering him, despite Richard Harvey's evidence that Richard Henning 'often voided blood and was very weak'. Charles Henning was committed to Dorchester Prison, and died only two years later.

Charles Henning senior died eight years later, and it is clear from his inventory that he was farming as well as potting, and was a prosperous man. The evidence at the Inquisition shows his potter's workshop had five people working there in 1702, and three of them were related to him. The two young brothers and their relative were perhaps weighing up clay, or preparing it since Richard pelted his brother with bits of clay. His journeyman, Richard Harvey, who stated in evidence that he had been with Charles Henning senior for twelve years, later went on to be a master potter, as did one of the younger sons, Robert Henning.

Inventories survive for five potters from 1707 to 1728, the largest and last group of these useful documents. The three most prosperous potters were clearly also farmers – Thomas Sims of East Worth who died in 1707 had corn threshed and unthreshed, and in the ground, five horses, a colt, six cows, two pigs and thirty-one sheep. His earthenware and clay were valued at £5, but he had debts amounting to £70 from his total of £188 17s. Charles Henning of Alderholt had a similar total in real terms – £109 9s 8d with no debts. He was also farming, but by the time of his death in 1710 he only had seven cows, three horses and corn. His inventory is the most detailed, covering seven rooms and including luxuries like a looking glass, two dozen diaper napkins, a damask board cloth and huge quantities of pewter dishes. His 'working tools in the shop' were valued at £5, a 'kill' (presumably a kiln) of ware at 15s and clay at £5. His 'faggots and other wood' were worth as much as all the rest of the pottery materials put together – £10 12s.

John Major of Alderholt was also a potter and farmer, but he was more wealthy than the other two when he died in 1722, his possessions totalling £170 10s. Of this, £40 was 'in wood and faggots', with 'tools and clay for making earthenware' only £5. He had sheep, cows, pigs and horses, and £20 'in bond'. A lease for his land survives from 1721,

The first edition of the Ordnance Survey, surveyed about 1811 and with the railway added later. It clearly shows the heathland surrounding Verwood, and the gradual reclamation – Verwood Common has nearly disappeared. 'Potteries' is shown at Daggons.

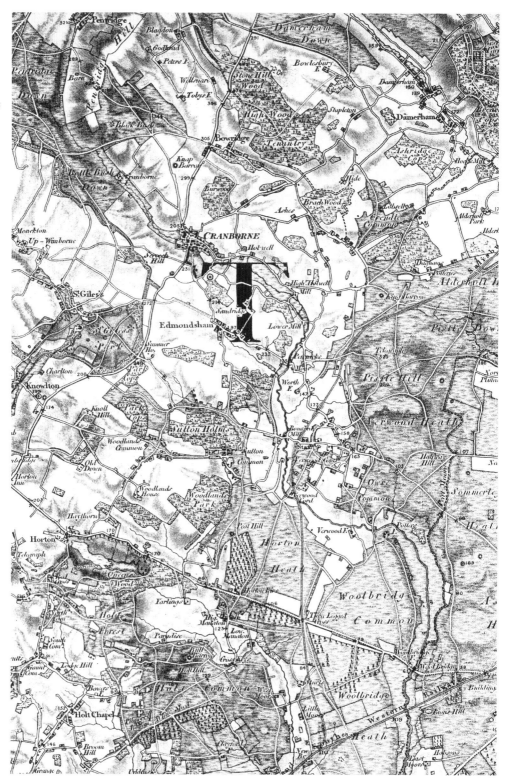

only a year before he died, showing that he held two tenements or houses, and several small fields 'lying next the common heath', a convenient position for potting with the clay, furze and heather to hand. His son and grandson (both named in the lease) were also called John Major.

The money on bond may have been to the Manor of Cranborne for clay digging. Slightly later bonds survive, for example one to Nicholas Francis in 1735 for £10 to the Earl of Salisbury who granted Nicholas Francis 'liscence to dig and raise clay for his own use by proper workmen, upon the Earl's waste lands called Crendell Common' for seven years, at a yearly rent of 5s. The potter was to 'fill up and level all such pits as shall be opened for digging and raising clay, and shall contribute his share of charges towards repairing the Kings highway between Crendell Gate and an oak called Gold Oak on that Common … Also he shall not cut or cause to be cut any turf, heath, furse or bushes on the said waste lands, to be burnt or employed by him in his kiln or otherwise for his carrying on of his trade as a potter.' The bond money would be forfeit if he broke the contract.

The two poorest potters (whose possessions totalled £16 or less) have no corn or animals listed, which suggests that they were full-time potters. John Vincent of Alderholt died in 1719 worth only £9 5s 6d. Half of this was faggots and wood (£4 16s 6d) with clay and shop goods 16s. Henry Foreman of East Worth (died 1728) was a little wealthier – with two leasehold tenements (£40) and debts of £6 removed, his possessions were worth £10 2s 6d, with 'Boards and useful things belonging to the pottery shop [workshop] and pot kill [kiln]' at £1 10s. He has no wood listed at all, possibly because of the time of year, or perhaps because he had been ill for some time before he died.

These last two potters were not simply potters' labourers because they owned pottery-making equipment, clay and wood. There were only eight to twelve potters working in the early eighteenth century, so those five inventories could represent half the potters. Clearly, they vary greatly in prosperity – the two apparently full-time potters are much poorer than those who were also small farmers. The Sims, Major and Henning families were well off, the Foreman's and Vincent's less so.

The last potters' rental from Cranborne for potters is 1743, and it lists eighteen people. This, combined with the increase in clay rents, suggests a greatly enlarged industry.

Prairie Farm

One typical mid eighteenth-century pottery building survived into the 1980s. In 1756 Humphrey Sturt, the landowner, granted a lease to Richard Henning, potter, of 'all that new erected cottage and about an acre of Heath adjoining as the same is now marked out and inclosed' on condition that Henning built at his own cost and expense a small cottage, doubtless the one named in anticipation on the lease. The Henning family was potting at Alderholt in the seventeenth century, and at East Worth and then Verwood in the eighteenth century. Robert Henning, probably a relation, was working in Verwood from 1728. The lease suggests that this Richard Henning was setting up a new kiln, and the position of the holding, on the edge of the heathland, tends to confirm this. The lease included the 'liberty of cutting heath and furze to burn in his house for the use of himself and family only but not to sell any'. He is described as a potter, but no mention is made of fuel for the kiln.

The cottage at Prairie Farm in 1986, with one of the outhouses to the left. The buildings are all of cob. The cottage was small, with three rooms on each of the floors.

Prairie Farm from the air, 1986. The cottage is to the left, and the big hedge to the right of the field with the buildings is where the kiln mound survives. The original holding, shown on the 1770 map, only extended to that boundary. Heathland survives in the background.

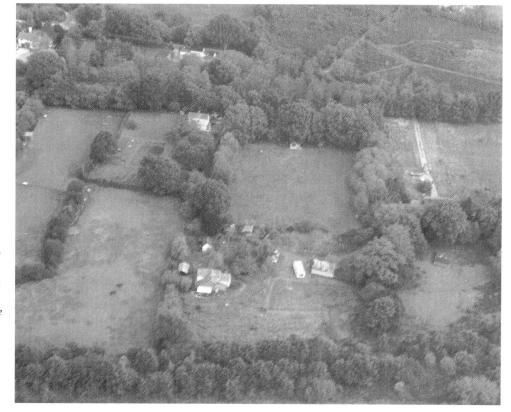

*P*rairie Farm in the 1980s. The kiln mound is clear between the trees on the right, and the cob workshop further to the right.

A close-up of the kiln mound at Prairie Farm, showing the trees, estimated to be 150 years old, growing through it. These cannot have been there when the kiln was in use, and they fit well with the documentary evidence suggesting that it ceased being used about 1840.

By 1770 the holding had increased to 4 acres (1.6ha), and is clearly shown on a map of that date. The Henning (sometimes Hanning) family continued as tenants into the nineteenth century, but ceased potting in the 1840s, changing over to farming. The dates are significant because Prairie Farm survived remarkably unaltered, a fine example of an eighteenth-century potter's house and holding. The kiln mound still survives, set into what was, in the mid eighteenth century, the boundary with the heathland. Close by is a cob workshop, and a little further away the cottage itself and other cob buildings. Set into the cob wall of an outhouse is a large bowl, which surely must be one of the pots the Henning family made here. A few sherds were excavated from the kiln mound in 1973, but it is difficult to be sure that they were made at Prairie Farm because large quantities of late nineteenth- and early twentieth-century domestic rubbish were also found – the by then out-of-use kiln had been used as a rubbish dump. The forms present included the usual big bread bins, large numbers of big shallow dishes for separating cream, jugs and an unusual shallow mug with a simple round-profile handle. These forms could well represent pre-1840 production on the site, but we cannot be certain.

A bread bin set in the vertical face of a wall of the cob outhouse at Prairie Farm. Although very decorative, it is difficult to see this being very useful as a cupboard because of the rounded shape. Similarly placed pots are known from several other cottages in the area.

Earthenware flagons imitating stoneware ones. The one with the facemask is just like mid to late seventeenth-century stoneware bellarmines, and is probably of that date. It may have been made at Verwood. The tiny one is probably late eighteenth century, as it is like stoneware flagons of that time, and is certainly Verwood (left, Dorset County Museum, 230mm high; right, Borough of Poole Museum Service).

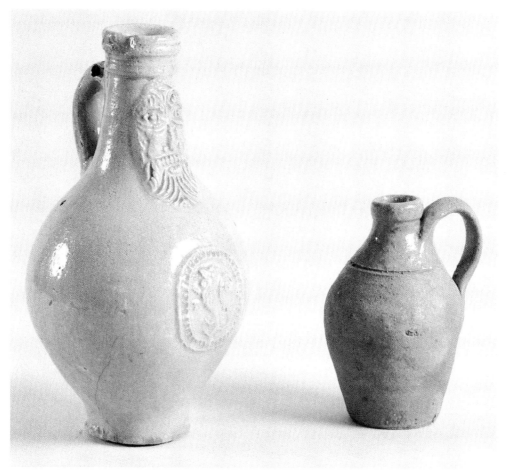

The Other Kilns

John Hutchins was the first writer to mention the potteries. In 1772 he noted 'Crendal, a small hamlet near Alderholt. Here is found good potter's clay, of which a great quantity of earthen-ware is made.' Two eighteenth-century kilns have been excavated – one at Crendell and the other at Ebblake, and huge quantities of wasters have recently been discovered at Cross Roads, Verwood, dating from the mid eighteenth century.

The Crendell kiln and Cross Roads were producing a finer ware with a good dark brown (manganese) glaze alongside the coarser earthenware. Handled bowls, often with lids, decorated with incised patterns are found in the brown glaze, and four odd puzzle jugs with holes right through the body. Three have 'WZ', apparently for the maker, and one is dated 1799, one 1605 (Salisbury Museum). Three similar jugs in an orangey glaze are known. These puzzle jugs may well have been made in the Verwood area, but it is extraordinary to find two virtually identical jugs with dates nearly 200 years apart. Suspicions of later fakes are aroused.

A small jug with a manganese glaze was found at William Bailey's kiln, Alderholt, in the 1930s (*see* photo on page 52). This is one of the few simple manganese vessels to survive, and is said to have been found actually in the mouth of one of the kilns at Alderholt.

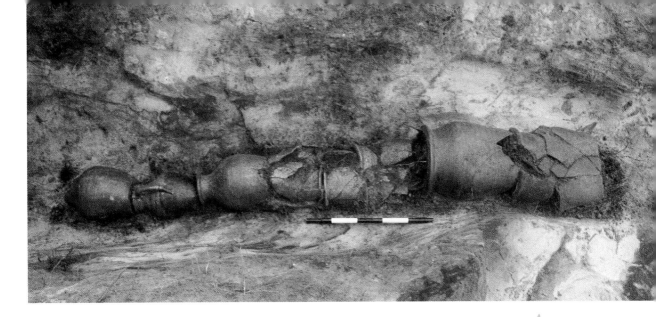

Slipware, tinglaze and imported stonewares had taken over parts of the market for pottery in the seventeenth century. Because demand was high with increased prosperity and a larger population, the Verwood area pottery industry actually expanded. Competition from more sophisticated ceramics became intense during the eighteenth century. Staffordshire grew to become a national potting centre, developing fine earthenwares that were more like expensive porcelain than local earthenwares. They produced white stoneware from the 1720s and creamware from the 1750s, both of which were thin, light, white and durable.

Luckily for Verwood, these were largely tablewares – plates, tea services, dinner services and so on, which Verwood had never produced. Staffordshire also made coarser earthenwares, and these destroyed the local potteries in the counties around, but Verwood was too far south to be affected. The finewares were distributed nationally, and were made at several other centres including Leeds and Derbyshire.

A drain at the Ebblake kiln, excavated in 1997, made out of pots which must have been produced at the kiln there. They date from the early eighteenth century. All the brickwork of the kiln had been removed, but it had a single fire-mouth like the later kilns.

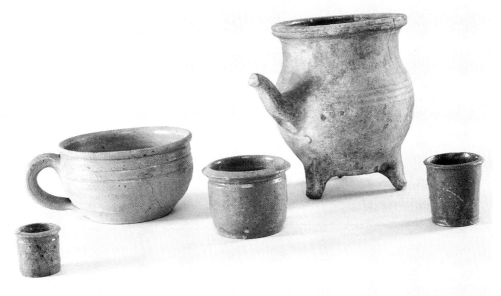

A pipkin (cook-pot with feet and handle; 165mm high), and a little handled bowl, both found in Dorchester and dating from the early eighteenth century, and three small jars from a late seventeenth-century group excavated at Greyhound Yard, Dorchester (all probably made at Verwood, and all Dorset County Museum).

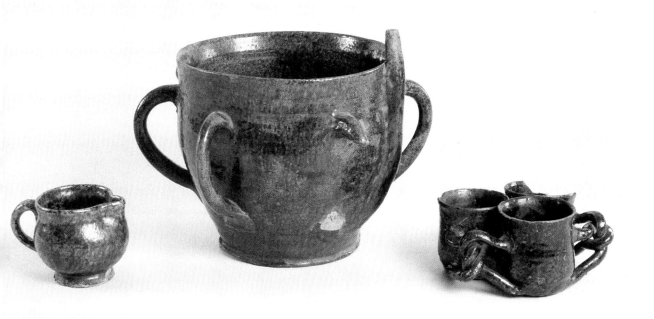

Fancy pots were made with brown (manganese) glaze, like the puzzle jug (centre; 209mm high) which has two spouts, only one of which works. Fuddling cups (right) are joined together, and are also vessels intended for display and ceremonial use (both in Dorset County Museum, and early eighteenth century). The little jug was found near one of the Alderholt kilns and is probably eighteenth century too (Penny Copland-Griffiths Collection).

Donyatt (Somerset) was an important competitor in the eighteenth century, as it had been in the seventeenth. Many of the Donyatt earthenwares were decorated with slip, and local excavated pit groups show that they were common in Dorset and even Hampshire. A much smaller kiln at Lyme Regis supplied similar slipwares to west Dorset and east Devon.

There is a reasonably large number of archaeologically excavated pit groups from the eighteenth century, which makes it possible to identify the shapes that Verwood was making and what else was being sold and used. The early eighteenth-century groups from Dorchester include small amounts of porcelain, lots of tinglaze and stoneware and many dishes and bowls with slip decoration from Donyatt. Verwood was supplying plain bowls, dishes and chamber pots, and sometimes huge dripping trays. Poole is different – it is closer to the Verwood kilns, and very little Donyatt is found. Huge quantities of imported wares are present, unsurprisingly as Poole was a port. Early eighteenth-century groups at Poole include German, Dutch and Italian earthenwares as well as fine imports.

By the late eighteenth century finewares had invaded parts of the market that Verwood supplied. A big pit group of about 1790 from Dorchester contained seventy-four different pots, but only twelve of them were from Verwood, and seven of those were unglazed flowerpots and their saucers. Earlier in the century all the chamber pots would have been earthenware, but now they were fine whitewares from Staffordshire, as were the jugs. The storage jars were tinglaze, and the Verwood vessels were all large and heavy – a bread bin, bowls and a commode liner. Verwood was still producing jugs and storage jars, but in Dorchester white industrial finewares, which were probably not much more expensive than local earthenware, were both available and preferred.

Dealers in pottery and other ceramics were to be found in most towns from the mid eighteenth century. By chance, the inventory taken of the contents of one such shop in

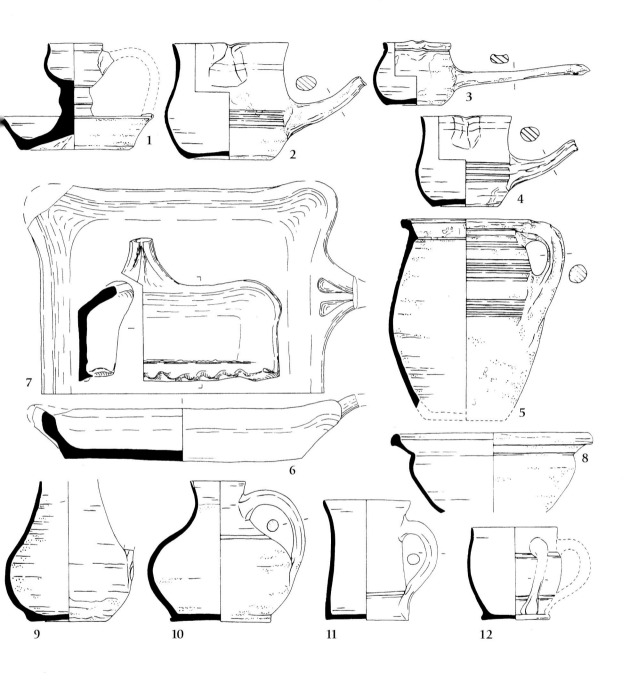

A selection of the more unusual eighteenth-century Verwood shapes excavated at Poole. Left, oil lamp (1); handled cook-pots with lips (2, 3, 4) and handles, some very long; an odd handled jar with lid-seating (5). The big dripping tray (6) and a roaster (7) are from an early eighteenth-century group at Dorchester; the five smaller vessels (8–12) along the bottom are all in brown manganese glaze, and are the more commonly found types at Poole. All at one-quarter life size.

Blandford, 22km west of Verwood, survives from 1759. The shopkeeper had nearly 1,500 pots in stock when she died, all of them finewares – stoneware, white stoneware, tinglaze and porcelain. The general run of pots was very cheap – half-pint mugs in stoneware or 'whiteware' (probably white stoneware) were only 1d each, and plates varied from 1d to 3d each. Verwood would have had difficulty in matching these even if they were whole-sale prices. Only the porcelain was expensive, with a china cup at 1s or a blue and white teapot at 3s.

The earliest Directory for Blandford in 1793 gives three ceramics dealers in the town – one a 'Staffordshire-ware and Glass-seller' like the shop in the inventory (which also included glass) and two 'Earthen-ware men' who would have stocked Verwood's products as well as those from other kilns.

Inventories of furniture and possessions in people's houses rarely list earthenware because it was too cheap, but at Blandford there are a few which do. From 1740 one inventory has 'three large Earth pans' at 6d, another at 3d. Another inventory of 1718 has '6 earthen plates 2/–'. There are too few in the eighteenth century to get any reasonable idea of prices. A bill of 1783 to the Bankes estate at Kingston Lacy is endorsed 'for earth-enware', so we can be sure that the twelve chamber pots listed at 9s (or 9d each) were earthenware not industrial whiteware. This seems rather expensive. They were bought from a shop in Wimborne, not directly from the potters.

The only record of distribution in the eighteenth century comes from a diary of 1758 kept by James Warne, a tenant farmer at Wool near Dorchester: 'About 2 this morning Molly Hurl from Pottern by Verwood Arrived in Farmer Crisby's Wagon of Ower Who brought a Load of Earthen ware from thence.' Warne's grammar is a bit shaky, but it must have been Molly Hurl who brought the pottery. A William Hurl is recorded as potting in Verwood in 1730, and on 19 September Warne meets 'William Hurl of Verwood and his 2 Daughters and Molly's husband' at Woodbury Hill Fair, near Bere Regis. The family were probably all there to sell pots, as well as having a good outing. It is surprising to find a woman bringing pottery, but not at all surprising to find the potters selling at Woodbury, which was an important annual fair.

5 The Nineteenth Century

The Verwood area had thirteen or fourteen different potteries at the end of the eighteenth century, spread over Crendell, Alderholt and Verwood. This was probably the peak of the industry. Most fortunately, a letter to the Marquess of Cranborne survives from 1832, stating how many people depend on the pottery industry. All the potters are listed.

Number of Potteries

Joseph Sherren	1	
Henry Sherren	2	
Henry Sherren Jn	3	Verwood
Henry Andrews	4	
Amos Ferret	5	
James Bailey	6	
William Butter [?Butler]	7	Harbridge
Richard Foster	8	Alderholt
John Viney	9	
James Foster	10	
James Thorn	11	Crendle
George Thorn	12	
James Baker	13	

The letter then goes on to estimate how many people were employed:

Persons employed in various ways by the Potteries

Potters in each Shop and their assistants	8	
Clay Diggers, Wood and Turf Cutters and Carriers	2	
Traders and Customers who buy the ware and sell it again	15	
	25	on the average
No. of potteries	13	
	325	Persons

If the Wives and Children of the above Persons were brought into Account it would exceed 500 Persons who subsist by the Potteries.

This list is interesting because it is the first time the number employed in each pottery is estimated. The figure is probably too high in some ways and too low in others – it is unlikely that every pottery employed exactly the same number of people, and the clay diggers and turf cutters were certainly seasonal. The number of wives and children seems like an underestimate, as it is less than one of each per man. The letter has a rather legalistic ending:

*T*he Verwood owl or pill, the most characteristic vessel made at the kilns. These are nineteenth century, but it is difficult to give more precise dates (VDPT; largest 240mm high. Penny Copland-Griffiths Collection). Small jug made about 1858 by James Budden, potter at Verwood (Dorset County Museum).

We the undersigned declare to the best of our knowledge and belief

That the above is a true statement of the real facts –

 Signed the mark X of William Roper, Foreman

 Proprietors $\begin{cases} \text{Stephen Shering} \\ \text{John Viney} \end{cases}$

 Richard Foster, Trader

Six of the potteries are in Verwood itself, one in Harbridge just over the border into Hampshire, only two in Alderholt and four in Crendell. The kiln at Edmondsham seems to have closed in the late eighteenth century, and had certainly gone before this 1832 list.

 This is the first clear picture of the whole industry, carefully listed by someone who knew the area, and in co-operation with the potters. Before, the documents have not

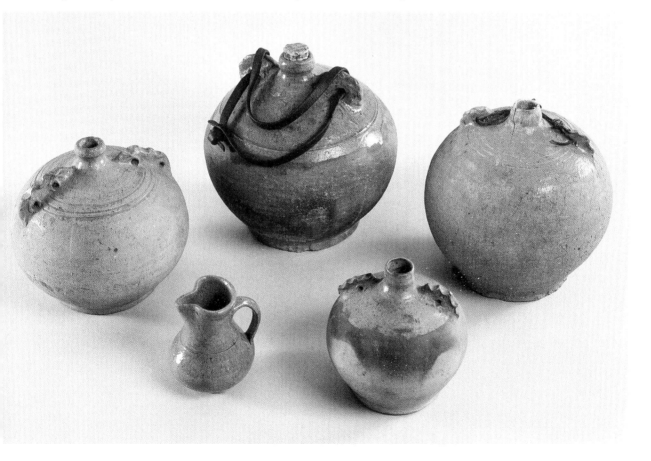

indicated whether lists of potters are lists of the master potter only, or everyone involved. This document suggests that the earlier lists of 'the potters' are of the master potters.

The best evidence for the number of people working at one kiln comes from Cross Roads in the early twentieth century, before 1925 when it was sold. About ten men and boys were employed, and there were two wheels feeding one kiln which was fired about every five weeks. Two potters threw the pots on the wheels, assisted by a labourer, and boys were employed at all tasks except the throwing. Cross Roads sounds similar to the seventeenth- and eighteenth-century kilns – Richard Henning, who died in 1682, had two wheels, just as Cross Roads had. There was an optimum size of pottery to feed one kiln – they took three days to fire and three more to cool down, and with the packing and unpacking a firing took a minimum of eight days. It would have been possible to fire the kiln once a fortnight, but once every three weeks to a month seems to have been usual for Verwood, with eight to ten people being the number needed to make enough pots to fire that often. Conversely, kilns cannot be left unfired for too long because the structure gets wet, which makes firing difficult. In order to fire more often, not only would more people have been needed, but they would have had to work a factory system, where jobs were divided up. At Verwood the potteries were on a craft system where everybody did everything, except for the skilled throwing.

The way the potteries worked is clear from the twentieth-century evidence. The master potter had to organize everything – making sure supplies of fuel and clay were adequate; deciding which types of pot to make; overseeing the packing of the kiln and its firing. These were all fundamental to the business; he not only had to produce pots successfully, but also to sell them. The apprentices and labourers helped, but the master potter made the decisions. Some of the difficult jobs, like packing the kiln, must have had traditional solutions which had been long worked out by trial and error. Experience also decided the supplies needed. We know that Fred Fry, Mesheck Sims and Herbert Bailey, the last three master potters at Cross Roads, were also very skilled throwers, making the big pots which were the most difficult, so it seems the master potter also had to be good on the wheel. At Verwood it seems that the potters had little or nothing to do with the actual selling of the pots. This was done by traders and hawkers right to the end, although the potters had to ensure that the pots made were ones which would sell.

Pottery was becoming more widespread in the early nineteenth century, and William Cobbett disapproved, as he did of many things. In his *Cottage Economy* (1824), he firmly stated:

> The plates, dishes, mugs, and things of that kind, should be of pewter, or even of wood. Anything is better than crockery-ware. Bottles to carry a-field should be of wood. Formerly, nobody but the gipsies and mumpers, that went a hop-picking in the season, carried glass or earthen bottles.

Cobbett knew the south and south-east of England well, but he obviously had not seen the labourers of Dorset and Wiltshire with their Verwood earthenware 'bottles' or costrels. They may have been becoming more common: Cobbett disapproved of all new fashions.

Cross Roads and other long-lived kilns tend to dominate the surviving documentary evidence, but some of the nineteenth-century potteries had only a short life. James Forster (or Foster) was granted a lease in September 1822 for a 'piece of land lately

*THIS PAGE AND
OPPOSITE:*

*B**arrel costrel
inscribed 'Charles
Budden/Verwood/
Dorset'; 'C. Budden'
impressed with type
and incised pictures
on each face,
including a man
with a ball and
chain, a locomotive,
caricatures of people.
It comes as no
surprise to find that
Charles Budden was
a potter – no-one
would have wanted
to buy a pot
decorated like this.
The Budden pottery
only existed from
about 1858–70;
Charles died in
1864. Possibly this
pot was inspired by
the construction of
the railway through
Verwood 1864–66
(Hampshire County
Council Museums
Service).*

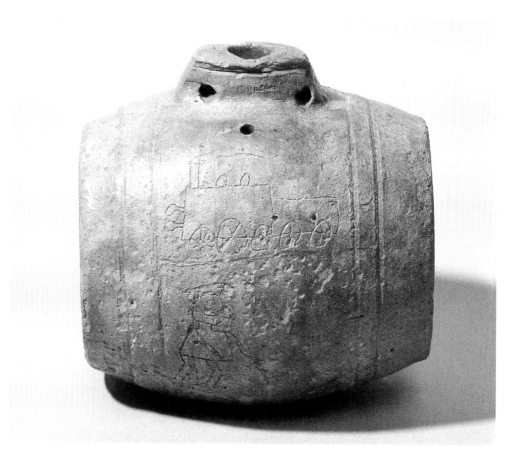

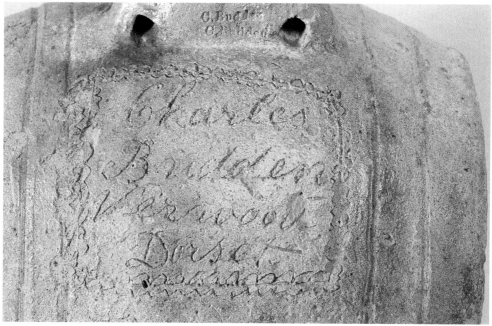

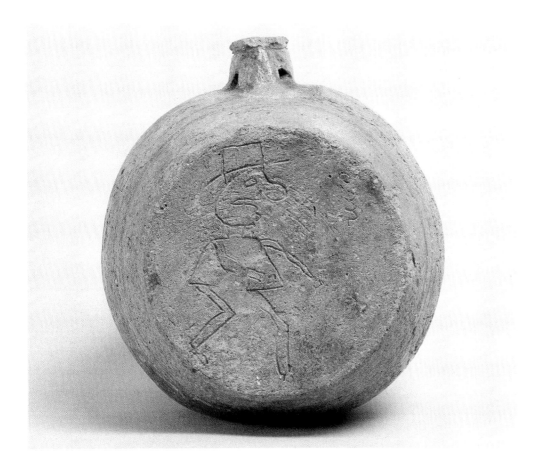

enclosed out of Cranborne Common near Daggons with a cottage and workshop thereon'. James Forster is on the 1832 list and the Cranborne Manor Survey of 1831 with house, garden and pot kiln, but a note on the lease states that in 1841 that 'the pottery or workshop is now pulled down and a barn and cart shed erected in lieu'. The Forster pottery had lasted less than twenty years.

The Buddens ran another short-lived pottery, but at Verwood itself. James Budden and his son Charles are both on the 1861 census as 'potters'. Charles Budden made the amazingly decorated costrel (*see* photos left and above), and his father the little jug (*see* photo on page 56). The latter is in the Dorset County Museum, and has a handwritten paper label on the base 'Bought September 15th, 1883 from [Mary] Budden at Verwood who said it was the first her husband made about thirty years ago. Their pottery is now extinct.' The note finishes 'Verwood Ware', showing that collectors at least used the term in the 1880s. Until 1858, James Budden was described as 'labourer' in the baptismal record for his nine children, but at this date it changes to 'potter'. It seems likely that his pottery was set up 1857–58, but he had certainly stopped potting before the 1871 census, because he is described as an 'agricultural labourer'. Charles Budden died in 1864, aged only twenty-seven. The kiln lasted less than fifteen years. These two kilns – the Forster's and the Budden's – are a reminder that many had only a short life. More is usually known about the long-lived kilns like Cross Roads or Blackhill, and so they tend to dominate our knowledge, giving a false impression.

Robert Shering – An Innovator

Very little earthenware from any pottery is marked before the twentieth century, and even then only a tiny proportion of what was made. No Verwood pottery is marked until the twentieth century, with the sole exception of a few pots made by Robert Shering. Three big bread bins and one small jar have been found with his name rouletted around them.

The Shering family varied the spelling of their name – it occurs as Sherren, Shearing, Shering and Sherring in the early nineteenth century. Since he had it inscribed into the wheel that he used to put the name on to the pots, we can be sure that Robert spelt it Shering. The family were potters from the early nineteenth century, with three Josephs and two Henrys listed as master potters in 1832. Luckily, there were only two Robert Sherings, potting from the 1820s until the 1870s. On the tithe map in 1847 Robert Shering II was tenant of Cross Roads, and sherds of one of the rouletted bread bins was found in material from the Cross Roads kiln. The bread bins are difficult to date closely, but

Little storage jar and bread bin made by Robert Shering of Cross Roads in the mid nineteenth century. The lid seat of the storage jar is like stoneware ones of the 1830s. The bread bins are difficult to date. Bin at one-quarter life size; jar at one-half life size.

would certainly fit a mid nineteenth-century date. The other marked vessel is a much more unusual type – a conical jar, probably for storage and with a complicated rim designed to take a tight-fitting lid. It resembles stoneware jars of the 1830s, which helps with the dating. Robert Shering was enterprising in marking his pots, and was the only potter to do so. The storage jar (the only one known of this type) suggests that he was also more adventurous in the types of pots he made.

Changing Times

An appeal to Lord Salisbury in 1854 shows the state of the pottery industry in Dorset in the mid nineteenth century:

> I have been soundly informed that the three kilns, Zebedee's and Thorn's at Crendall and Bailey's at Alderholt [Mowland's, the second at Alderholt has just been shut up] support almost entirely one hundred and twenty three men and women and children, independent of the employment it gives to Wood and Turf cutters, many of whom are unfit for farm labouring and must get a living.

J.M. Key of Alderholt Park, the writer of the letter, is only referring to the three kilns at Alderholt and Crendell, omitting those actually in Verwood. Sadly, he does not say how many actual potters there were. Wood and turf cutting seem unlikely occupations for anyone not fit for general farm work.

Pottery being sold in Salisbury in 1829. The stall has bread bins, jugs, etc., and although a bit artistic, they probably come from Verwood, because most of Salisbury's excavated pottery does. The stall next door is selling baskets; these competed with pots for packing and so on (courtesy Salisbury Museum).

The 1854 dispute was about:

a man in the village of the name of Thorn was fined about a fortnight ago ten pounds, the mitigated penalty for hawking ware without a licence which is an old law, but I believe never before been enforced in our village, indeed I cannot see how they can afford to pay it, the amount is eight pounds each, sufficient to knock up the kilns, for it is no use making if they cannot sell, and the trade has been very dull this winter, the sum for a licence is equal I believe to the Staffordshire Ware, of which the potters say a man can take a load worth twenty pounds with one horse, but three pounds is the average value of a load of our ware.

Whether by Lord Salisbury or others, this seems to have been sorted out as there is no later mention of licences for hawkers.

The third edition of Hutchins (1868) notes under Verwood that 'The land in this district is of a wild and heathy character and sterile nature, but a vein of strong clay gives employment in the potteries, where a coarse common kind of ware is manufactured'. He also mentions potteries at Crendell.

Verwood potteries managed to survive the expansion of more specialized kilns in the eighteenth and early nineteenth centuries. The number of potteries in the Verwood area actually increased later in the eighteenth century, and in 1832 there were thirteen recorded. The second half of the nineteenth century was not so good, and by 1900 half these firms had closed. This was typical of the country as a whole because mechanization in Staffordshire and elsewhere had reduced the cost of factory-made pots to a level

Dorchester's large china shop in the 1880s. Most of the stock is Staffordshire whitewares, but on the pavement on the right are Verwood earthenwares, with bread bins in at least four sizes, jugs and possibly dishes. The pale jars with dark tops on the pavement to the right are stoneware, which had driven earthenware out of the market for pickling jars in the early nineteenth century.

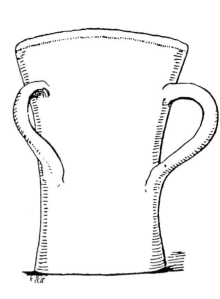

Two of the unglazed 'artistic' pots from Verwood purchased by 'Grandpa' in 1893. Typically for this market, they are not 'practical ware', but merely decorative.

where they competed easily with local earthenwares. The factory pots were white, often with attractive printed or painted patterns, and lighter in weight than local earthenwares. The white pots were pretty, and seemed more hygienic with their overall glaze. In addition, cheap distribution by railway meant they could be sold in every corner of the country.

Industrialization was also affecting food production. Many of the Verwood (and other earthenware) pots were used for baking, and for butter, cheese and bacon production. Over the nineteenth century, home production of bread and bacon declined because these products became available easily and cheaply as bakers and grocers became more common, while butter and cheese making increased in scale and needed better equipment.

However, local crafts started to be valued from the 1860s, and it is astonishing that no traveller or local historian seems to have recorded a visit to the traditional potteries of Verwood. There are many descriptions of the county from the mid nineteenth century, and many published tales from travellers, but none even mentions Verwood.

Wake Smart kept notes in a copy of his *Chronicles of Cranborne Chase* (1841), presumably hoping for a third edition which was never published. The annotated book has a note dated 1885 stating that at Verwood:

> a new branch of the industry has of late years come into fashion requiring a more educated skill, consisting in the production of vases of a finer paste and finish which are sent to London to supply a demand which has sprung up in the Schools of Art for painting artistic designs on porcelain and earthenware. The ware made from this clay [from Crendell] is found to be well adapted for the purpose.

Wake Smart is recording the first fancy wares from the Verwood kilns; before this, all the pots were utilitarian. By happy chance, there is a record of some of these pots. A man who is only identified as 'Grandpa' had printed a description of his *Three Weeks at Bournemouth* during August–September 1893. It is very detailed, and includes his shopping:

The kiln mound at Bailey's, Blackhill, Verwood, as it was before excavation in 1985 with trees growing all over it. The excavation is just starting in the middle.

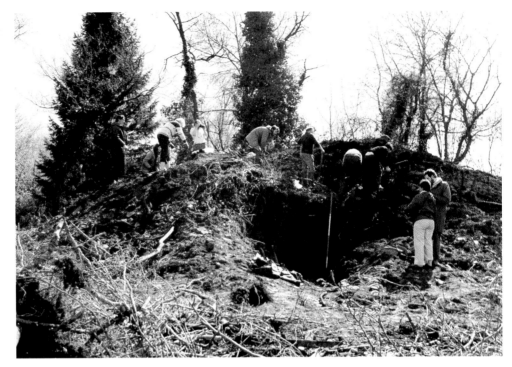

On one occasion he was attracted by a display of local pottery, of which were several kinds made of the clays of the district, at potteries in that part of the country. There was a great assortment of rough unglazed vessels, of quaint and curious shapes, which Grandpa was told were purchased by ladies for garden ornaments, and for decorating with Aspinall's Enamel

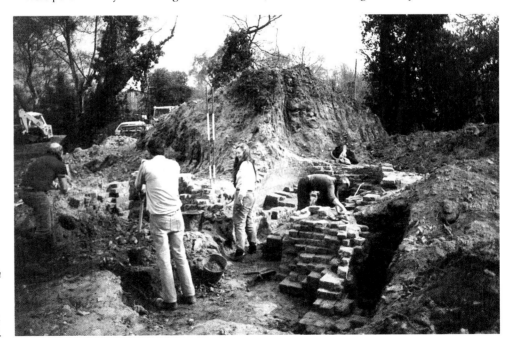

The mound at Bailey's, Blackhill, fully excavated, with the brick-lined kiln in the middle. The sand mound is clear, especially on the left.

and in other ways. These were made at Birwood, of the Hampshire clay. Grandpa would not resist the temptation of carrying off some small specimens of this kind of ware; they are made in classical and fancy shapes to suit the tastes of purchasers'.

Local dialect has turned Verwood into Birwood, but Grandpa's careful description tells us that small as well as large unglazed pots were being made, and sold in Bournemouth, 19km from the kilns, as well as being sent to London for the Art Schools.

Nationally, the remaining local earthenware kilns were diversifying in order to survive. From about 1880 many, like Farnham (Surrey), started making vases and other decorative forms with a strong green glaze. These were sold at Liberty in London and other 'arty' shops. Verwood never made pots with coloured glazes, but did supply Liberty with at least two different types of pot in conjunction with Rivers Hill, a firm set up at Corfe Mullen 16km to the south-west of Verwood in about 1906 to produce perfume and pot-pourri. They grew 60 acres (24ha) of lavender, roses and herbs, and produced oils and so on, at their small distillery at Broadstone. Verwood made tiny costrels for the lavender oil or water, as well as bowls for the pot-pourri. Many of these are marked 'Liberty London' or Rivers Hill.

There was a cluster of nineteenth-century kilns at Blackhill, the eastern end of Verwood. The oldest one was Bailey's, shown on the tithe map of 1847 as a pottery, owner William Bailey, tenant James Bailey. James Bailey is on the 1832 list of potters. It continued as a kiln until 1914, with the last potter, Samuel Bailey, being a descendant of the 1847 owner.

The kiln mound survived until 1985, when it was excavated because it was about to be destroyed. The kiln was very like the larger, older kiln at Cross Roads. The firing chamber for the pots was about 3m across and was enclosed in a mound of sand, supplemented by waster pots. Access was from the top, and it was fired by a single flue covered by a small building.

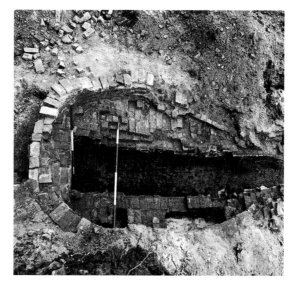

The kiln at Bailey's, Blackhill, fully excavated in 1985. The chamber is slightly oval, and much of the floor of the kiln has gone.

The small amount of pottery found during excavation included jugs and bread bins just like those made at Cross Roads, several types of bowls, big creamers, flowerpots and an elegant single-handled flask. These probably date from the late nineteenth or twentieth century. A sherd with the single word 'Bailey' was found – it must have come from an inscribed pot (including the potter's name) which went wrong in the firing and was discarded. This is the only nineteenth-century kiln to have been excavated at Verwood, and it is surprising how little waster pottery was found.

The 1902 Ordnance Survey map of the Blackhills' area, Verwood, showing the three potteries. The mound excavated in 1985 (Bailey's) is top right. The pottery to the left has the typical kiln mound with small building, but the central one seems to be a different pattern and is labelled 'kilns', suggesting that there was more than one. This pottery belonged to Seth Sims. The earlier large-scale Ordnance Survey map of 1887 shows the same number of potteries here, but a much smaller clay pit, which was presumably used by all three of the potteries in this area.

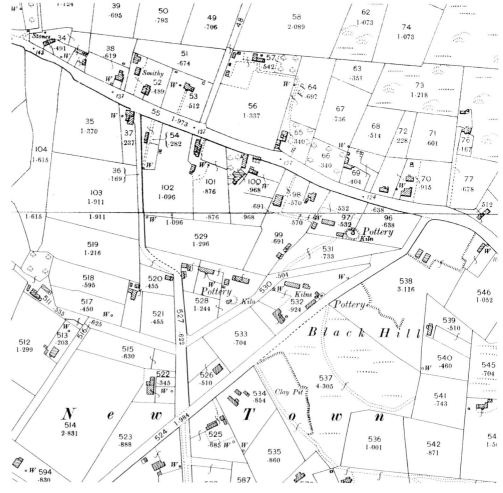

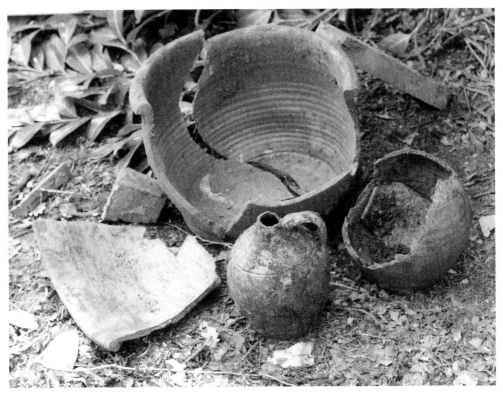

The other two Blackhill kilns were run by members of the Sims family. Mrs Mesheck Sims told John Musty in 1965 that one kiln had been built about 1850 by her late husband's father, Seth Sims, and this was the last to close, about 1920. Mesheck Sims trained with his father at Blackhill, and moved to Cross Roads, potting there until his retirement in 1943.

The other kiln belonged to Robert Sims, brother of Seth and father of Fred Sims who set up at Monmouth Ash. These relationships are typical of the Verwood potting industry – everybody was related to everybody.

Unfortunately, archaeologists have only recently become interested in nineteenth-century groups of pottery, so there is much less evidence from excavations for earthenwares of the period than there is for earlier pots. A few groups have been published, and luckily there are three for the early nineteenth century, one of them large. A Dorchester group of about 1800–10 had huge quantities of Staffordshire finewares – ninety different vessels in creamware, pearlware, basaltes and so on, but only nine earthenware vessels, which included a bowl, jug and big creamer from Verwood. A group of around 1800 from Christchurch has the only excavated example of a late Dorset owl or pill, alongside Verwood kitchen bowls and big creamers. Finewares would have been more easily available in Dorchester and other towns than in the villages, but this is a very low proportion of local earthenware.

A much larger group from Shaftesbury dating from the 1820s has twenty-eight fineware vessels and twenty-nine local earthenware ones. The range of forms is much wider – there are four bread bins, in two different sizes; four huge dishes for skimming cream; a triangular ham pan; smaller bowls; chamber pots; and a commode

Small bread bin or peck pan, dug out of the wall of a cob cottage at Robert Sims' kiln, Blackhill, when it was demolished in 1976. It was probably made at the kiln in the nineteenth century. These pans were set into cob walls as cupboards (see page 49). (VDPT, 235mm high.)

liner. This is (apart from jugs) a good sample of what Verwood was producing in the early nineteenth century, and slight variations amongst the pots suggest that they came from several different kilns.

A group of about 1830 from Dorchester has one bread bin, a huge jug, a creamer and bowls, but only seven of the thirty-eight vessels are local earthenware from Verwood.

It is clear that Verwood, although still flourishing in the first half of the nineteenth century, found it necessary to adapt its production because of competition from industrial wares. Verwood's output was mainly large pots like bread bins and creamers, where transport would be expensive because of the size, and kitchenwares like bowls and ham pans. Even humble forms like the chamber pot had largely been taken over by industrial whitewares – there were seven creamware or pearlware chamber pots in the 1800–10 group from Dorchester, and this is typical.

A small group of the 1850s from Dorchester shows the range still further reduced, with kitchen bowls, chamber pots and unglazed flowerpots the only local earthenwares. The only late nineteenth-century group published is from Christchurch, and has kitchen bowls, big bread bins and a big creamer and flowerpots from Verwood alongside a variety of industrial wares. Some of the large pots in this group have spalled, that is, the surfaces have flaked, and also some of them have splits through the body, suggesting that at least some of the pottery being sold from Verwood in the late nineteenth century was not of very good quality.

The pottery that has survived whole from the nineteenth century gives a very different picture from the excavated groups. Jugs and costrels of several kinds are common in collections, but rare in excavated groups. The more attractive vessels like costrels or inscribed pots are more likely to have been preserved and collected.

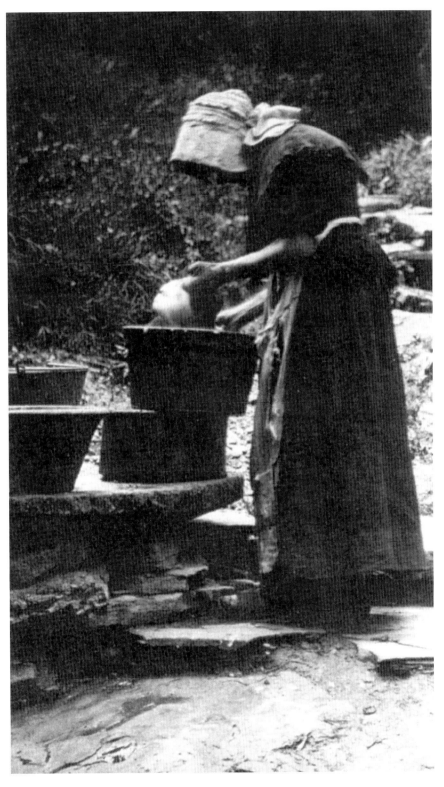

*W*ashing or washing up at the spring, Stoke Abbott about 1890–1900. Background left is a metal bucket, but the one in front of it is an earthenware pancheon, as are the two in front of the woman. Taking the job to the water was easier than carrying the water home; the pots were heavy, but large quantities of water were even heavier.

6 The Twentieth Century

In the 1903 *Kelly's Directory* there are seven potteries listed under Verwood. All the Alderholt firms have gone, and the area is down to half the number that existed in 1800. The seven represent seven separate kilns, but one of these – Cross Roads – dominates our knowledge of the potteries because it was the only one to survive the early 1920s. Sadly, even the few pre-1914 photographs of potteries are of Cross Roads, so all we have for the other six potteries are written records and some physical remains – a few buildings and occasionally pots that can be associated with a kiln. By the 1911 *Directory* there were only four potteries listed, a rapid decline, and in 1920 only one – Cross Roads.

Lot Oxford, born 1866, was a hawker selling pottery, brooms and other products from about 1886. In 1924 he wrote an article about seven men from Verwood, where he had always lived. He could remember when 'there was 10 Potteries in Verwood but there has been so much Tin and Enamel that it has Crushed out the Pottery work in Verwood a great deal'. Len Sims remembered being told by his uncle Josiah Sims that there

The 1903 Kelly's Directory for Verwood, the earliest directory to list more than a couple of the potters. At Verwood itself there are seven potters, seven earthenware dealers, four brickmakers, six hawkers or higglers, and five broom-makers. This is easily beaten by Three Legged Cross, to the south, where fourteen broom-makers are listed. Nineteen out of the twenty broom- and besom-makers listed for Dorset at the back of the Directory are from Verwood or Three Legged Cross.

VERWOOD.
Brown Rev. Claud M.A. (vicar), Vicarage
Drake Rev. Herbert B.A. (curate), St. Michael's cottage
Fellows Miss, Heathland cottage
Fletcher Miss
Frayer William Rolles B.A., J.P. Manor house
Tennyson Miss, St. Gabriel's Home

COMMERCIAL.
Alexander James, gamekeeper to Capt. Burbage
Andrews Job, potter & earthenware ma
Andrews Joseph, hawker
Bailey Edward, carpenter, wheelwright & painter
Bailey Henry, cowkeeper, Pond farm
Bailey Herbert, earthenware dealer
Bailey Saml. potter & earthenware ma
Bailey Sidney, earthenware dealer
Bailey William, blacksmith
Barrow John, grocer, baker &c
Billett Edmund Edwd. head gardener to W. R. Fryer esq
Brewer Dennis, higgler
Brewer Job, brick maker
Butler Elizabeth (Mrs.), farmer
Button Geo. carpenter & wheelwright
Colborn Charles, broom maker
Colborn David, broom maker
Davis Mark, farmer
Ellis Wm.Fredk. beer retlr. & shopkpr
Ferrett Chas. potter & earthenware ma
Fry Samuel, farmer
Habgood Henry Thomas, brick maker, Railway station
Haskell George, broom maker
Haskell John, broom maker
Henning Ira, coal & coke merchant, furniture remover, general contrac-

tor, potato merchant &c. **Railway station**
Hibberd Charles, boot maker
Hopkins Arthur, brick maker
Hunt William, farmer, Baker's farm
King Job, hawker
Lockyer Lewis, higgler
Morgan Thomas, farmer, **Eastworth**
Oxford **Lot,** earthenware dealer
Parker Samuel, Albion commercial hotel & posting house ; horses & carriages ready at the shortest notice
Read Job, market gardener
Roberts Edward, marine store dealer
Rose Walter Henry, grocer, provision dealer, baker & mealman, draper, milliner, boot & shoe warehouse & hardware dealer, Manor Road stores
Shaftesbury Earl of (Edward S. Wilbraham, manager), brick maker
Shearing Charles, blacksmith
Shearing Edwy, earthenware dealer
Shearing Frank, higgler
Shearing Jas. potter & earthenware ma
Shearing Morris, shopkeeper
Shearing Seth. insurance agent
Sims Fred,potter & earthenware makr
Sims Jesse, earthenware dealer
Sims Robert, potter & earthenware ma
Sims Seth, potter & earthenware ma
Sims Seth, jun. earthenware dealer
Standfield Geo., Albrt. & Frank,frmrs
Standfield Tom,threshing machine ownr
Steel George, broom maker
Thorne Frank, farmer, Potterne
Thorne Job, higgler
Thorne Sam, farmer, Manor farm
Trickett Joseph, coal dealer & higgler
Trickett William, farmer
Wareham William, carpenter

THREE CROSS.
Letters for Three Cross are received through Wimborne.
Marked thus * letters are received through Ringwood, Hants.
*Bailey John, broom maker
Barrett Harry, higgler
Beasley Frederick, broom maker
Beasley James, broom maker
Brine Thomas, Travellers' Rest P.H
Burt Frederick Charles, broom maker
Crutcher Edward Thomas, hawker
*Davis Thomas, farmer
Dymond Thomas, blacksmith
Independent Order of Oddfellows (Lodge No. 5,009) (William P. Stickland, sec)
Ingram William, pork butcher
Joy James, higgler
Joy John, sen. broom maker
*Joy John H. farmer, Woolsbridge
Keith Mark, broom maker
King John, broom maker
*Orman Charles, higgler
*Orman George, broom maker
Orman Henry Stephen, broom maker
Revel Andrew, broom maker
Revel George, broom maker
Revel George, jun. broom maker
Shearing David, cowkeeper
Shearing Henry, broom maker
Sims Henry, blacksmith & wheelwright
Steel Jesse, broom maker
*Stickland Jesse, farmer, Woolsbridge
Stickland William Peter, public auditor of Friendly Societies & insurance agent
Stickland Eliza (Miss), grocer & baker
Thorne John, farmer, Crab orchard
Thorne Mark, gamekeeper to **Capt.** Burbage

had been thirteen potteries working in the Verwood area when he was young. Josiah Sims potted at Cripplestyle and 'had a big firm up there' (interview 1993).

Competition from enamelled iron struck exactly the market Verwood supplied – bread bins, large jugs and bowls. Enamelled iron was attractive – brightly coloured, often white or pale, and whilst it did chip, it did not break like earthenware does, and it was much lighter in weight and easier to clean.

Cross Roads survived for a number of reasons – it was certainly the most adventurous of the potteries, diversifying into fancy wares probably from as early as the 1880s. It was also more central than some of the other potteries, and managed to pick up some passing trade because it was on a main road. But ultimately its survival was due to the people involved, both the potters and the owners.

Fred Sims' Kiln

Only one set of account books survives from all the Verwood kilns. Fred Sims had the kiln close to Monmouth Ash, which had been built in the early nineteenth century, with more land 'taken in' from the heath in the 1870s. Three notebooks cover 12½ years of his pottery, from 25 March 1898 into 1910. He listed receipts by the 'lot', which certainly means by the kiln load. The last two firings listed are four and five months apart, but omitting those the kiln was fired seventy-four times, an average of once every eight weeks. This average conceals much variation – in the first full year, 1899, the kiln was only fired five times. By 1903 the firings were seven times a year, a level which was then maintained. The accounts for two kiln loads are missing – they are simply numbers in the sequence, but adding the others up, over 11½ years £2,535 7s worth of pottery was sold, with the kilns fetching an average of £34 5s 3d. The lowest sale was £19 17s in February 1901 and the highest £48 15s 11d. Both were exceptional, with the usual total being between £30 to £38.

Verwood,

Wimborne,

.. *190*

M...

Dr. to F. SIMS,

POTTER.

Manufacturer of Flower Pots, Bread Pans, and all kinds of Earthenware.

Billhead printed for Freddy Sims, after 1900.

All the entries are dated, and there is a two-week gap between groups of sales, presumably covering the firing of the kiln. This suggests that all, or virtually all, of the stock was sold before another firing.

The purchasers are listed mostly by initials, but occasionally fuller names are given – twenty-three people buy regularly, with eleven of them noted by their full names. Lot Oxford was one of them, a well-known pottery hawker. Brewers, Baileys, Sherings and Sims abound, including both Fred (Pans) Brewer and his brother George (Brush). Seth Sims, who bought quite often, was perhaps the potter of Blackhills and may have been buying to complete his own orders rather than hawking, or it was his son of the same name, who was a hawker.

An analysis of the sales for 1906 shows eleven regular buyers. Total sales were £257 16s. One of the buyers, John King, bought 40 per cent (£101 0s 6d); Pans Brewer bought 14 per cent, while the others varied from 8 per cent down to less than 1 per cent. There were still five pottery kilns working in the Verwood area in 1906, so the hawkers were probably buying elsewhere as well, and some of them sold brooms and other things besides pots. Tom, Brewer's son, remembered that he bought from both Cross Roads and Fred Sims. Some of the hawkers bought from each kiln load, but others only once or twice a year.

Fred Sims also listed small sales to other named people who do not seem to have been hawkers, as they often only bought once. Someone listed only as 'Sam' occurs often, buying largish quantities of flowerpots, and possibly he was a nurseryman in West Moors, just to the south. Sometimes pots are listed: 'butter churn', 'milk pans', 'bushel pans' or enigmatic 'odds'. In 1906, these non-hawker sales were only 5 per cent of the total £11 19s 1d, despite Sam buying flowerpots.

Most of the pots mentioned by name are flowerpots, but only a tiny proportion are identified. Fred Sims' surviving billhead, which dates from between 1900–17, states 'manufacturer of Flower Pots, Bread Pans and all kinds of Earthenware', and his putting the flowerpots first suggests that they were his main line.

Two of his daughters – Gertie Sims and Katherine Brophy – were interviewed in the 1970s, and they remembered the kiln still running when they were young. The firings, they recollected, were irregular, varying from once a month to every couple of months, which is confirmed by the account books. Seven or eight people worked there, and the whole method of production sounds just like at Cross Roads, with an open-top kiln, the pots fired upside down, and only wood used as a fuel, except for 'fuzz' (furze) occasionally. A long iron spike was used to push the fuel in the firemouth. At the end of the firing, flames emerged from the top of the kiln which had been covered with broken sherds as a topping. They remembered that loading the kiln was difficult, and had to be carefully done. For example, they recalled one load that was not dried well enough, with the result that the pots collapsed in the kiln and only some of the smaller stuff survived.

Both daughters remembered seeing the yard covered in pots drying on boards, and how they were taken in every night or if it looked like rain. One vividly remembered a long fire of turf in the open yard with the pots all around it, presumably for drying. Turf and heather were burnt in the drying shed, directly on the floor, to dry pots. The large number of sheds would be stacked out with pots before a firing.

The sisters recollected that their father made flowerpots (and saucers to go with them); bushel pans and peck pans which were half that size; plus a smaller pan whose name they could not remember. These latter three made a set of bushel pans. Milk pans were also produced, and jugs which their father called mugs, rather than pitchers or jugs. Fancy pots were occasionally made, but generally Fred Sims made 'very practical stuff'.

*M*oney box inscribed 'Joseph Shearing maker Verwood Dorset'. Why didn't he add the date? Many Shearings were potters, including three called Joseph in the early–mid nineteenth century, but it is unlikely that this money box dates from earlier than the 1890s, and it is most likely to have been made by the Joey Shearing who worked for Freddy Sims as a thrower. If so, it is the only pot currently identifiable as from that kiln. The slot is vertical, and there is a hole pierced in the knob (VDPT; 105mm high).

They had admired the pretty pots made at Cross Roads in their youth, which were much more ornamental than their father's.

In a letter of 1911 about one of the many land transactions between Fred Sims and H.C. Fryer, who owned the Manor of Verwood, Sims must have suggested giving up potting. Fryer replied: 'As to the land behind the leasehold with the kiln etc., I do not wish to part with that – it is I think a pity to discontinue the pottery work which should find work for several people – and in this case I find that about £70 was expended on the kiln etc., not many years ago'. Interesting that the landowner is the one trying to preserve the industry.

Fred Sims was in the *Directories* as a potter until 1915, but he is not in the 1920 *Directory*. His daughters remembered that he had a smallholding and kept cattle even when potting, as well as building houses at West Moors. With the cut-back in building, he went over to farming during the First World War, and gave up potting soon afterwards. The trade was declining, and so no one took over the kiln.

The Pottery Buildings at Cross Roads

The 1901 Ordnance Survey map shows Cross Roads' isolated position on the edge of the village, with only open land to the north. The two buildings in the right-hand end of the site are cottages, the top one probably the old cob thatched cottage. The kiln mound has two kilns within it, each with a small building over the firemouth. The smaller building to the right of the mound is the barn in the photograph opposite, and the long building close by is the surviving workshop.

More is known about the buildings at Cross Roads than any other pottery at Verwood. Typically the largest construction, and the centre of the pottery, was the kiln. In 1900 there were two kilns, both in the same huge mound. The heap of soil built over the kilns had been supplemented by hundreds of waster pots, thrown over the side because they were found to be defective after firing. In 1912 the potters had to scramble over these waster pots to get to the top of the mound for access to the kiln (*see* photo on page 95), but later steps were built and a loading platform constructed around the top of the kiln. This kiln was replaced in the 1920s by a smaller one, which was used until 1952. For a while, the larger and smaller kilns were both used. Len Sims remembered in a 1993 interview that there was a larger and smaller kiln side by side but not connected. At ground level, the old kiln had a cob-and-tiled forebuilding which protected the firemouth and provided a dry store for some of the fuel.

Two old cob buildings were used by the pottery in 1900 – an old thatched cottage (*see* photo opposite) and what seems to have been a small barn. The main workshop (one of only two buildings surviving) was also built of cob, and was 52ft (16m) long by 16ft (4.9m) wide. These long narrow buildings are typical of the Verwood potteries, judging from buildings which survived until recently at Sandalholme and Prairie Farm. At Cross Roads the building was divided into two parts – one for clay storage and preparation, one for throwing the pots. At other potteries, like Prairie Farm, these were separate buildings. There was space in the roof for drying pots.

By the time of the sale in 1925, the workshop had been extended widthwise towards the road, and the cob barn had been replaced by a shed constructed out of brick and corrugated iron. A long range of corrugated-iron sheds had been built along the southern side of the site, mostly for drying the pots (part of this survives). A new brick-built showroom was the physical evidence of the Cross Roads trying to sell pots directly to the public.

All the pottery buildings were utilitarian and very plain. The earlier ones were built of cob, and the later of brick and corrugated iron, which was used for walls (*see* photo on page 10) as well as roofs. The two thatched cob buildings, the cottage and barn, must be the earliest on the site. The surviving cob-and-tile workshop is very difficult to date because it is so plain.

Because so much research was done in the 1970s, finding and interviewing all the people who had worked at Cross Roads, we have a great deal of information about the people, the way they worked, and the whole life of the pottery. The twentieth-century potters maintained that Cross Roads had been established in the early nineteenth century – the classic 'time of our grandfathers' – but recent excavations on the site have shown that there was a pottery at Cross Roads in the eighteenth century.

In 1900 it was worked by Charles Ferret, whose family had been there since the mid nineteenth century. Fred Fry, a relation, took it over in about 1908. He was a very good potter, and an innovator. Some of the Verwood potteries (it is not known which ones) had been making fancy pots from the 1880s. Pans Brewer's son remembered that Cross Roads moved away from practical wares to vases, which suggests that they had been one of the kilns to produce the fancy vases for painting on. Cross Roads co-operated with Rivers Hill (the local perfumers) from 1907 to make fancy wares that were sold at Liberty in London. Fred Fry seems to have been the potter who extended this – he made a wide range of fancy pots alongside the standard bread bins, jugs and bowls. Some photographs of the pottery were taken in 1912, and one of them shows Fred with a selection of his decorative pots.

Some of these – like the neat posy basket with a handle – continued in production to 1952, but others such as the fluted vase seem only to have been made by Fred Fry. Martin Sims was the person who hawked many of the fancy wares, and he remembered that they sold well at Corfe 1910–30, doubtless to shops selling to tourists. Apart from

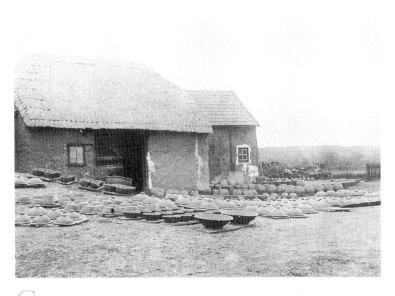

Cross Roads about 1900, with the old cob barn (left) still thatched. In the background is the workshop, and then only open country. Pots drying in the yard include many domed bread bin lids, bread bins and a few huge cream pans (centre).

In the yard at Cross Roads in 1912, with one of the old cob cottages in the background. This is supposed to be loading a trap for distribution, but it must be simply a set-up for the photographer. The bread bins would not get a hundred metres down the road stacked like that, never mind the one filling the space where the driver had to sit. Fred Fry is taking a Verwood owl from an assistant, one of only two photographs showing owls at the pottery.

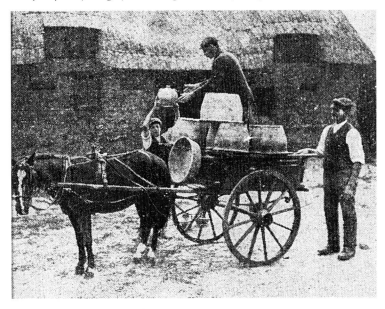

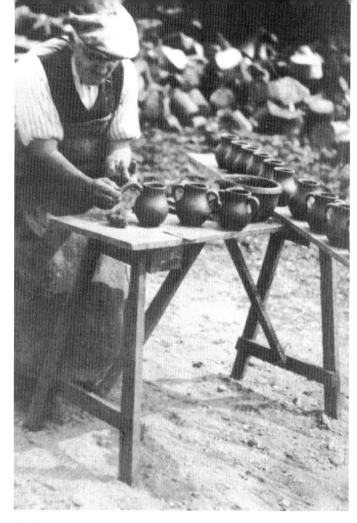

being a fine potter, Verwood remembered Fred Fry for two reasons – being a local preacher, and playing tunes on a special set of flowerpots, which he struck with a key.

In Fred Fry's time, Cross Roads employed about eight people, and tried to train several boys as apprentices. None of the boys stayed long – they left for better prospects elsewhere. A short film showing pottery being produced at Cross Roads was made in 1917.

Fred Fry sold the pottery in 1925, and it was bought by Robert Thorne, a timber merchant who was not then interested in the pottery, but regarded the purchase as an investment. Cross Roads closed, but so many people came to buy pots from the stock still in hand that Robert Thorne's son Horace (who lived in a house next to Cross Roads) decided to reopen the kiln. They employed Mesheck Sims as master potter. He had trained at his father Seth's pottery at Blackhill, and had worked at Cross Roads since the early 1920s. His widow remembered that when he first started he was paid about 15/- a week, little better than an agricultural labourer's wage. He worked from 7.30 am to 5 pm. George Brewer, who

Herbert Fry putting handles on little two-handled vases, in the yard at Cross Roads c.1930s.

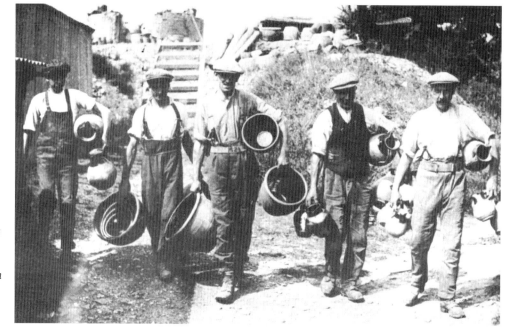

The kiln about 1930, with the steps up to the top of the kiln and the brickwork of the kiln itself. The men are outside the end of the long workshop.

*T*he forebuilding to the kiln about 1900. This cob-and-tile building protected the firemouth of the larger old kiln whose brickwork is seen at the top.

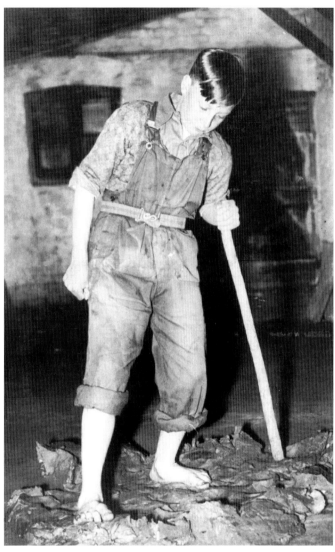

*T*reading the clay in 1938 – the apprentice Fred Thorne looks a bit small for the job.

worked as a boy at Cross Roads in the mid 1920s, remembered working until 5.30, for which he was paid 2s 6d a week. Hours were even longer when the kiln was being fired. Mesheck Sims stayed at Cross Roads until about 1943, and appears in many of the photographs taken of the pottery.

Harold Churchill worked at Cross Roads 1927–30. He was fourteen years old when he started and his first jobs were treading the clay and turning the wheel for the potter. He helped to fire the kiln, but was too small and young to be allowed to carry the heavy pots. The boys practised on the wheel at lunch times, and when they got bored they speeded it up to make the pot collapse.

After 1925 the numbers of men and boys working at Cross Roads declined. As in the early 1920s, boy apprentices did not stay long, most lasting only a couple or three years. Mesheck Sims, Herbert Bailey and Len Sims were the constants.

Mesheck Sims talked about his life to a reporter in 1937:

Mr Mesach Sims was, as he himself says, 'born and brought up at pottery'. His father was a potter and as a child he played with the broken 'crocks'. As a boy he learnt the trade, and as a man was a 'compleat potter'.

Before the war [First World War] he owned a pottery. There were nine or ten potteries at Verwood when he was a boy. The war lost him his own pottery. Now he is potter and manager to Mr Robert Thorne.

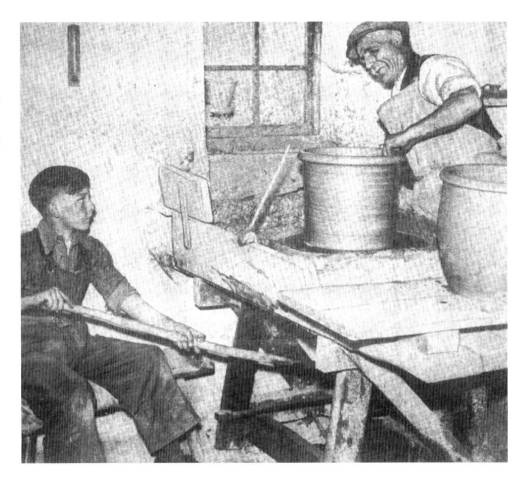

*C*ross Roads in 1938, with Mesheck Sims throwing a big bread bin, powered by the apprentice Fred Thorne. The height stick is fixed to the front of the wheel with a lump of clay.

Herbert Bailey started work at Cross Roads in about 1905, and was the last potter working at Verwood, leaving only when the pottery closed in 1952. Cross Roads closed for a short while in about 1943, when Mesheck Sims retired to work on potting at home, but it reopened after a short while with just Len Sims and Herbert Bailey. Kendrick interviewed Herbert Bailey in late 1955:

> He told me, proudly, that he had started on leaving school at the age of thirteen, and had worked there until its closing when he was forced to retire. A self-taught thrower (he eagerly showed me his 'potter's thumbs'), he became very proficient in making the traditional Verwood shapes. He told me of his first years at Verwood when the pottery, in its heyday, employed ten men, who kept the two wheels constantly busy. The older and larger wheel was a simple, yet effective, piece of mechanism. The thrower did not control the speed of the wheel but was left free to concentrate on moving the clay. A second man, or boy, sat at one side, grasping the long, rough pole which was connected to a crankshaft, directly attached to the wheel head. By simply pushing the pole backwards and forwards the assistant turned the wheel. This apparently was not a difficult operation, for most newcomers to the pottery were placed at this task. Mr Bailey remembered it as his first job. Complete unity between the two men was essential; however, after practice this was often achieved without a word being spoken.

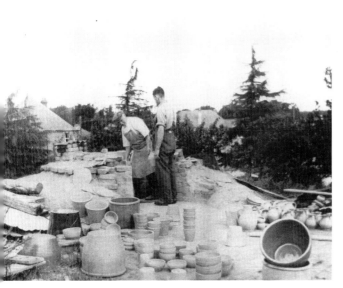

Len Sims was the other half of the last two potters at Verwood. He started work there in 1917, at fourteen years old, and was always a potter's labourer rather than a potter. He remembered his hours as 7.00 am – 5 pm, with half an hour for dinner (lunch). From the 1920s, they started later in the morning. He trampled the clay, turned the wheel and helped load and unload the kiln. Photographs were published in many newspapers of this clay-trampling by Len. He was interviewed several times

*H*erbert Bailey *(left) and Len Sims unloading the kiln at Cross Roads about 1950. Flowerpots, bread bins and jugs are still the main products.*

*T*he kiln at Cross *Roads in 1949, drawn by Kenneth Clark, the tile-maker, who helped at Cross Roads in 1949 while still a student.*

in the 1970s, and it is his descriptions of making the pots which forms the basis of much of the knowledge about Verwood.

Arthur Bailey, who worked at Cross Roads in the 1920s, remembered that 'Good Morning' and 'Good Night' were often all that Len Sims and Herbert Bailey said in a whole day. Others recollected that they never quarrelled because they never spoke. Len knew exactly how to adjust the speeds for Herbert's throwing.

Michael Cardew, the studio potter, had decided that he could not work at Verwood after visiting for several days in the mid 1920s when he was looking for a pottery to work in – he felt he would have been a 'sort of cuckoo in this ancient nest'. Nor did he feel he could cope with firing without saggars. In 1948, however, Cross Roads actually asked a modern cuckoo to insert itself into the ancient nest. Gertrude (usually known as Gilly) Gilham had worked at Poole Pottery as a thrower for twenty-seven years from 1915, and returned there in 1946 after spending most of the Second World War as a Land Girl. She also taught at Poole and Bournemouth. Mrs Thorne, wife of the owner of Cross Roads, attended some of Gilly's classes in 1948, and invited her to set up a studio pottery at Cross Roads. This had been Gilly's ambition for years, and so she came to Verwood, working on an electric wheel in a little room separate from Herbert Bailey and Len Sims, and using a different clay supplied from Staffordshire. She also minded the shop. She made coffee sets, jugs, bowls, vases and mugs which were finished with 'matt' glazes in several colours, and even occasionally with slip decoration. They were fired in an electric kiln, and mostly sold to Heal's in London. Herbert Bailey was surprised by some of her factory methods, but all three got on well together. Len Sims remembered in 1993 that she 'wanted it done different' and that it was 'altogether different in there' (Poole Pottery). After fifty years, he still sounded a bit disapproving. Gilly threw a large pot on Herbert Bailey's wheel, with Len supplying the power, which must have impressed both the men. Miss Gilham marked some of her pots 'Gilly' and may have also

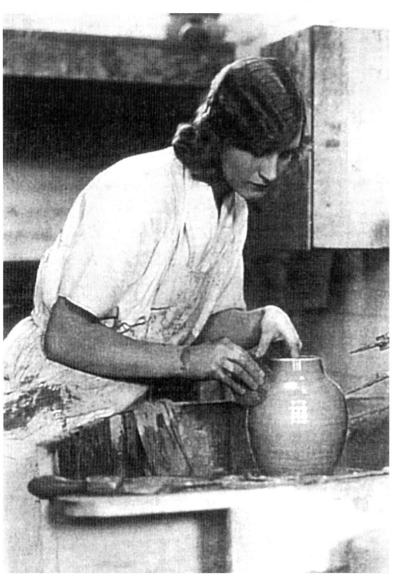

Gertie Gilham throwing at Poole Pottery, from a set of postcards issued in 1937. As Len Sims said in 1993, 'altogether different in there'.

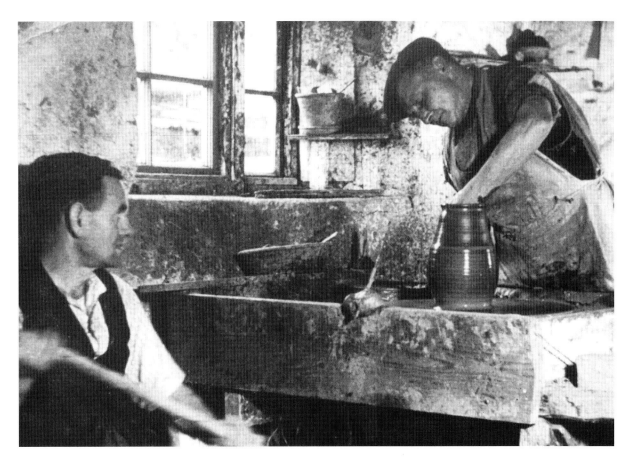

employed the Verwood stamp which was being used for the traditional pots at that time. She seems to have only been at Cross Roads for less than a couple of years as disagreements made her work impossible.

The last reporter to visit the working potteries came to Cross Roads in May 1950 and met Len Sims and Herbert Bailey. He realized that he was seeing a rare survival.

'You can try if you like?' he offered me, but I shook my head. I did not want my clumsy hands to crush what seemed a magical illusion.

I was standing in the old pottery at Verwood watching the wonder which must have awed countless others throughout the centuries – the potter at his wheel.

One moment just a lump of wet clay in the centre of the revolving plate, and then, under the persuasive pressure of his hands, a fluted vase emerges; then a water pitcher: just such a one as the Romans would have made.

The pottery is one of the most unique in the world, for nearly all the original methods and types of tools are still in use.

Standing there amid the crumbling walls and under the low roof it is indeed easy to lose oneself in time.

Could this not be any century of the past?

Could this man, fixing his measures with a notched wooden stick, be one of Alfred's villagers, and his companion silently turning the wooden crankshaft, tell tales of the Crusade?

Herbert Bailey throwing in 1950, with Len supplying the power. Stuck to the edge of the wheel with a lump of clay is a height stick, and a shallow dish on the left is probably keeping a tool wet, ready for use – a wooden handle protrudes from it. It could even be the stamp for impressing the 'Verwood' mark. On a shelf in the windowsill is the pot which held a damp rag for wiping the pots.

1950 version

But this is 1950, and the potter at the wheel is Mr H.J. Bailey, and it is Mr Alfred (Len) Sims who supplies the motive power.

The kiln is one of the very few remaining in the country to be wood fired, and it is the variations in temperature brought about by the wood which cause the distinctive variations in the tones of the red-brown glaze.

This reporter was in fact one of the first to admire in writing the variations in finish caused by the wood firing.

John Musty in 1965 thought that 'the closure of the industry was the result of attempts to modernize it by the introduction of pug mills, electric kilns, powered wheels and an improved repertoire (cups, plates and so on)'. This may reflect the views of Mrs Mesheck Sims, widow of one of the last potters, who was Musty's main informant. In fact, all these new devices (and there was only one of each) were for Gertie Gilham. Herbert Bailey never used the electric wheel, and along with Len Sims, he went on throwing and firing the wares in the old traditional ways right up to the last firing sometime in 1952.

It is probably more sensible to ask why Cross Roads survived so long – it was the last and only pottery from about 1920 to 1952, with all the others closing from the 1860s onwards. The old markets for local earthenwares were being eroded by industrialized ceramics and other materials, and true appreciation of the craft products of Verwood did not come in time to save Cross Roads. In 1955, Kendrick wondered:

> What, then, is to blame for the decline and final extinction of the Verwood pottery? Is it the fault of Verwood itself for not bringing its production methods and styles up to modern requirements? Or is it the lack of public taste, wooed too often by ill-designed, bright, cheap wares into a state of mind where elaboration and decoration have become the hallmark of snobbish civilization?
>
> I, for one, am glad that Verwood did not change. Admittedly, if it had, its pots might have been more suited to our modern way of life. (Unglazed earthenware is not hygienic in domestic use.) Now, as it is, the name of Verwood is connected only with their simple, dignified ware and not, as might have been the case, with a conglomeration of decorated, machine-made pieces.

If Cross Roads had only managed to survive into the 1960s, Verwood pottery would have been appreciated for what it was, without any need of 1950s' 'brightness' and colour, because of the revival of interest in handmade, traditional crafts.

7 Making and Selling the Pottery

The potters worked in Verwood because the local geology and vegetation supplied them with virtually all their raw materials: clay and sand for the pots; turf and heather for drying them; and wood to fire the kilns. The potters went on processing these local raw materials in much the same way into the twentieth century.

The Clay

Potters are recorded in the area from the fifteenth century because their clay pits were a danger to travellers. Clay digging was restricted to commons and wastes because no one, tenant or lord of the manor, wanted them digging on useful farmland or woodland. The earliest references to a specific place where clay was dug are dated 1521 in 'the common next Goldocke' that is Gold Oak on Crendell Common (*see* photo on page 34). This

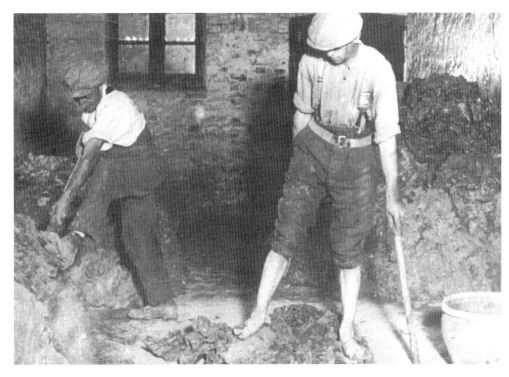

T rampling the clay at Cross Roads in 1926. Len Sims supports himself with a stick, while George 'Drummer' Brewer shovels in more clay from one of the stacks stored in the clay room.

common was a wide area either side of roads, which resulted in the complaints that the pits posed a danger to travellers. By 1627 potters were in trouble for digging clay in Cranborne Common, which is probably not Crendell but the large area just to the south of Alderholt still called Cranborne Common today.

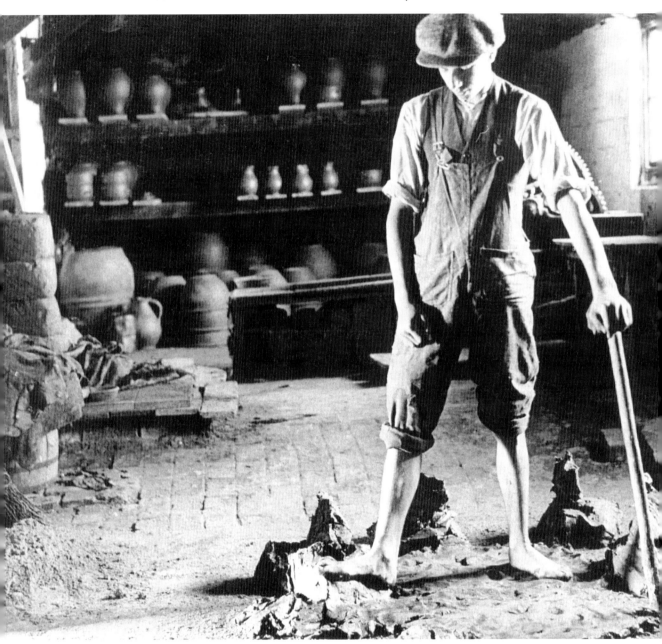

Len Sims trampling at Cross Roads in 1928, with a pile of sand on the left waiting to be used. The cogged wheels on the right were an extruding machine, used to replace hand wedging. The big cheese-like rolls stacked extreme left are of clay that Len has already prepared. Behind are drying racks filled with pots.

The longest-winded complaint was at the Manor Court in 1716:

> We present the ways going between the clay pits and clay hills very dangerous ordered by the
> court that no potter, nor other persons whatsoever shall for the future summon to dig or raise
> clay in the Lords waste until the clay pits already opened to be filled up and leveled and ten
> such potters shall give two sufficient securities to the Lord of the Manor for their good behav-
> iour in this case for the future. 6d for all offenders.

Well, they tried to tie it up, but complaints continue, and the potters expanded into
other areas. In 1726 two potters were fined for digging clay in Pie Lane, which was to
the south-west of Crendell Common, and obviously continued to be used for clay
because by the time of the Cranborne Tithe Map (1848) it was called Old Clay
Grounds. In 1730 a potter was fined for 'digging [a] clay pit near John Perkins mill,
which pitt is very dangerous for passing travellers'. Crendell had no mill – this must be
Alderholt Mill to the north, or possibly Romford to the south.

With the increase in the number of kilns during the eighteenth century came increased
demand for clay. In 1732 the Crendell Common pits were described as 'so deep as to be
dangerous'. The potters were probably also obtaining clay from Verwood itself, since
there were kilns there from the eighteenth century and it seems unlikely that clay was
transported far.

Few writers mention the clay, but Wake Smart in 1841 does describe the earthenware
being made from 'a strong blue clay' at Crendell. In the 1930s Heywood Sumner says:
'seeking further afield, the Verwood potters nowadays use the local yellow clay which fires
red, and the Holwell grey clay which fires red, while at Ebblake, near Verwood, there is a
white clay which has been used for making white bricks'. Surprisingly, the potters rarely
made use of this unusual white clay, with the exception of a couple of pots found in the
recent Cross Roads excavation. In the late nineteenth century, the potters at Cross Roads
dug at least some of their clay from the triangular green just outside the pottery – now a
car park surrounded by shops.

Harold Churchill, who worked at Cross Roads 1927–30, remembers that yellowy
clay was used for flowerpots and blue clay for everything else, while Harold Ferrett,
who worked at Freddy Sims' pottery in 1915 (and at Cross Roads 1918–20), recalled
the good blue clay used at Sims, and that yellow clay was mixed with the blue for flow-
erpots there. Len Sims, who worked at Cross Roads from 1917, remembered the pot-
ters digging their own clay at Crendell, but that later it was delivered from Corfe
Mullen. Holwell Farm, three-quarters of a mile east of Cranborne, also supplied clay,
as did 'some brickyard near the station', but that had lots of stones in it (interview with
Len Sims, 1993).

Sand

The potters mixed the clay with sand to improve the way it fired. Sand was available
locally: in 1627, four potters were fined 6s 8d each 'for digging of sand in the common
of Alderholt' and not filling the pits in. The potters needed much more clay than sand,
and so it does not get listed in their inventories in the way that clay does.

Turf and Heather

Both turf and heather were used locally as fuel, but they were specifically used by the potters to make slow fires to dry their wares or even to fire the pots. They were fined often for taking them: in 1503 six potters were fined 2d each for 'cutting heath in Alderholt Common to burn pots there'. This sounds like firing the kiln. Richard Harvey, a potter, was fined in 1709 'for cutting a great number of heath faggots in our common to burn his pots'. In 1758 potters were told not to 'cut any turf, heath or furse to burn in the drying houses or kilns'.

Gertie Sims remembered that her father, Freddie Sims, used to burn thin-cut turves propped up directly on the floor in a shallow V shape, along with heather, to dry pots in his drying shed. Cross Roads did the same, which accounts for the blackened rafters in the surviving building there.

Furze

Gorse, or furze (sometimes known as 'fuzz' or 'furse') is an ideal fuel, burning brightly and quickly. The potters were told not to take it from the commons in the eighteenth century, but it was an important resource for them, needed to 'flash' the kiln, that is, drive the temperature up high to 'flash' the glaze at the end of the firing. It is possible that heather had been used for the same purpose.

Wood

The major fuel used to fire the kilns right through the life of the potteries was wood. This was easily available locally because of the large amount of coppicing that took place. In 1937, Mesheck Sims told an interviewer from the *Bournemouth Echo* that it took two faggots to fire the kiln. He must have meant two cords – Heywood Sumner recorded that a cord of wood was 8ft long by 4ft high and 4ft wide, and was exactly a cartload. Michael Cardew noted in the mid 1920s that Cross Roads 'belonged to a local timber merchant for whom its chief merit was as a place where his offcutts, otherwise useless, could be used as fuel'. Later on, it was noted that three to four lorry loads of timber were needed for each firing, mostly tops and loppings from timber felled locally.

Preparing the Clay

At Cross Roads in the twentieth century the clay was sometimes soaked in a large pit filled with water for several days to make it more plastic, that is, more malleable. Next came every visitor's favourite part – the clay was trampled by foot. For the last thirty-five years at Cross Roads, the feet belonged to Len Sims. Sand was spread on the brick floor to stop the clay sticking, and then it was trampled to break it down and remove the stones.

This ancient method of preparing clay fascinated visitors and photographers. Quite a few small stones managed to survive the trampling because they can be seen in the sides

*The Cross Roads
extruding machine,
drawn in the 1990s
by Len Sims, who
used it. Top and
bottom are side
views, centre a plan
with the handle used
to work the machine.*

of surviving pots, even late ones made after the Second World War. The sand certainly stopped the clay sticking to the floor, but it was also needed to 'temper' the clay, making it fire better and not crack in the kiln. In some potteries, more sand was added to the clay if it was to be used for large pots so as to improve their firing; or for cooking pots so that they could withstand the shock of heat, but it is not clear if this happened at Verwood.

In 1993, Len Sims described how after trampling he had 'a nail on a stick for to cut the clay', and it was cut into strips, rolled up (looking like a huge swiss roll) and then the process was repeated two or three times. Suggestions that he might have fallen over were rejected – he had another stick for balance, and never fell. In winter, they would 'go down the common and get turf to heat the floor' to make it warmer for Len. He reckoned that he prepared 5–6cwt (250–300kg) at a time, which only took a small part of a morning. After trampling, it was necessary to 'work it up a bit', which was usually done

by wedging, that is, making a large ball of clay, cutting it into wedge shapes and slapping them together to remove air bubbles or stones. Verwood had a machine for this, an extruder, which can be seen behind Len Sims in the photograph on page 84. Len made a drawing of this, but by the time of the 1950 press interview, wedging was again being done by hand. After wedging, Len said you had to 'work it up a bit, weigh it in different weights for different pots'. He remembered that for the largest bread bins 34lb (15.5kg) of wet clay were needed.

Herbert Bailey described clay preparation to Kendrick in 1955:

On arrival at the pottery, the clay, blue-grey in colour, was placed in a shallow pit about 10ft [3m] square, set in the floor of the room adjoining the workroom. There it was left to soak for three days, after which it was moved on to the stone floor on which sand had been sprinkled. It was then wedged with the feet in the style of the Japanese; when fairly evenly trodden, it was rolled up like a carpet and more sand was put down before it was re-wedged. This was repeated three times, by which time the texture had become even and the sand evenly distributed. Pieces were then cut from the main mass to be wedged by hand. With the addition of the sand the clay became strong and not too difficult to throw.

A demonstration of throwing performed outdoors for the 1917 film. There is a height gauge stuck to the edge of the wheel frame with clay, and ready-prepared balls of clay to the left, with the assistant forming another.

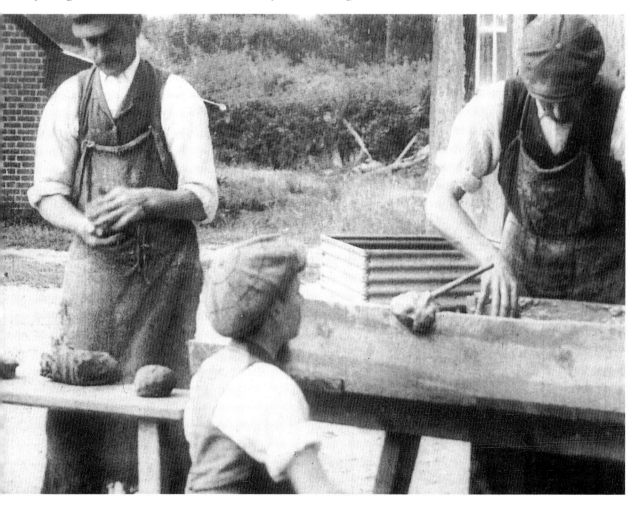

Throwing the Pot

Throwing on the wheel was the most important part of the whole process, the centre of the craft. Everything made at Verwood was wheel-thrown, right to the end in 1952. All visitors, but especially aspiring studio potters, were amazed by the skill and speed of these old craftsmen potters. From the seventeenth century, potters elsewhere were using moulds to cast pots, lathes to turn them for a fine finish and other techniques that were never used at Verwood.

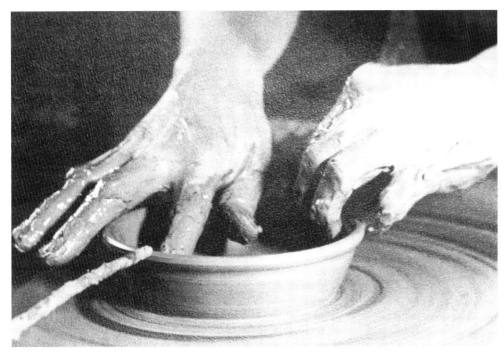

Herbert Bailey throwing a flowerpot saucer at Cross Roads in 1950. The height gauge suggests that it has reached its full size. The delicacy as well as the strength of his throwing is clear – one hand is finishing the inside, the other shaping the rim. He boasted to Kendrick in 1955 about his 'potter's thumbs'.

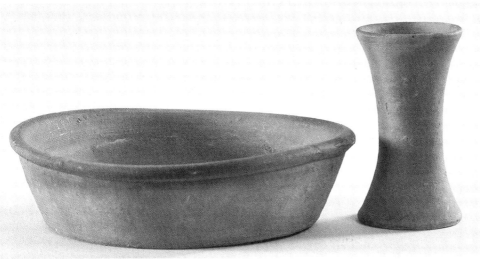

Flowerpot saucer which belonged to Marjorie Bailey, Herbert Bailey's daughter, and probably made by him (see above). It has warped and been blackened in the kiln – typical to keep an unsaleable flawed version. The unglazed spill vase has 'AS' inscribed large on the bottom. It is the only pot made by Len (Alfie) Sims (both VDPT; spill vase 125mm high).

The wheel was basically a device to keep the lump of clay spinning round fast enough so that the potter could shape it into a pot. Wheels were ancient machinery, used by potters from Roman times. At many potteries a kick-wheel was used, where the potter provided his own power by kicking. Interestingly, this is what Cardew thought he saw in the mid 1920s, but he was wrong – at Verwood in the twentieth century crank-shafted wheels were used, the power being supplied by a boy pushing a stick. This was a boring job, but said not to be as hard as it appeared – momentum helped. In the 1920s there were two of these wheels, which were dragged out in the yard for demonstrations or for photography (*see* the photograph on page 10).

Herbert Bailey described the wheels to Kendrick in 1955. In the 1910s and early 1920s the pottery had employed ten men:

who kept the two wheels constantly busy. The older and larger wheel was a simple, yet effective, piece of mechanism. The thrower did not control the speed of the wheel but was left free to concentrate on moving the clay. A second man, or boy, sat at one side, grasping the long, rough pole which was connected to a crankshaft, directly attached to the wheel head. By simply pushing the pole backwards and forwards the assistant turned the wheel. This apparently was not a difficult operation, for most newcomers to the pottery were placed at this task. Mr Bailey remembered it as his first job. Complete unity between the two men was essential, however; after practice this was often achieved without a word being spoken. The second wheel was smaller, but again an assistant was required, this time to turn a rather imposing handle. This was connected to cogwheels and chain of an old bicycle, set in a heavy wooden frame. By a simple method of cogs the wheel was rotated. Both wheels seem to have been quite practical, except for perhaps using more manpower than was necessary. They were used for many years and, though out of use for three years, were still in working order last year.

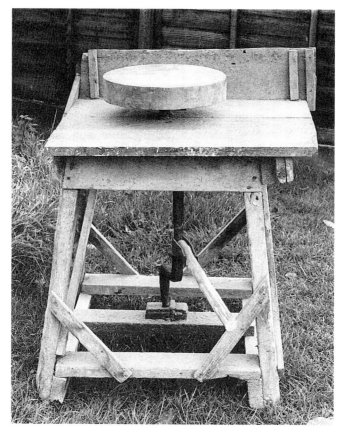

One of the Cross Roads wheels, photographed after the closure. It clearly shows the handle (right) used to turn the iron cranked shaft, and the simple but heavy construction.

The weighed-out ball of clay was put at the centre of the wheel, and the potter shaped the vessel with his wet hands, the spinning of the wheel keeping the pot symmetrical. The miracle of changing a ball of clay into a pot always astounded visitors, because it seemed so unlikely a

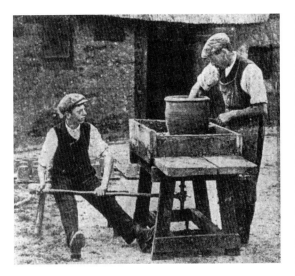

transformation, and also because it happened so fast. The assistant had to match the speeds needed by the potter – the last pair, Len Sims and Herbert Bailey, were so used to working together that they barely needed to speak; indeed, they were said to have spent whole days at the wheel without a word spoken. Len knew exactly what speed Herbert needed at every stage of each type of pot. Thomas Hardy described two keepers with the same style in *Under the Greenwood Tree*: 'the long acquaintance with each other's ways, and the nature of their labours, renders words between them almost superfluous as vehicles of thought …'. Len and Bert rendered them completely superfluous.

Fred Fry throwing a big bread bin in the yard at Cross Roads in 1912. These big pots were the most difficult to throw.

Pots needed to be of standard sizes so that they could be fitted efficiently into the kiln. The only gauges used at Verwood were height sticks held by lumps of clay. Decoration was added on the wheel when the shaping was finished – most Verwood vessels have simple incised lines, although bread bins often have rouletted lines produced by holding a clock wheel on a stick against the pot as it revolved.

The pot was cut off the wheel with a wire (like cutting cheese), and placed on a long narrow sanded board for drying. Large pots (like the bread bins) needed both the potter and his assistant to move them. Some Verwood pots still show the dents accidentally made during this move, when the pot was still rather soft. From the 1940s onwards, the VP or Verwood mark was impressed in the bottom of the pot at this stage.

Verwood bread bins like the one being made in the photograph. On the right is one with two rouletted lines around the outside, the other is plain (both VDPT; the one on the right 283mm high).

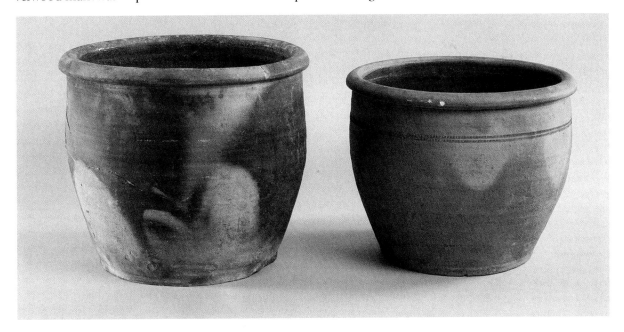

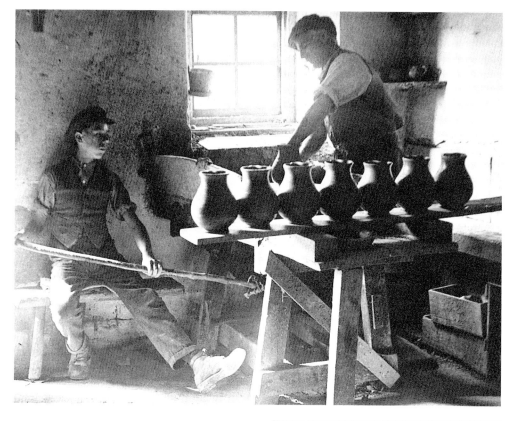

Throwing was normally done inside. Here Harold Churchill provides the power for Herbert Bailey in 1928. He is making jugs, which have yet to receive their handles. In the window is a pot of water in which was kept a damp rag for wiping the sides of the pots to smooth them. The thrown pots are on their board ready for drying.

The second wheel at Cross Roads in 1926 – Herbert Bailey throwing, Harold Churchill turning the handle. This wheel fascinated visitors because it used the cogwheels and chain from an old bicycle to transfer the power from the handle (a wonderfully angled handle) to the wheel. A bread bin makes a convenient seat.

Handles and lugs were added to partly dried jugs, costrels and so on by the assistant potter, who needed great skill to make the handles both efficient and attractive. The body of the pot was scratched to make a key so that the handle could be fixed securely. Len Sims remembered 'scratch or make it rough down the bottom, press 'em on there, pull them out and press it in' to the top.

The pots were dried sitting on the boards, outside if the weather was good, up in the roof of the workshop if not. Harold Ferrett, who worked at Freddy Sims' pottery and later at Cross Roads, remembered that the pots had to be carefully turned every so often to make sure they dried evenly and not too much. At Cross Roads, originally turf or heather fires were lit overnight directly on the floor of the workshop to dry the pots, but from the 1930s a slow combustion stove was used, with a flue pipe running along the upper floor where the pots were stacked.

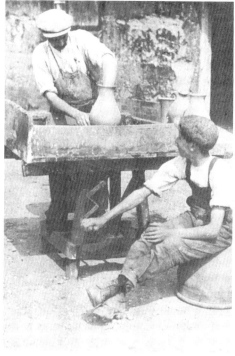

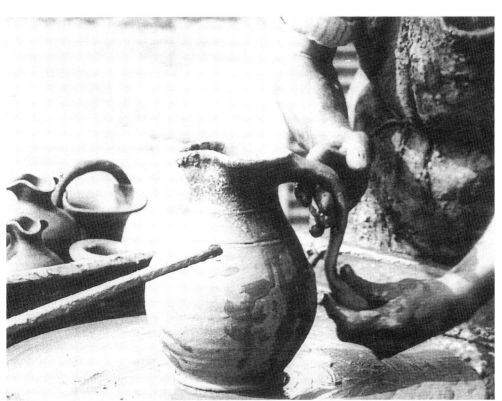

*H*andling a jug, from the 1917 film, which is why Fred Fry is doing it at the wheel, not the usual place for handling, but simply a demonstration for the film, made even stranger by the fact that the pot has already been fired. Len Sims said it was done the other way up – bottom first.

*T*aking the wares, on their boards, out to dry in the yard, from the 1917 film. These are all flowerpots in at least three different sizes.

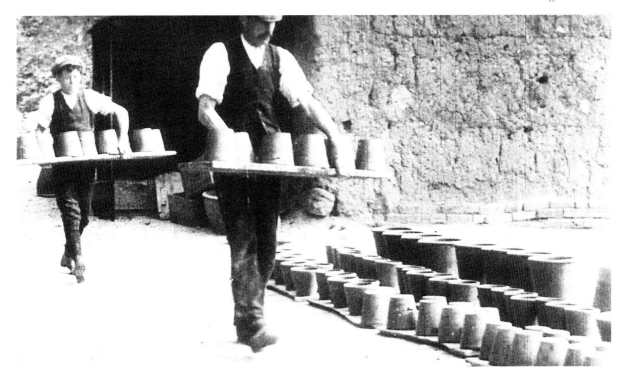

Glazing

The earliest description of glazing is by Wake Smart and probably dates from the 1850s:

> The method of glazing the earthenware vessels adopted by the workmen in these potteries is probably of a very remote date but answers the purpose perfectly and it is as follows. After the ware is formed, it is set aside to dry, and in about 24 hours is sufficiently firm to take the glaze. The glaze is made by melting metallic lead until reduced to a black powder, an oxide, which is mixed with barley meal for use. 2½ cwt of lead is mixed with 2 bushels of meal.
>
> The surface of the vessel is then moistened by a small mop dipped in a mixture of cow dung and water, and the glaze being dusted over it adheres to it.

Photographs rarely show glazing because the other processes were more attractive. In the 1920s and 1930s it was painted on: Verwood was fairly meagre with glaze, so this method suited them. This photograph shows a bread bin and a jug being glazed in 1926.

George Sims remembered Fred Sims making his glaze in just the same way about the time of the First World War – a dangerous process of melting lead into dust, stirring and raking it the whole time. The pottery bought scrap lead for the purpose. Gertie Sims, Fred's daughter, remembered the pots being dipped in horse urine before applying the lead mixed with water; they were still dusted with barley meal, although sometimes cow dung was used.

The lead glaze produced a rich, wet-looking finish, but it ran in the firing. This is one of the reasons that Verwood limited the amount of glaze – for vessels glazed overall, separators would be needed in the kiln to stop the pots being stuck together when the glaze flowed.

Just after the First World War, Cross Roads changed to a purchased lead glaze powder (galena), which was mixed with water and painted on just like the old glaze. Most potteries mixed one part clay to two parts galena to make glaze, but Verwood used galena without any clay. Both the glazes fired to a clear coating – the colours of the pots are due to the clays used.

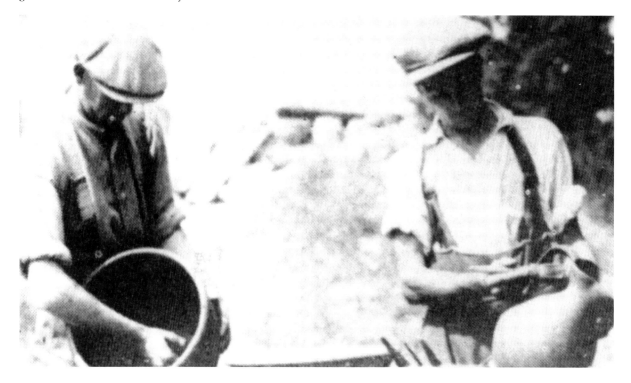

Firing

Michael Cardew, the potter, saw the larger old kiln in the mid 1920s and was amazed at its simplicity:

> The kiln was perhaps the most remarkable feature of this pottery: enormous, partly below ground level, and loaded from the top. It looked as if it was the direct descendant of the Romano-British kilns which have been uncovered in the New Forest area. When it was full, a temporary covering was made, consisting of old broken pots and pieces of tile. There was only one fire-mouth and it was fired with wood only, whereas at Truro – and even I think at Fremington – coal was burnt in the earlier stages of firing.

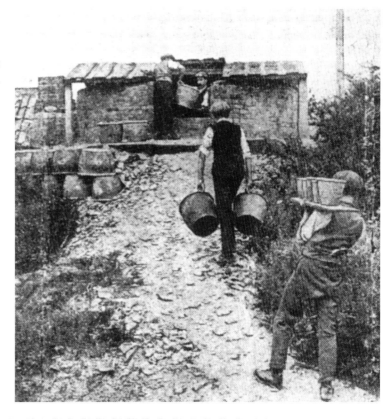

Carrying pots up to the kiln in 1912. The insulating heap of broken sherds makes the path.

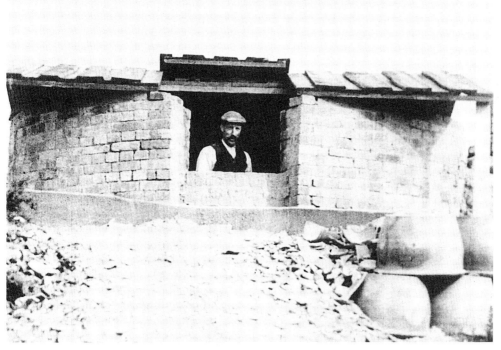

Fred Fry in the kiln, from the 1917 film. The bread bins (right) have many marks from kiln firing – they may have been the ones reused each time to give enough strength to the stacks so that the potter could stand inside. The entrance he is peeking through was needed for the loading and was rebricked up each time for firing. The temporary roof seen here was removed and replaced by a thick layer of broken sherds before firing.

OPPOSITE PAGE:

The mid seventeenth-century kiln at Horton used a very wet glaze which ran in the firing. The brown flecks in the body ran in the glaze during firing, so it is possible to tell at what angle the pots were fired. Most of them are at very odd angles indeed – packing the kiln must have been an art.

Kendrick described the last kiln, the smaller one, at Cross Roads soon after it closed:

The kiln itself resembled a well on a mound of earth. The 'well' was made of bricks and reached down into the mound for some distance. Under the 'well' was the firing chamber, with one fire mouth through which all the fuel had to be fed. The floor of the 'well' or 'kiln chamber' was full of holes to allow the flames through on to the pots.

The kiln was stacked and unstacked through the top of the 'well', which was built up and covered in before firing. Firing took up to three days and nights, and during that time the kiln required constant attention. Wood was the only fuel used, except that towards the end of the firing faggots and gorse were thrown on to the fire to clear the smoke and raise the temperature enough to flux the glaze; this is called flashing. Firing the kiln was purely a case of instinct and experience on the part of the potters. No scientific aids were used to indicate the temperature.

Virtually all the information about firing comes from twentieth-century Cross Roads. Kendrick saw the smaller, later kiln, which was about 10ft (3m) across, and had been built about 1930 to replace one about 15ft (4.5m) across. Len Sims remembered that the smaller kiln was used for firing the perfume bricks – he implies that both kilns were in use at one time. Apart from size, they were very similar. Both were simple, with one flue and loaded from the top. The loading was very important because unless it was just right, pots could be over- or under-fired. In the worst case a whole kilnful could be ruined. Len Sims remembered the collapse of a whole kilnful at Cross Roads, caused by the pots being too wet and producing steam.

Firing the kiln, from the 1917 film. This is the old kiln, which still had a building over the firemouth, which is why the picture is so dark.

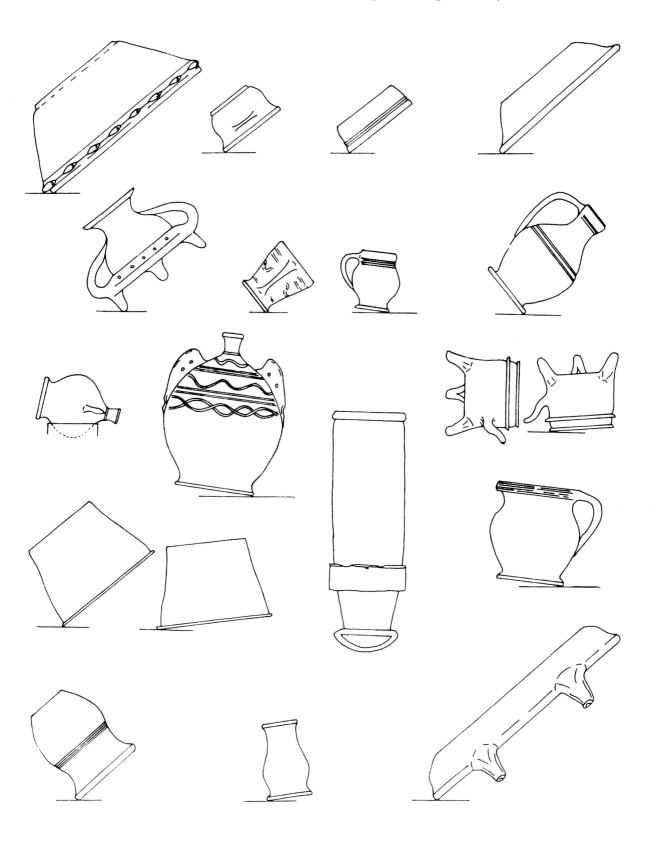

Many potteries used saggars, big rough containers with holes in them, to protect the wares during firing. Verwood did not use saggars, but, in effect, Cross Roads used the big bread bins as baffles to deflect the heat, and as a sort of saggar. Small pots were fired inside larger ones, but glazed surfaces could not be allowed to touch anything because they would fuse on when the glaze melted. Broken sherds of pottery were used as parting sherds to separate vessels if necessary.

The Cross Roads' potters included some already-fired bread bins in the kiln to support boards for them to stand on, as they filled the kiln. Photographs show that most of the wares were fired upside down, and this is confirmed by 'runs' in the glaze.

When the kiln was full the open top was covered over with broken sherds to baffle the kiln, stopping the heat getting out too easily. The earliest description of firing is by Wake Smart, probably in the 1850s:

> When in the kiln [the pots] are exposed to a fierce heat, at first gradually applied, and continued for three days and two nights. In the course of 24 hours after the fire has been extinguished, the ware is cool enough, though still very hot, to be drawn.

The heat needed to be gradual at first because the kiln might be damp, or the pots not completely dry, and fierce heat could cause the pots to split. The old kiln at Cross Roads was fired for just the same period in the 1920s – two nights and three days, but the

T wo bread bins with curved marks on their bases showing where other pots have been stacked on them in the kiln. The left bread bin was dug out of a cob wall of a cottage on Robert Sim's kiln at Blackhill (VDPT). The right bread bin has rings of glaze from other pots (Richard Percy Collection, 483mm across).

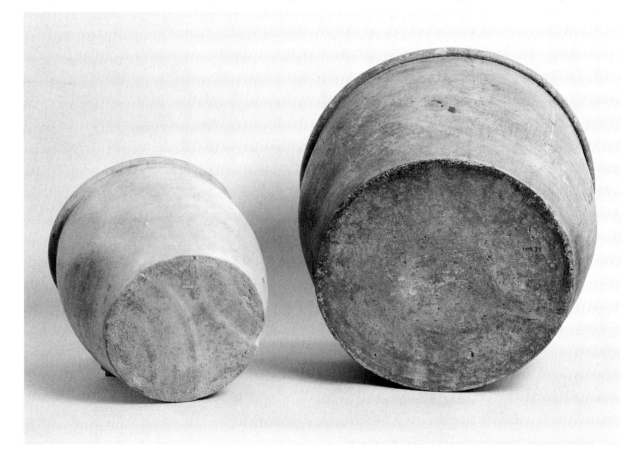

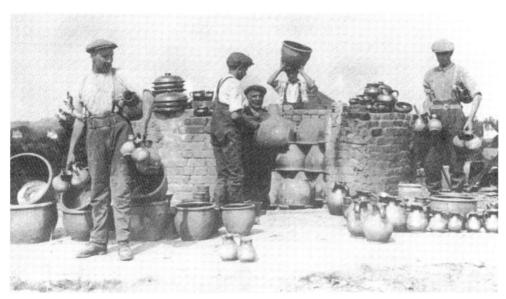

*U*nloading the kiln in 1926. The brick platform around the top of the kiln was very useful for loading and unloading. The bread bins in the middle are yet to be unloaded and are in the position they were fired, upside down. The bricks which had blocked the entrance (centre) have been removed for unloading.

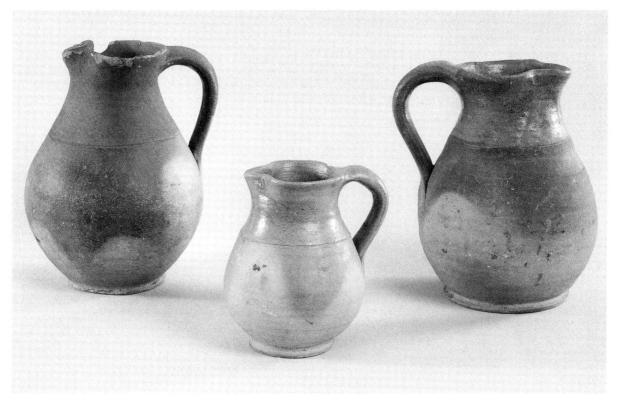

*J*ugs showing the marks created by the flames in the kiln – seen as attractive and indeed artistic today, they were probably not admired by the potters when they were made. The marks are usually black, but the centre jug (Graham Zebedee Collection) has red ones. All were probably made at Cross Roads in the early twentieth century (left, Ian Waterfield Collection, 245mm high; right, Martin Green Collection).

newer, smaller one took only twenty-four to thirty-six hours, according to Len Sims. Len remembered staying up all night to fire the kiln: 'You had a job to keep awake'.

All the Verwood kilns right up to the end in 1952 were fired with wood, and the greatest heat came at the end of the firing when small wood and furze faggots were burnt to 'flash' or melt the glaze. Mrs Mesheck Sims, widow of one of the last potters at Cross Roads, recollected that at the end of the firing flames started to lick out of the top of the kiln which was then stoked until 6–8ft flames appeared.

The temperature inside the kiln was judged by several methods. Herbert Bailey watched certain bricks on the outside of the kiln to see that they glowed red enough, and a yellowish coating on the roofing sherds also indicated that the right temperature had been attained. Occasionally, a small pot was placed in the kiln so that it could be hooked out during firing as a check. When the firing was complete, the fire mouth was bricked up and the kiln left to cool for three days. If the kiln was unloaded too soon the pots could split or explode.

Gertrude Gilham, who potted at Verwood 1948–50, remembered that firing the kiln started with faggots of wood about as thick as a pencil and progressed to split logs. The temperatures reached were the lowest possible for earthenware production, and at one firing she persuaded Herbert Bailey and Len Sims to get the kiln a lot hotter, so that they could see the glaze running. The pots came out much darker than usual, and had a good 'ring' to them. Her own pots came out black. Some of them were displayed at a county show, and were much admired. Judging by the general run of late pots, Cross Roads soon returned to its usual low temperature.

George Brewer, who worked at Cross Roads 1922–28, remembered the big kiln being fired once a month, with the firing taking three days and two nights. He also remembered any pots that had broken in the kiln or had fired badly simply being tossed down the heap around the kiln.

The unloading must have been exciting, but also worrying financially. On at least one occasion at Fred Sims' kiln a complete load was ruined. The kilns only reached a

Pans Brewer with his wagon loaded with pots – it looks like 1860, but is actually about 1920. He would load the wagon the night before he set off, and the local boys would drag it up the hill simply to give him the trouble of finding it in the morning (Harold Ferrett).

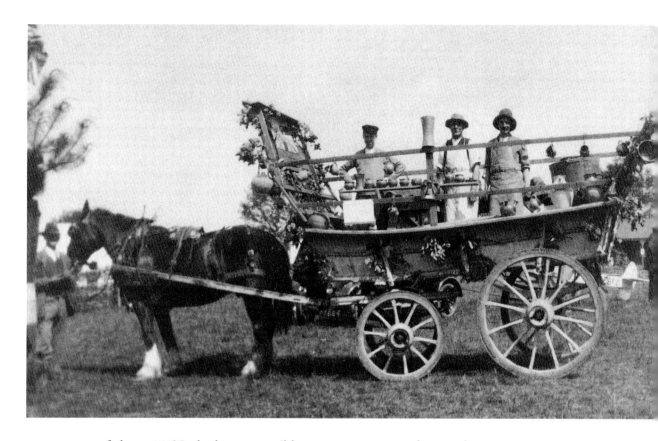

temperature of about 950°C, the lowest possible temperature to produce earthenware. The wood firing produced wonderful variations in colour between different pots, and some have shadows of other pots caused by the flames in the kiln. The potters probably regarded these as blemishes, but today they are greatly admired.

Selling the Pots

All the potteries probably sold a few pots directly to customers from the kiln, but this was only a tiny part of their trade. Cross Roads tried to increase this public selling from the 1920s, if not earlier. A small showroom was opened, and demonstrations of pottery-making were offered to visiting groups. However, the main distributors were the hawkers. In 1927:

> the most primitive method of marketing was found at Verwood, where the household ware is hawked about the countryside together with the besoms which are another local product. This Verwood firm and several others which produce both kitchen crocks and also 'fancy lines' – vases and other decorated ware – use two different methods of marketing. Whilst the heavier and simpler goods are sold locally – at the cottages and farmhouses in the Verwood district – the lighter things are sent by rail to retailers in more distant places.
>
> *Rural Industries Survey, 1927*

The potters from Cross Roads at Verwood Carnival about 1928, with a wagon decorated with pots and greenery. Hanging front left is a costrel, the last time a Dorset owl appears in a photograph of the potteries. Most of the rest of the pots look like jugs. Cross Roads tried many marketing ploys in the 1920s and 1930s.

The 1841 census, the first to detail occupations, lists three 'ware dealers' in Verwood, and the 1898 Directory lists seven 'earthenware dealers' and two hawkers. It is likely that this division between making and distribution was even older. In the 1920s there were about five hawkers, some of whom had smallholdings. Some only sold pots in the winter, doing other work in the summer. Some of them dug clay for the potters, including Pans Brewer.

The hawkers hoped to double their money – Harold Ferret remembered in the 1920s a load cost about £3 and they would get £6. Pans Brewer was the best-known hawker – he started in 1904 and went on until nearly the end of Cross Roads. In 1932 he changed from a horse and cart to a motor van. His son remembered that Pans went to Bridport, Dorchester, Salisbury, Wincanton and Warminster. For some places like Yeovil he would collect a load which had been sent on by train to save coming back to Verwood. He apparently sold bushel pans, wash basins, seakale pots, pitchers, milk coolers, bread pans in several sizes (often used for preserving eggs), flowerpots and saucers, but no fancy goods. He also sold besom brooms.

In the earlier twentieth century Martin Sims ran the local routes, going as far as Bournemouth and selling pots from Black Hills as well as Cross Roads. He remembered that 'fancy stuff' sold well at Corfe between 1910 to 1930. He seems to have been the only hawker who sold fancy wares as well as domestic pots.

Mrs Rose Vine of Three Legged Cross recalled that the hawkers called out 'pots, pans and pitchers'. Olive Philpott remembered the hawker who came to Semley, Wiltshire, in the 1920s shouting 'Verwood Chiney – Come and Buy!'. The hawkers took a wide range of household wares, but because they ran regular routes, they also took orders for special pots. Len Sims, asked in 1995 what sort of people bought the pots, replied firmly 'ordinary people'.

Just as Cross Roads continued its preparation and manufacture of pots in an almost medieval way, the arrangements with the hawkers in the 1920s sound like a long-standing system, with the hawkers not only distributing and selling many of the pots, but also digging the clay. Running a smallholding and selling pots in the winter is just what could be expected to have happened in medieval times.

The hawkers stayed away all week, sleeping at pubs that had stabling for the horse. They also sold pots at some of the pubs and sometimes they perhaps spent too much time there: The *Salisbury and Winchester Journal* of 26 September 1868 reported:

> On Saturday evening Samuel Ferrett, a dealer in earthenware, was returning to Verwood in a pretty intoxicated state, and driving very furiously. When near a barn in Frog Lane [Fording-bridge], the cart upset, and he was thrown under it, whereby he sustained some very severe bruises, which rendered it necessary to remove him to the Union Workhouse, where his wounds were dressed. We understand he is now in a fair way of recovering.

The hawkers' business was virtually all retail – direct to the customer. Cross Roads also sold wholesale to shops, sending the wares out by rail. Spicers, the Dorchester china shop, probably received its stock by rail, and pottery also went to Bournemouth and Poole. In the seventeenth and eighteenth centuries, more must have been sold at regular weekly markets like Salisbury, and the annual fairs.

8 Jugs and Costrels

The Pots

There are several ways of approaching or classifying large groups of pottery: by date; by the kiln they come from; or by their function. Too little is known about the individual kilns in the Verwood area to make that approach possible, and exact dating is a problem for many pots. Function seems the best way to look at them, and does put the pots into the context in which they were used.

Jugs, Cisterns and Bucket Pots

Jugs were a major product of all the Verwood potteries from medieval times, and many collectors of Verwood have started by buying one of these elegant plain vessels. Huge quantities were still being made all through the twentieth century, right up to the last closure in 1952.

Michael Cardew and Bernard Leach were two of the most famous studio potters of the twentieth century, and they both admired the Verwood jug (or pitcher) made in the twentieth century. Cardew wrote that the Verwood pitchers were 'of a very fine shape, much fatter than the Truro and Fremington pitchers, but, like them, free and generous in feeling'.

Cisterns are closed vessels for the storage of liquids, often with a bottle-like top, and always with a bunghole towards the base to let the water, beer or whatever out. They were less common than jugs, but also were made from medieval times and continued to be produced into the first half of the twentieth century. Bucket pots are a strange variant on jugs, only produced in the seventeenth century, but quite common then.

Jugs

When the twentieth-century potters from Cross Roads (and their relatives) were interviewed in the 1970s, they all called jugs 'pitchers', an archaic term which suits the traditional Verwood jug. Fred Sims' daughters remembered that he always called jugs 'mugs'. For example, '4 doz 6 mugs' are listed in his accounts, '6' probably being the size.

Earthenware jugs, especially the large ones, bring thoughts of beer and cider to modern minds, a sort of bucolic nostalgia for an invented peasant past. In fact, the liquid most likely to be found inside them was water. Before piped water supplies, getting water

*J*ugs from the mid seventeenth-century kiln at Horton (1–3), typical of their date and distinctive by their glaze and large base. Eighteenth century jugs (4–6) excavated at Poole and made at Verwood. Most have round handles but, apart from that, the shape of the bellied one is very similar to later jugs. Their glaze is very different to later pots. No. 7 is a bucket pot, also from Horton. All at one-quarter life size.

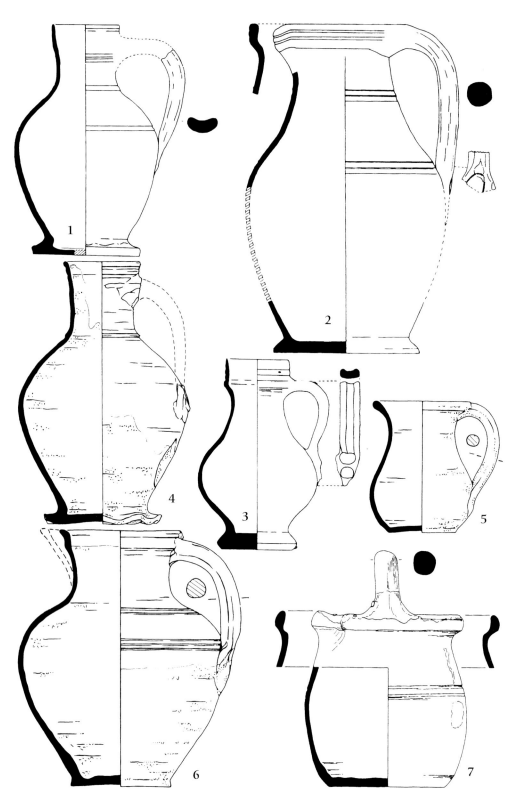

into the house and disposing of it were time-consuming tasks. The more fortunate households had a well, but water still had to be drawn from it in a bucket, and moved into the kitchen or dairy for use. Some villages and many towns had public wells, often with a pump to force the water up, but again it had to be carried home. In the worst case, water had to be bought from water-sellers, who came round the streets. The earthenware jugs were large because they were used for parts of this work. Some, especially the largest ones, did see a richer liquid, of course – beer and cider were standard drinks. Jugs are sometimes found in old wells, dropped in while getting water. A well near Wimborne was made deeper in the 1930s and twenty-five big earthenware jugs (all from Verwood, judging from a photograph) were excavated from the bottom.

The jugs from the seventeenth-century kiln at Horton are very similar in shape to later ones, except for the pronounced foot rim. Some do not have a lip, and so look like large mugs, but this was common in the seventeenth century. The wet-looking, very streaky glaze is distinctive. Judging from wasters at the kiln, jugs formed only a small proportion of production in the mid seventeenth century, but they came in a variety of sizes.

Identifying the eighteenth-century Verwood jugs is more difficult. The huge quantities of eighteenth-century Verwood from excavations at Poole contain only very few jugs, suggesting that competition from metal and finer ceramics was driving the local earthenware ones out. Fineware jugs are common finds in all excavations in Dorset towns from the mid eighteenth century.

Three jugs from collections almost certainly date from the eighteenth century. Two have the brown glaze used for a small proportion of Verwood wares in the eighteenth century. One small jug (*see* photo on page 52) was found in the mouth of one of the

Two jugs which probably date from the eighteenth century (left). The green-glazed one has multiple incised lines and, like the brown one, much more glaze than later jugs. The right one is perhaps early nineteenth century, as it resembles a common shape then, and is different from the usual Verwood jugs (green-glazed jug, private collection, 186mm high; brown-glazed, Martin Green Collection; other, Priest's House Museum Trust, Wimborne).

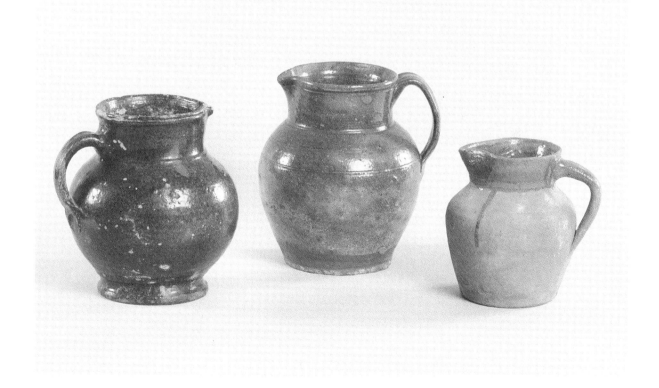

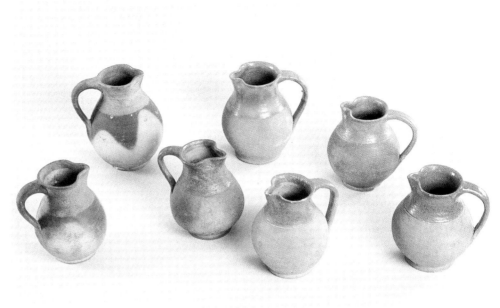

The smallest size 'classic' Verwood jug, which contains 2 pints brimful, 1½ pints sensibly. Right, an unusual jug because it is glazed overall internally, perhaps 1930s; second right marked 'VP', 1940s, and with an unusual reddish surface; centre back with a probably accidental green band in the glaze marked 'Verwood', c.1948–52. The other four are all unmarked, and probably late nineteenth century to 1940s (left, private collection; next two VDPT; two marked at the back, Julian Richards Collection; two front right, VDPT). All 148–170mm high.

Alderholt kilns, and the other manganese-glazed jug is of similar shape to one with mottled green glaze. This has the multiple rings, broad handle and thorough glazing typical of eighteenth-century Verwood. Another manganese-glazed jug dating from the early eighteenth century was found at Poole (*see* drawing on page 53).

A Verwood jug of 'classic' form (*see* above) was found in a big excavated group of 1800–10 from Dorchester, so these pots were being made by that date. A few jugs do not fit the classic shape, but probably date from the nineteenth century. Three are known (*see* photo on page 105, right), with a sharp angle at the shoulder, the handle starting from below the rim, and all with a reddish body and glaze. One is from the area of Seth Sims' kiln at Blackhill, which closed during the First World War. The

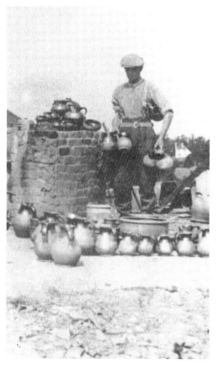

*L*en Sims unloading jugs from the kiln at Verwood. The jugs displayed in the front are of four sizes, seen most clearly as they increase in size to the left. The group on the extreme left are all large ones. On top of the bricks of the kiln are some which seem to be completely glazed; they occur in other 1920s' photographs and were made as part of jug and basin sets.

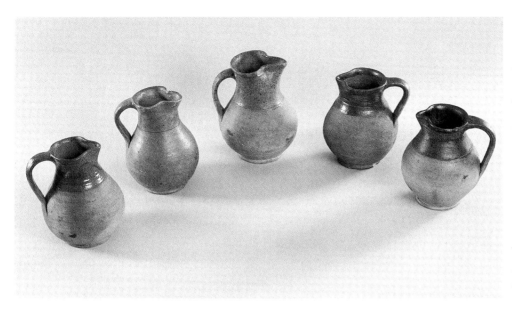

The second size in 'classic' jugs, taking 3 pints comfortably. Second and third from left have unusually large lips, and it is possible that these are mid–later nineteenth century. The two on the right have very dark glaze (the three on the left, VDPT; second from right, Dorset County Museum; right, Peter Irvine Collection). All 180–224mm high.

shape is very like early nineteenth-century fine earthenware jugs, and these could date from that time. With so many kilns working over such a long period it is often difficult to be certain whether pots are different because they are of a different date, or were made by different kilns.

Taking water from the stream at Winterbourne Steepleton about 1890, possibly posed for the photographer, but likely still to be an everyday event. The jug looks like a Verwood one.

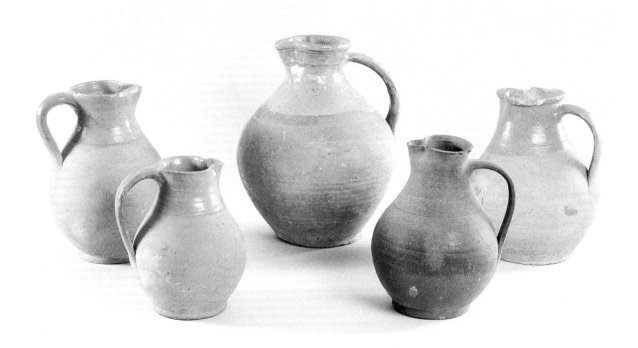

The classic Verwood jug is very plain, its beauty coming from the quality of the throwing. They have a very small amount of glaze outside, in a band from just inside the rim down to the line that marks the swelling of the body. The line is sometimes rather roughly done and can be partly double. The upper half of the handle is also glazed. All the jugs have this incised line but no other decoration. The glaze is solely decorative and because the interior of the jug is unglazed, it is porous. Argument rages as to whether this mean amount of glaze was due to economy on the potters' part – making the best show with the least glaze – or whether it was designed to make the jugs better at keeping cool because they could be soaked in cold water. Admittedly, the jugs were also easier to fire because of the small amount of glaze – they could be packed tightly together without glazed areas coming into contact.

Right up to the end in 1952, the traditional jugs were made in several sizes (*see* photo on page 106). Photographs of the kiln suggest as many as four different sizes at one firing. George Brewer, who worked at Cross Roads from 1911–28 (with a gap for the First World War), remembered three sizes of pitchers being produced. He may have been discounting the very large ones, which were less commonly produced. The smallest traditional jug takes exactly 2 pints if filled right to the brim, and more like 1½ pints for sensible use.

The neck of the jug is relatively narrow, and swells out to a wide belly. Many of the larger jugs, from about 240mm high, have a collar at the rim to strengthen them, and the handle sometimes comes from lower down, below the rim of the pot, on these larger vessels.

The oval-shaped handle (sometimes called a straphandle) springs directly from the rim, coming out horizontally, and is smoothed away into the body of the pot at the other end. Many show faint rings around the body from the throwing process.

The largest size in 'classic' jugs. Right, jug used in the Noah's Ark public house Dorchester in the early twentieth century (Michael & Polly Legg Collection, 284mm high); second right, unglazed with unusual blackish surfaces, marked 'Verwood', c.1948–52 (Salisbury & South Wiltshire Museum); centre VDPT; second from left marked 'Verwood' c.1948–52 (Ian Waterfield Collection); left Martin Green Collection. All 230–350mm high.

The greatest variation is in the lip – a few have big parroty beaks (*see* photo on page 107), and the only dateable comparison for these is the tiny jug made by the Budden family kiln in about 1858 (*see* photo on page 56). However, this is so much smaller than the 'classic' jugs that comparison may be inaccurate. A few late jugs, dating from the 1940s, have very small lips, giving them a sparrow beak (*see* photo on page 106, right), but these are uncommon. A few otherwise standard jugs are glazed all over the inside (*see* photo on page 106), and may date from the 1930s. A *Bournemouth Echo* article of August 1936 stated that 'the large pitchers which are a speciality of this pottery [Cross Roads] are glazed inside and on the upper half of the outside'. Len Sims remembered that 'small little jugs' were 6d and the biggest were 2s 6d in the twentieth century.

Dating these classic jugs is difficult. They have been found at the kilns at Sandalholme, Seth Sims' and Bailey's at Blackhill and Cross Roads, in effect every kiln where pottery has been found. There were at least twelve potteries in the Verwood area from the later

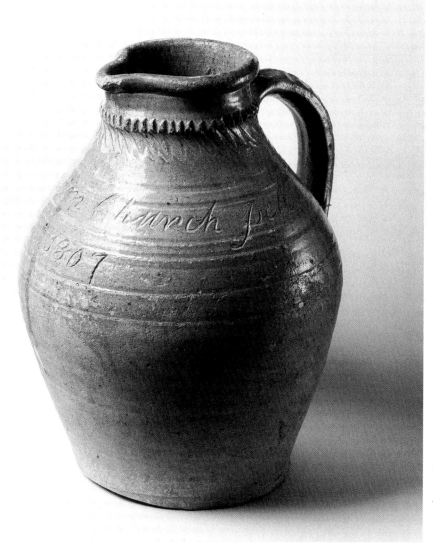

LEFT AND FOLLOWING TWO PAGES:

*T*hree large jugs made for bell ringers, and still surviving in the churches they were made for (from two central and one eastern Dorset churches). Left, a heavy jug inscribed '–Church Pell 1807', which makes it the second earliest dated Verwood pot. The collar with finger impressions and slashing is unusual for Verwood (381mm high).

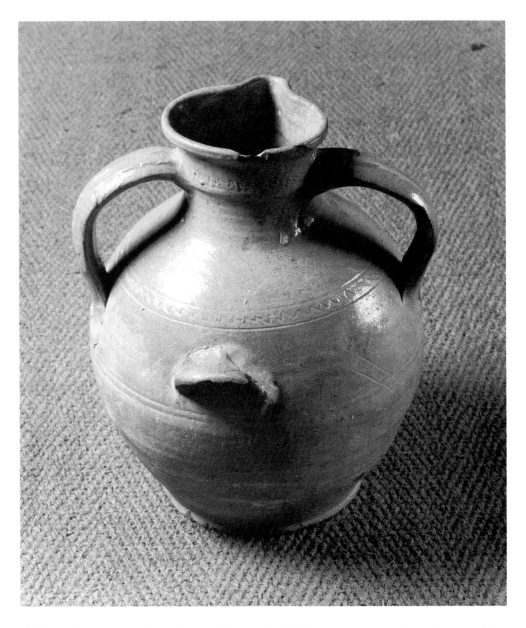

Large jug, very similar to that opposite, but with a 'drawer' type handle at the back (394mm high).

eighteenth century to the 1860s, and seven in 1900. They cannot all have been making exactly the same pots, but distinguishing between changes over time and differences between kilns is impossible until more pots from specific kilns have been recovered. The shape was being made from about 1800, maybe a little earlier, and it seems likely that many surviving jugs are from the nineteenth century.

Huge jugs were made occasionally, sometimes even with inscriptions. The three surviving monster Verwood jugs are all in churches, and seem to have been supplied to quench the thirsts of bell ringers. One has the inscription '–4 the Bellfrery' which is clear, if a bit concise. Another has the name of the village and then 'Church Pell 1807'. Pell presumably mean Peal, that is, the bells. It must have been the ringers, rather than the bells,

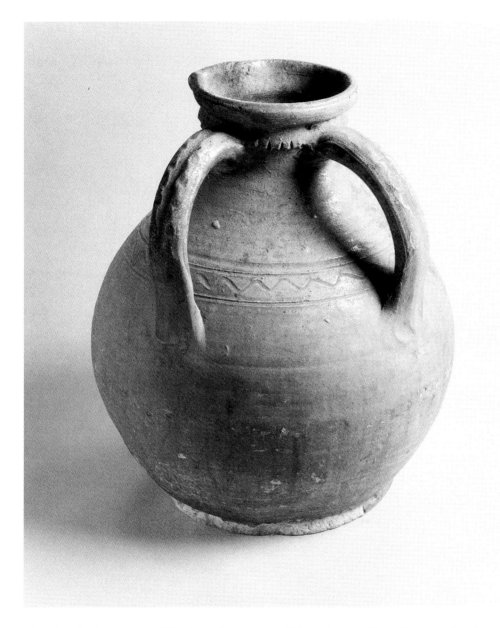

who drank the contents. The large jugs may well have been sold to farms and pubs and other places using or selling large quantities of liquid, but none survive.

Three really big jugs have been found in archaeological pit groups – one in an early eighteenth-century group from Poole, and a huge one (at least 300mm across and more than 390mm high) from a late eighteenth-century group from Corfe. Both these are plain and come from Verwood. Another from Greyhound Yard, Dorchester, of about 1830 is slightly smaller than the Corfe one, and has big rouletting on a collar below the rim. Only the top was found, and it was probably made at Verwood.

These huge jugs are so large that they are difficult to lift even when empty – full of beer, cider or water, they must have been impossibly heavy. Some have multiple handles

'Fancy' jugs made at Cross Roads, all probably 1930s to 1952. The back row all belonged to Marjorie Bailey, and were probably made by her father, Herbert Bailey (Dorset County Museum). The one on the right has an oddly placed handle (Peter Irvine Collection). Only two of this type are known. Left front was bought at Cross Roads about 1943 (VDPT). Front centre marked 'Verwood' c.1948–52 (Dorset County Museum). (Back right, 131mm high.)

to help, but they must commonly have been poured from by tipping, which accounts for the excessive wear found on the front of the bases.

These jugs suggest lots of beer or cider for lots of people. Large harvest jugs from north Devon and Somerset have decoration scratched through a slip coating, sometimes with instructions as to their use:

In harvest time when work is hard
Into the field I must be Carr:d
Full of Good Cyder or Strong Beer
your thirsty work folks for to cheer
but If you Do Leave me at home
but Little work There will be done
for work is hard and Days are Long
I hope your Liqure will be strong.
 From a Donyatt jug dated 1796 in Somerset County Museum

Harvest is com all Bissey
Now in Mackin of your
Barley Mow when men do
Laber hard and swet good
Ale is bether far then meet
 Bideford April 28th 1775 M & W

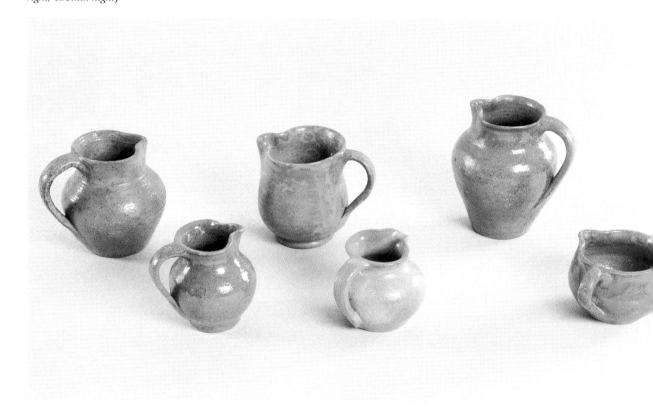

An inscription on a jug in Exeter Museum refers to harvest feasting as well as drinking:

> Work on Brave
> Boys and never fear
> You shall have ale,
> Cyder and Beer, Beef
> pork and pudding as I
> thinke is Rear good
> Eating with Strong
> Drinke
> 1771

Rear must mean rare. On a Bideford jug there is an inscription which could mean it was a ringers' jug rather than a harvest one:

> Come fill me
> full and Drinke
> a bout and Never
> Leave till all is out
> and if that will not
> make you merry
> fill me again
> and sing Down
> Derry 1766

Occasionally pots have inscriptions referring to their transformation from clay. On a Bideford jug, made by the potter John Phillips:

> When was I in my native place
> I was a Lumpe of Clay
> And Digged up out of the Earth
> And brought from thens a way
> But now a jug I am become
> By Potters Art and Skill
> And I your servant am became
> And Carie Ale I will
> John Phillips 1760

Cross Roads made 'fancy' jugs from at least as early as the 1920s, with a little squat jug (*see* photo on page 165, foreground), presumably for milk, being made for the first time (*see* photo on page 112). Fred Fry may have introduced these, as he did many forms. The 'fancy' jugs go on being made in a wide variety of shapes up to 1952, with many of them being glazed overall.

One large and full-bellied jug type was made to sell with bowls as a jug and basin set, again from the 1920s. They are distinctive both from their shape and the amount of glaze.

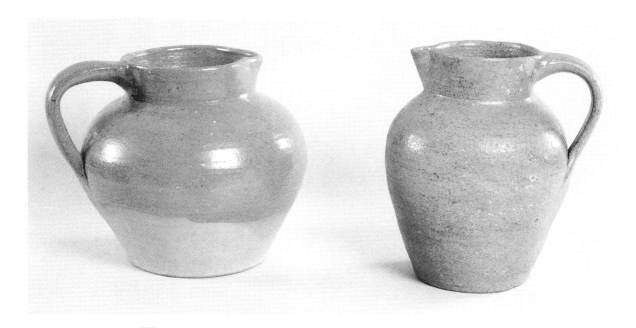

The jug on the left is exactly like the fully-glazed one in the photograph below, foreground. A couple of these still survive with their matching basins, so this shape was for a jug and basin set (Martin Green Collection; 230mm high). The one on the right may be a large water jug (Dorset County Museum).

Bringing pots in from the kiln after firing, Cross Roads in 1926. A rather posed photograph, with the pots artfully arranged on the ground. The first boy is carrying a cistern, and there are two more on the ground – second from the left and in the middle. All three have a rich dark glaze and two handles. The jug third from the right is identical to that illustrated above.

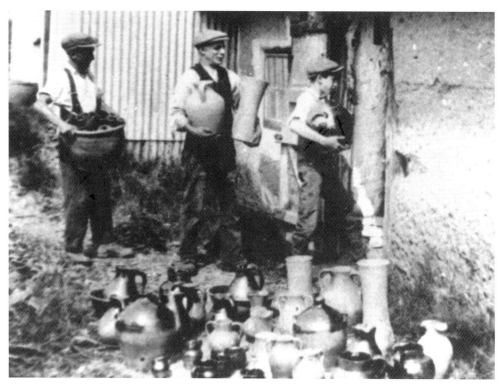

Cisterns

Cisterns are large jars with a bunghole towards the base; they were used to store liquids. Doubtless the bucket pots (*see* drawing on page 104) were used to fill cisterns with water. They were made from medieval times, and were commonest in the sixteenth century (*see* photo below). Like storage jars, they were not intended to be moved about, so they tend to be thick-walled and heavy. They were made at Horton in the mid seventeenth century, and are occasional finds in eighteenth-century archaeological groups. They seem never to have been a common pot.

Only four examples are known from collections of Verwood, three of them smallish for cisterns. Two have neat bands with an incised wavy line bordered by two straight ones, and similar glaze and handles, although one (not illustrated) is rather fatter. It is possible that they were made at Seth Sims' kiln at Blackhill because one of them was found there. They probably date from the mid to later nineteenth century. An even more rounded plain example with no handle is completely glazed and has a bottle-like top. It is difficult to date but is perhaps early twentieth century because it has so much glaze. The largest cistern (*see* photo below) is on a totally different scale, weighing over 9kg and standing 400mm high. This is a serious pot, used to store water or beer, not for moving around. It probably dates from about 1800 as its feeble little handles and multiple rings can be paralleled from that time.

Cross Roads made a few cisterns in the 1920s, because three can be seen in one of the photographs taken in 1926. They look like the cisterns produced by studio potters,

Cisterns, the one on the left being one of the largest Verwood pots (401mm high). It probably dates from the eighteenth century. Right, a smaller cistern with both its handles missing, and a wavy line incised between two straight ones (365mm high). (Both Salisbury & South Wiltshire Museum.)

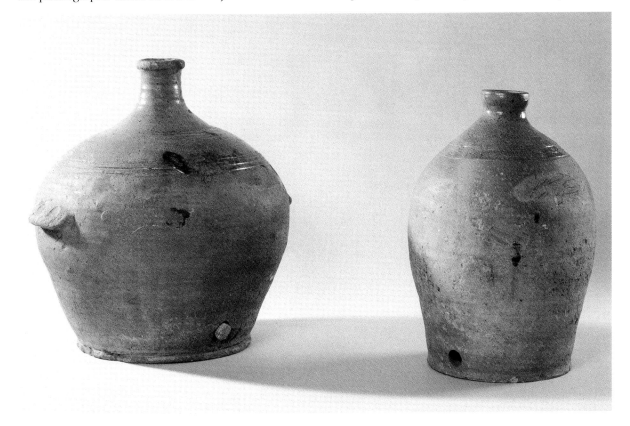

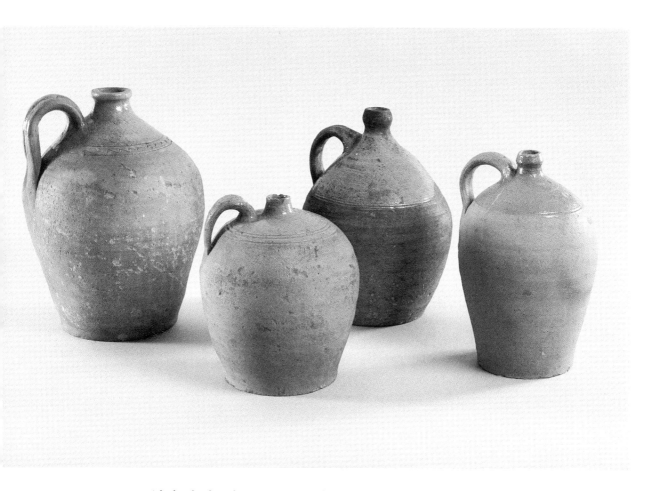

*L*arger Verwood flagons showing the range of shapes made – left, with a wavy line incised between two straight ones (VDPT, 345mm high); second left, high-shouldered and third left, sloped shoulders (both Dorset County Museum); right, just like late nineteenth-century stoneware flagons (Graham Zebedee Collection). The necks also show great variety.

wide-bodied and smooth-shouldered. These are only known from the photograph – no twentieth-century cistern has yet been identified in collections. In Wales and the north of England, large cisterns were made for brewing beer, but these have very wide necks, not the bottle-like neck of the Verwood ones. The northern examples were called brewing jars or spigot jars (spigot being the tap put into the bunghole). It is possible that cisterns intended for water have the bungholes low in the body, while those for beer have it higher to keep it above any sediment.

Bucket Pots

These strange vessels (*see* drawing 7, page 104) look like a wide jug or even a chamber pot, but they have a thick handle over the top, obstructing the mouth. They were made at the Horton kiln in the mid seventeenth century, and are known from the Donyatt (Somerset) and Hole Common Lyme Regis kilns. They were used to move water, and are efficient dippers, being easy to submerge totally in, for example, a big bucket of water from a well. The handle is more suitably placed for this than the side handle of a jug. At Verwood they seem only to have been made in the seventeenth century, but at Donyatt they go on into the eighteenth century, with one dated 1755.

Costrels and Flagons

Earthenware costrels and flagons were made to carry liquids, with the costrels having lugs for carrying-strings and the flagons having handles like jugs. Costrels tend to be squatter and the flagons taller. Both forms are designed to have the neck sealed up, usually with a cork.

Flagons

The mid seventeenth-century kiln at Horton only made costrels, and no earthenware flagons are found in archaeological groups of the seventeenth century. This must be because stoneware bottles or flagons were a very common import from the mid seventeenth century and were made in England from the late seventeenth century. They are much stronger than earthenware ones. An earthenware imitation of a typical stoneware flagon (bellarmine) may have been made at Verwood, but these are very uncommon.

The only excavated Verwood flagon from the eighteenth century is a wide-necked variety (*see* drawing 10, page 53) and it seems likely, as there are virtually none in the huge eighteenth-century groups from Poole, for example, that most of the surviving flagons date from the nineteenth century at the earliest. A broken flagon found at Alderholt was

Smaller Verwood flagons: the central one with green glaze and multiple incised lines was found at Alderholt, and probably dates from the eighteenth century (Salisbury & South Wiltshire Museum, 225mm high). The two smaller flagons are probably nineteenth century (left, VDPT) and eighteenth century (right, Dorset County Museum).

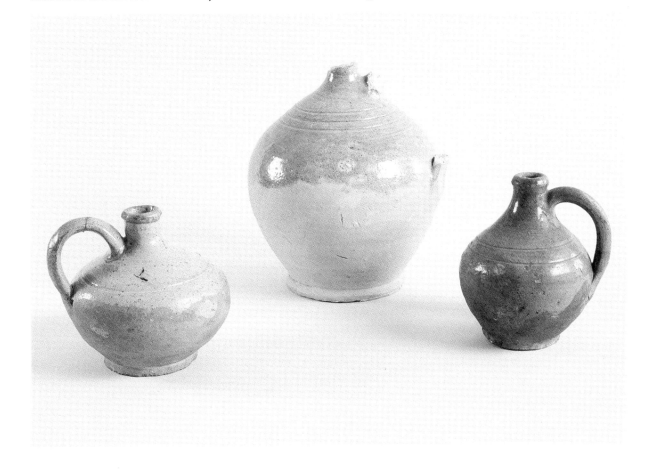

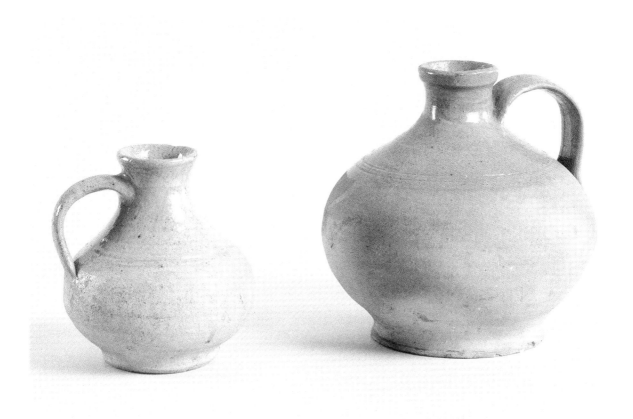

Wide-necked flagons from Verwood, not a common pot. Mostly they have a collar at the top of the neck like the one on the right, which is probably early nineteenth century (Dorset County Museum, 194mm high; left, VDPT).

probably made there before the 1860s when the Alderholt kilns closed, and its green glaze, multiple lines and general appearance suggest that it dates from the late eighteenth or early nineteenth century. A very similar flagon, also with no top, was found at Potterne Farmhouse (Verwood Historical Society). The top was broken off before firing, as the brown glaze has flowed over part of the break.

The larger Verwood flagons come in two basic shapes – classic big bottle shape with a low belly and sloping shoulders, and high-shouldered. A rare variant is virtually spherical. All have a neat narrow mouth, easy to stopper with a cork. The handles are prominent, sticking out from the body after springing from below the neck. Some look just like the common stoneware flagons.

The smaller flagons tend to be more low-bellied, and inevitably the handles look a bit large as the pots are small. A few flagons are distinctive because they have wide mouths, and look like jugs with no pouring lip. They must have been sealed with a large cork, or had paper or cloth tied over them. One excavated at Colliton Park, Dorchester, may be the earliest – it has multiple lines around, a complex sectioned handle and slightly odd-looking glaze. It perhaps dates from the early nineteenth century. An eighteenth-century flagon excavated at Poole (the only one found there) is very like the one above left, but has a thinner rim and brown glaze (*see* drawing 10, page 53).

Large flagons have been found at the kilns at Sandalholme (like the photo on page 116, right) and at Bailey's, Blackhill (*see* photo on page 67), but with a much smoother, nineteenth-century feel. The Blackhill one has lost its top.

The only inscribed flagon is a late one. Its inscription is 'B. Haskell/Woodlands/ 16/4/1900' and is still with Bartemus Haskell's descendants. Woodlands is just to the west of Verwood. Interestingly he was a travelling cider maker, so the flagon was probably used for cider. It is also the only flagon with slightly flattened sides like the photograph on page 127, left. Otherwise it resembles the photograph on page 116, right, but with slightly smoother sides and a wide strap handle.

Costrels

The most famous shape made at Verwood is the round costrel, also known as a Dorset owl or pill. They seem to have been distributed more widely than other Verwood pots, turning up all along the south coast and even as far north as Northamptonshire.

They vary a little in shape, but are basically rounded with two distinctive lugs, one each side of the bottle-like neck. These lugs have pinched, pie-crust edges, making the costrels look a little like owls. They are beautifully suitable for their purpose – taking cold tea, beer, cider or even water for drinking while working outdoors, a sort of cold thermos. The narrow neck takes a cork, and the two pierced lugs are there to take carrying strings or a leather thong. Their almost spherical shape is very strong, and it is very unusual to find one broken except on the vulnerable neck and lugs.

Originally titled 'Dorsetshire Peasantry' and showing a group of 'average specimens'. The men wear smocks, and the one on the left holds what is clearly a Verwood costrel, although the engraver has made the strings look like the handles of a teapot (from The Illustrated London News, *5 September 1846).*

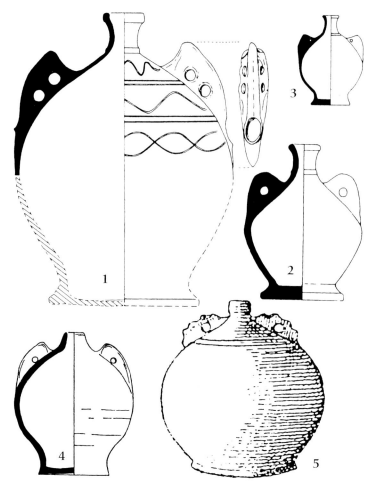

Costrels from the Horton kiln (1 & 2) and another (3) excavated nearby at Kingston Lacy which was made at the Horton kiln, mid seventeenth century. The smaller ones are plain, the larger have incised decoration. The lugs are plain and have 'ears', and the vessels are more conical-topped than later ones. Their glaze is also distinctive. No. 4 is from an early eighteenth-century group at Southampton; all at one-quarter life size. No.5 dates from the 1880s (illustration by Pitt Rivers).

The rounded costrel was the first Verwood pot to appear in a publication, featuring in a print of 1846, and being drawn for Pitt Rivers as a comparison for medieval costrels in 1887. He wrote that the costrels were 'still used in Dorsetshire by working men'.

The seventeenth-century kiln at Horton made costrels – they were a fairly common form then at many kilns, although less so later. The seventeenth-century ones have a more conical top than the later ones, and some are decorated with incised lines. Their lugs are plain, without the characteristic pinching which later costrels have, and are much larger, looking like ears. Without this starting point – having a shape that is firmly dated – it would be impossible to suggest a dating sequence for any Verwood costrels.

The conical top of the seventeenth-century costrels makes them look more like bottles with added lugs than the later, rounded form. A costrel excavated at Southampton in an early eighteenth-century group is a similar shape to the seventeenth-century small ones, with 'eared' lugs just like them, but with a simple spout-like top. It has no decoration (above). An unstratified costrel excavated at Poole (see photo opposite, top right) is perhaps mid to later eighteenth century, and has features in common with the Southampton one, although it is a more elaborate vessel. The plain lugs and bottle shape are like earlier ones, and the extent of the greenish glaze, along with the seven incised rings about the body, give it the 'feel' of an eighteenth-century pot. The earliest, rounded-bodied costrel comes from a pit of about 1800 at Christchurch. Unfortunately this pot has lost its neck and lugs.

The costrels with plain lugs and a conical top certainly date from the eighteenth century. Those illustrated also have the greenish glaze characteristic of the eighteenth century. Four costrels (see photo on page 125, right) are known, with conical top but pie-crust lugs, not plain ones. They are probably the link between the eighteenth century

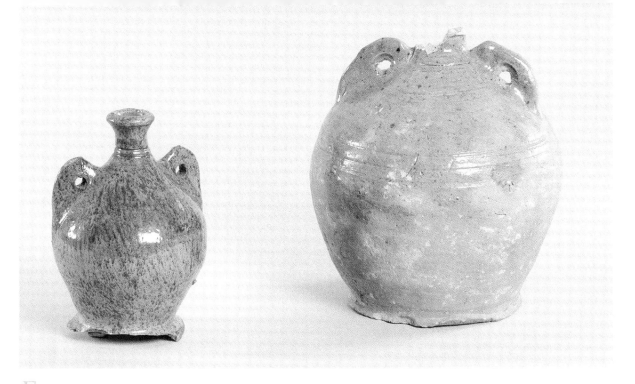

*E*arly costrels, left, from the Horton kiln, mid seventeenth century (Dorset County Museum); right, excavated in Poole (Borough of Poole Museum Service), 214mm high, with multiple incised lines and extensive green glaze, eighteenth century.

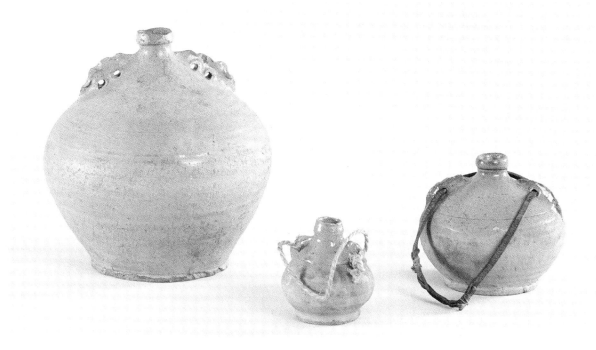

*T*he largest Verwood costrel (left, 270mm high), and two tinies only 145mm and 106mm. All three are nineteenth century – the conical shape of the smallest one is probably due to the difficulties of making such a small pot (largest VDPT; two smallest Dorset County Museum).

and the bulk of surviving costrels that are nineteenth century. The three not illustrated have a distinctive glaze heavily flecked with brown, and two of them were excavated in hedgerows.

The rounded shape was clearly being made by 1800, as the one found at Christchurch shows. In summary, it is suggested that seventeenth- and eighteenth-century costrels mostly have plain lugs, the earlier ones large and looking like ears, and they have conical bottle-like tops. An intermediate shape still has the conical top, but the lugs have pie-crust edges. This is all based on sparse dating evidence, and the sequence may well be proved wrong by further work on the kilns, more dated pots or more excavated groups.

The three eighteenth-century kilns that have been excavated so far have produced no costrel fragments, but the kilns are only a tiny sample of those working throughout the eighteenth century.

Most of the costrels in collections probably date from the nineteenth century, and they come in a wide range of sizes, with no standard heights discernible. They probably come in rough volume sizes, but the variety of heights and widths makes this difficult to demonstrate. The tiniest glazed owls are only 105mm high, and cannot have been any

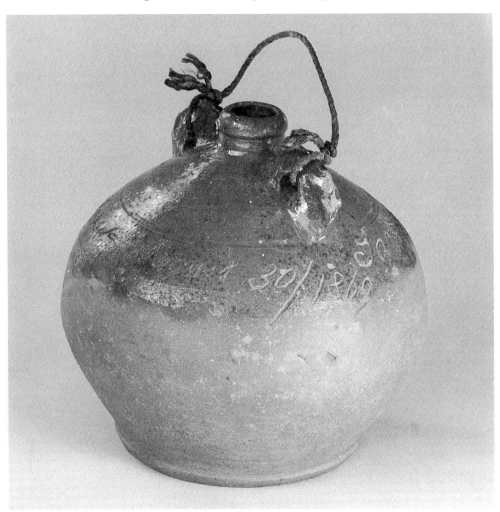

A very red costrel inscribed 'Samuel Read Alderholt, Dorset August 30th 1869'. He worked at one of the Alderholt kilns. The costrel belongs to his descendants.

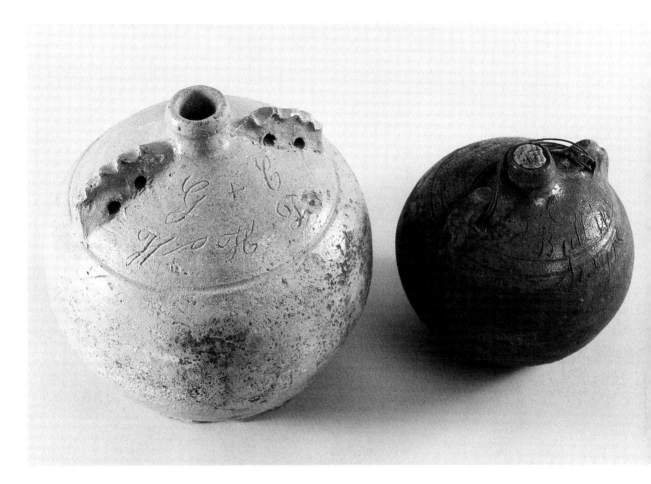

use at all. They are toys or decorative pots. The largest ones are 270mm high and nearly as much across, making them heavy pots. A complete range of heights in between was made, and the widths vary greatly as well.

Although the costrels all look alike at first glimpse, when examined closely they differ widely in details. Trying to sort out individual types of the costrels seems impossible – the lugs vary from wing-like elegance to stumpy slug-like things, and the necks from neat collared tops to amorphous spouts. The variety of body shape and finish seems endless. The positioning of the lines on the shoulder (through the lugs, below the lugs, on a line with the bottom of the lugs) seemed a good diagnostic feature, but did not correlate with anything else. The larger costrels tend to have more incised lines, but this is hardly a surprise as there is more room for them.

If, as seems very likely, costrels were made all through the nineteenth century, diversity is to be expected. There were fourteen kilns in the area in 1800, and still seven in 1900. They probably each made a slightly different costrel, and indeed may have made different costrels at different dates. With the jugs, or at least the surviving jugs, it is possible to define a 'Verwood type', which seems to have been made by many of the kilns. With costrels, the basic form is similar for all, but virtually every pot seems to differ in some detail of making or glazing. Detailed examination of more than 100 costrels showed only three pairs, that is, pots which showed similar shapes, finish, ears and so

Two rare inscribed costrels. Right, 'GC' and 'HHD', difficult to interpret but perhaps GC was the owner, and one of the Hs could stand for Hampshire, probably late nineteenth century (Julian Richards Collection). Left, inscribed 'J.C. Bull inn Swyre', probably 1870s or 1880s (Dorset County Museum, 161mm high).

*T*wo costrels with
unusual plain,
amorphous necks
and simple
uncollared tops
(Hampshire
County Council
Museums Service,
larger 235mm
high).

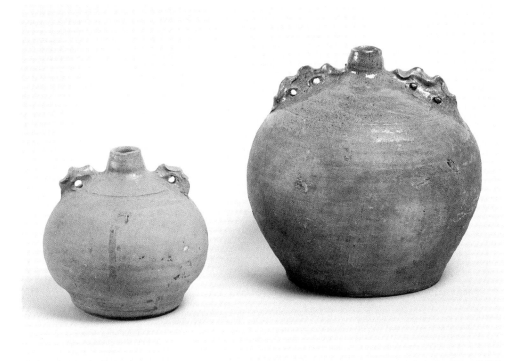

*T*wo very similar
costrels, perhaps
from the same kiln,
both with a
distinctive pale and
rather unpleasant
glaze. Right has
plain lugs, but is
clearly nineteenth
century (both
Hampshire County
Council Museums
Service, larger
202mm high).

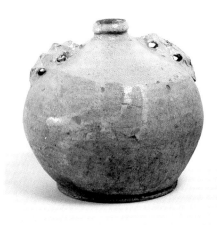 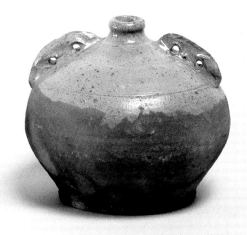

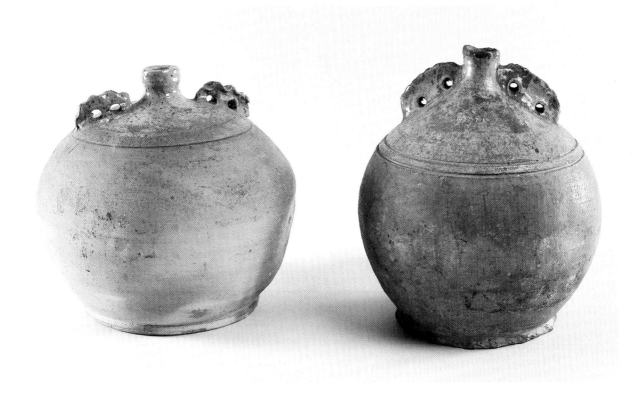

on. The variation is much wider than one would expect from even fourteen kilns, but changes over time probably account for this.

Generally, the costrels thought to be nineteenth century have an orangey or yellowy glaze, are rounded in shape, and have two lugs which have pie-crust edging. Only one of them has plain lugs. The lugs also lack the 'ear' effect of the early ones because they are a consistent width.

There is only one dated 'owl' costrel, a rounded shape. It is inscribed 'Samuel Read Alderholt Dorset August 30th 1869'. His granddaughter recollected that it was given to Samuel Read on the day he started work at one of the Alderholt kilns. Samuel Read died in 1932, aged 76, and so would have been thirteen or fourteen years old in 1869, just the right age to be starting at a kiln. In shape, it is like many costrels, but has a distinctive red body and very orange glaze. Only one other costrel of similar colouring is known (in Dorset County Museum), and probably only a limited number of the pots from Alderholt were of this distinctive colour.

A classic rounded costrel has the incised inscription 'J.C. Bull Inn Swyre'. There was no Bull Inn or any other pub at Swyre, but there was at Puncknowle, the next village only a couple of miles away. James Coombs was the landlord of the Bull in the 1875 and 1885 Directories, and this costrel must have belonged to him. He probably had it inscribed to make sure it was returned to him. A handsome Sussex earthenware flask has the inscription 'C. Stepney wants me home', making clear why it was inscribed.

Costrels were still being made in 1912, when one appears in a photograph of Cross Roads. Another is seen hung on the decorated wagon which Cross Roads entered in Verwood Carnival about 1928. Len Sims and others who remembered Cross Roads were asked

The contrast between the rounded shape of the nineteenth century and the bottle shape, both extreme examples. Left was found in 1910 at Cerne Abbas with thirty-nine other Verwood costrels, an extraordinary hoard, difficult to explain. Right has a nasty yellowish coating overall. It has the earlier conical shape, but pie-crust lugs with no 'ears'. It perhaps dates from the late eighteenth century (both Dorset County Museum, right 261 mm high).

in the 1970s about costrels being made in the twentieth century. The only person who remembered them was Harold Churchill, who started work at Cross Roads in 1927. It seems that they were not made after the later 1920s, and probably only a few were made between 1900–20. They do not occur in any of the 1920s to 1950s photographs of the pottery. Len Sims and Marjorie Bailey said that they were called wine jars or harvest jars, not owls or pills, but they were probably referring to the flagon type of costrel. Marjorie Bailey told one interviewer that costrels were made in the 1920s, but to another she said they were not.

These costrels were used by agricultural labourers to take cold tea, beer, cider or water with them to work. William Barnes was perhaps remembering a Verwood owl in 'Where we did keep our flagon':

*W*ide nineteenth-century costrels, the one on the left the only example yet recorded with a zigzag line between two plain ones (Priests House Museum Trust, Wimborne). The one on the right is from the Martin Green Collection (180mm high).

> When we in mornen had a-drow'd
> The grass or russlen' hay abrode,
> The lit'some maidens an' the chaps,
> Wi' bits o' nunchens in their laps,
> Did all zit down upon the knaps
> Up there, in under hedge, below
> The highest elem o' the row
> Where we did keep our flagon.

Several museums have costrels which have been dug out of hedge banks, presumably left there and forgotten, or even deserted when glass bottles (lighter but frailer) replaced them. William Cobbett writing in 1824 stated firmly that 'bottles to carry a-field should be of wood. Formerly, nobody but the gipsies and mumpers, that went a hop-picking in the season, carried glass or earthen bottles'. Cobbett obviously did not know Dorset,

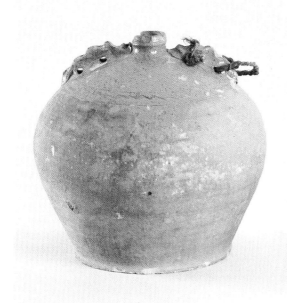
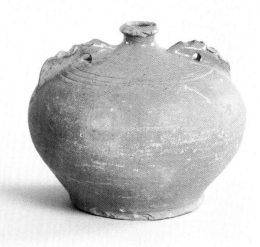

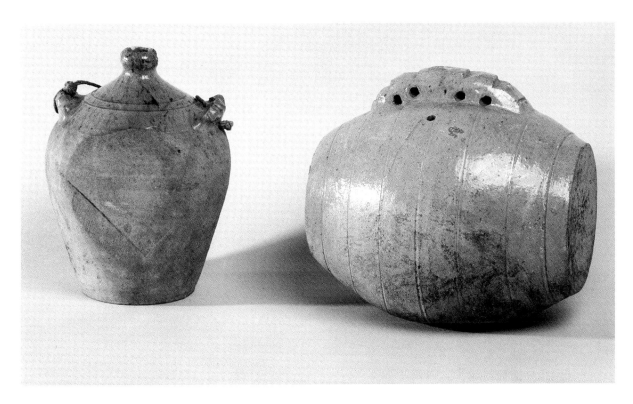

where earthen bottles or costrels were common, although wooden ones were certainly used as well.

Many earthenware kilns all over the country made costrels in the seventeenth century, but only a few in the eighteenth century, and virtually no one else except Verwood made them in the nineteenth century. They were an archaic form, common in late medieval times, but superseded by stoneware and glass from the late seventeenth century. The rural counties of Dorset, Hampshire and Wiltshire must have provided Verwood with a good market for them, however, judging by the large numbers that survive.

The Verwood costrel is the most distinctive pot made at the kilns, and many were bought in the late nineteenth and early twentieth century by collectors thinking they were medieval. Collecting pottery rather than porcelain and finewares was a new thing, starting in the 1860s or 1870s. The costrels seem to have had a wider distribution than other Verwood pots, so collectors perhaps did not have Verwood jugs and bushels to compare them with. To Victorian and Edwardian collectors costrels were associated more with medieval pilgrims than with contemporary farm labourers. Unfortunately, these collectors rarely recorded where they bought their pots, and they may have brought Verwood costrels from some distance. This may have widened their apparent distribution.

Other Costrels

Verwood made a few costrels of a totally different shape to the usual owls. Round forms, with one flat and one rounded side (sometimes called 'mammiform'), are the most common, although there are only about half-a-dozen known. They are like some medieval

A very unusual Verwood costrel, with the lugs running around the body, and the sides flattened to make it almost square. The glaze is very wet-looking and streaky; it is presumably late eighteenth or early nineteenth century (230mm high). Also a barrel costrel imitating a wooden one, with lines showing the bindings on the original (both Hampshire County Council Museums Service).

costrels, with multiple lugs around the edge to take string or leather thongs. Although they look like medieval pots, they all probably date from the mid to late nineteenth century, with the exception of an excavated, fragmentary one from Wimborne which is twice as deep (or thick) as all the others, with a very different glaze, probably dating from the eighteenth century.

A mammiform costrel almost identical to that illustrated below (and only the second known with pie-crust lugs like the usual costrels) has 'Stephen Butler 1874' incised on the flat side. He kept a shop at Cripplestyle and his pot is still with his descendants.

Four of these costrels are very alike in shape and glaze, but differ in their lugs. One is inscribed 'Oba Sims', and he is known to have lived in the late nineteenth century. Others have single or two lugs each side, and the fourth has single lugs with pie-crust edges like those on the round costrels (see below). The most interesting one made in this shape is quite unlike the others, being reddish in body and with a very flecked orange glaze. Incised on it is 'ENES SHERING MAKER MAY 12 1878'. The two lugs and the neck are tiny in comparison to the other costrels, but it is very useful in establishing a date. There were many Sherings (also spelt Shearing) who potted in the Verwood area from about 1800. On the pot he spells it Enes, but in the censuses and parish registers he is Enos Sherring, born in 1827 and dying in 1894.

Earthenware costrels imitating the shape of wooden barrels were produced at Ver-

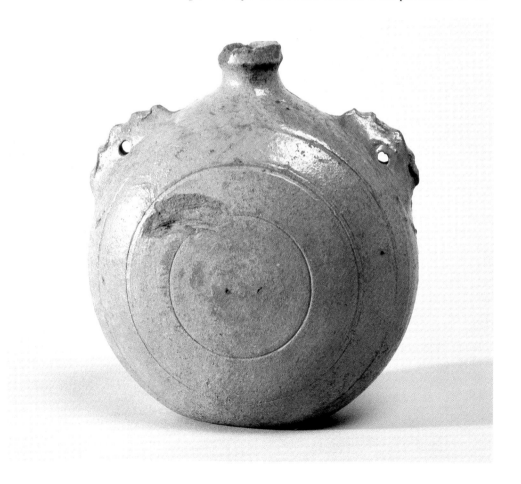

S mall costrel with owl-like ears, flat on the other side (Hampshire County Council Museums Service, 202mm high).

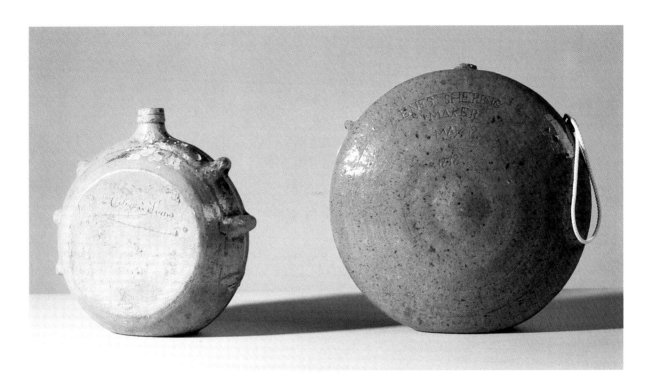

wood in the middle of the nineteenth century. Only four are known, but three can be dated. The earliest, and the earliest dated Verwood pot, is known only from photographs taken in the 1970s. It is rather like the Budden costrel (*see* photo on page 58), but smaller and with a shorter neck. One end is inscribed 'John Shering Maker August 1805' and the other end has simply 'R'. John Shering potted at Alderholt. The other barrel costrels are later – one is dated 1857, and the other is signed by a potter who was only working *c.* 1857–64. He covered his costrel with graffiti of a train, a man and so on, and finished it off with 'Charles Budden, Verwood, Dorset', but, sadly, no date (*see* photos on pages 58–9). It has the only example of impressed printer's type yet found on a Verwood pot.

The other two barrel costrels are slightly different. One has no inscription, and the spout and lugs are combined and stepped down in two stages rather than straight. The other is smaller, with a separate spout and suspension lugs, which are rectangular. It is inscribed 'Mathew Belky 1857'.

The kilns at Donyatt, Somerset, also made barrel costrels in the mid nineteenth century, with one of them dated 1851. Something must have sparked off this revival of a form which neither potting centre had made since the medieval period. They had been made in Sussex a little earlier, with dated examples from the 1820s, 1830s and 1840s, but these are smaller, neater and with slip decoration. Barrel costrels are a rare type in earthenware.

*M*ammiform *costrels. Left, the more typical shape, incised 'Oba Sims' on the flat side. Obadiah John Sims from Alderholt was killed in the First World War (VDPT). Right, a unique costrel incised 'Enes Shering maker May 12th 1878' (Dorset County Museum, 275mm across).*

9 Bread Bins, Pans and Dairy Work

Bread Bins or Bushels

Bread bins, bushels, big crocks – they are all the same pot, a large, wide-necked, cylindrical vessel with curved sides. They were a staple part of production at Verwood from the eighteenth century until 1952. This was not because they were a popular selling line (although they probably did go on selling well), but because they were essential to the successful firing of the difficult single-flued kilns. In order to spread the heat and fire everything in the kiln properly, it had to be virtually filled with bread bins as these deflected the heat and stopped it roaring out of the top of the kiln. These big pots also acted as a sort of saggar, a protection for smaller wares. In addition, a few already fired bread bins were placed at strategic points in the kiln as it was being loaded to support planks on which the potter loading the kiln stood (unfired wares would not have been strong enough).

History

Large open bins for storage were made at Horton in the mid seventeenth century, but they were smaller than the later bread bins, and not so thick-walled. The earliest excavated example of a true Verwood bread bin is from Colliton Park, Dorchester, and was found in a group of about 1700. Unlike later Verwood bread bins, it has two handles, and the top is not formed so as to take a lid. An example from the late eighteenth-century pit at Dorchester is much more like the nineteenth- and twentieth-century pots. There are too few known from the eighteenth century for it to be possible to work out when the shape changed. The bread bin of the 1790s is impossible to distinguish from later ones: Verwood bread bins seem to be pretty well undateable. A big early nineteenth-century group from Shaftesbury contains four bread bins in three different sizes which look just like those made at Cross Roads in the 1940s.

Wasters have been found at all the nineteenth- and twentieth-century kilns, and there seem to be no differences between the bread bins from the different sources. Small ones have been found at Blackhills and Sandalholme, but they too were probably made at all the kilns. There are a few which can be attributed to a specific pottery. Those produced by Robert Shering at Cross Roads are marked with his name. These date from the mid nineteenth century, and have only been found in fragments. A few twentieth-century ones from Cross Roads are known and some of them have the 'Verwood' mark used from 1948.

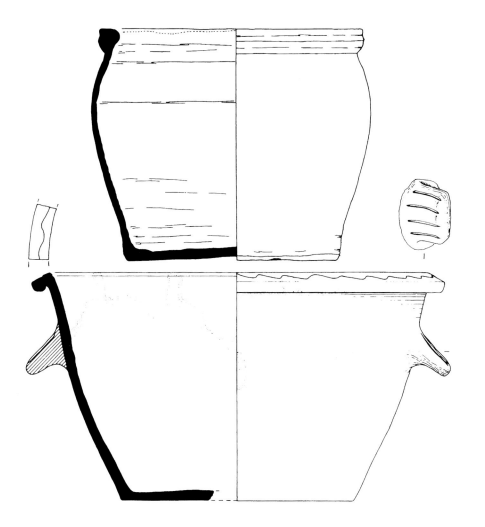

Bread bin or bushel (bottom) of about 1700 from Colliton Park, Dorchester; a very open shape, with a decorative incised line on the rim and two handles. The same form from Greyhound Yard, Dorchester, of about 1790 (top); it has a more rounded profile, and a rim suitable for a lid. The Colliton Park pot is glazed internally (edge indicated), varying from olive to orangey. On the rim and externally are blobs of dark brown glaze suggesting that it was fired with brownwares. Both at one-quarter life size.

Making and Decoration

Bread bins were the largest pots made at Verwood, and were the most difficult to produce because of their size. It needed 30–40lb (13.5–18kg) of wet clay to make one, and controlling this on the wheel required great skill and strength. The man powering the wheel had to get the speeds exactly right – faster for starting the throwing, slower for finishing the pot. At many potteries, it was difficult to take large vessels off the wheel because the potter was working alone – at Verwood, this was not a problem because there were always two people. Cross Roads had a set of especially wide boards on which to dry the bread bins. Some bread bins were decorated whilst on the wheel by running a clockwheel set in wooden handles round them, producing a band of rouletting. The bins had no handles, and were only glazed inside. The only decoration was incised or rouletted lines – these are very utilitarian pots.

Carrying fired pots back from the kiln about 1930; the man in the centre (George Brewer) carries four sizes of bread bin, neatly nested inside each other.

The Name

These big pots were intended for dry storage, as Marjorie Bailey recalled, most commonly bread. However, many of those who worked at Cross Roads and were interviewed in the 1970s refer to sets of bushel pans, which is a difficult idea because a bushel is a fixed volume, a measure, not another variable. The smallest 'bushel' seems to have been called a quart pan, another a peck (Arthur Bailey). Harold Ferrett remembered four or five sizes, but again only the same three names – bushel, peck and quart.

The bushel is an ancient measure of volume, used for dry goods like corn. Like all medieval 'standards' it varied in size from place to place. Dorset used the Winchester bushel, based on a standard container kept there, against which all others were calibrated. A bushel contained four pecks or eight gallons, because gallons were used for both liquid and dry measure. Only the very largest bread bins are as big as a real bushel, but the term came to be used for anything large. The usual bread bin is a half-bushel in capacity and only rare, very large ones would actually contain a bushel. The peck pans should be one-quarter of the size of the large bushel ones, but the pots do not seem to be so directly related in size. Gallon was not a term used for pots at Verwood – quart is the name for the smallest ones.

The pottery workers are united in remembering the three different names, but unfortunately they are also united in remembering that there were four or five different sizes, so one or two names are missing, unless they were called 'largish peck' or whatever. Photographs of Cross Roads show at least four different sizes together (*see* photo opposite). This would have been very convenient for firing as they could be stacked inside one another – making them all the same size would have required much more space in the kiln.

Lids for Bread Bins

Although some of the photographs of the yard at Cross Roads show large numbers of lids drying, they were nothing like so common as the bins. Wooden lids, or even just cloths, were often used. Pottery lids have a tendency to chip around the rim when in use, so wooden ones would last longer.

The lids in all the photographs of Cross Roads are rounded domes, but it is possible that Verwood also produced flat-topped bread bin lids. Several are found in local museums, having been used locally, but they are known to have been made at other kilns such as those in Oxfordshire that were supplying North Wiltshire.

A rather flattened-top Verwood bread bin lid is visible in the picture on page 154, but it has a round knob on top, rather than the strap handle found on most flat-top lids. The one in the photograph has a smaller flattened area than most lids of this type: it is a fine line between domed and flat lids. Flat-top lids are uncommon in Verwood fabric.

Uses of Bread Bins

Olive Philpott remembered life in Semley, Wiltshire, in the 1890s. The village was very short of water because there were no wells. Drinking water was brought to the village in milk churns and sold at a penny a bucket: 'Every house had great earthenware pitchers and tubs topped by covers of wood in which to keep the precious fluid. At rare intervals a man from far-off Verwood would come with his wares of earthenware pitchers and pans for needed replacements.' Water was particularly precious in Semley, but the containers were also used in houses that had their own wells, because the water was needed ready to hand in the kitchen, scullery or dairy.

Winifred Legg of Puddletown remembered three different uses of bushel pans in the earlier twentieth century:

> The bushel pan was used in the cottages, for drinking-water, with a wooden cover over the top and a jug to fill kettles or saucepans. Then there was the bread pan, covered with a cloth. A smaller pan was used by the men, to wash, and the water would stand on a box or backless chair, in what was then called the 'back house'.
>
> In hot weather the water would keep cold. Our 'bucket well' was 64 feet deep (the same depth as the height of the church tower) and then the water had to be carried uphill. The well served seven houses. We were well drilled not to waste water.

Marjorie Bailey recalled that her father made a few 'crocks' with no glaze to be used for wine-making, because people were conscious of the dangers of lead poisoning from the

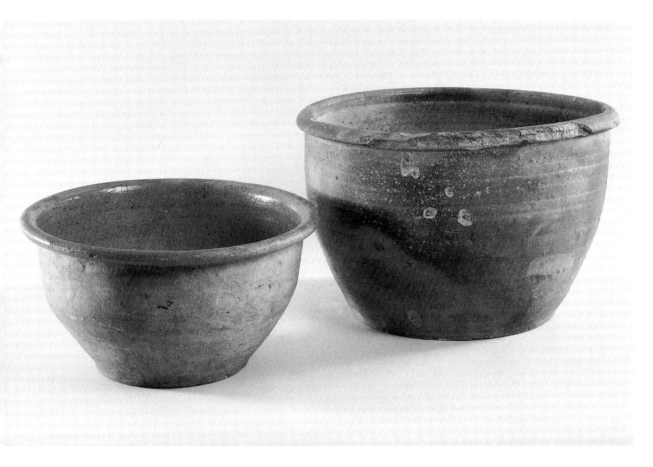

Typical bread bin shape (right), but with no glaze – made specifically for wine-making (Dorset County Museum, 315mm high). Some bins are more like large bowls because their sides are rounded and bases smaller than their tops. A few have rather more protruding rims like the one on the left (VDPT).

fruit acid on the lead glaze. Len Sims remembered that bushel pans cost 2s 6d (1993 interview).

The thick walls of the bread bins may seem excessive today, but storage of food before the Second World War was not just about keeping food clean, but keeping it safe from mice and rats. Earthenware bins would have been ideal for this, whereas wooden bins and sacks could be gnawed through. Both rats and mice spoil more than they eat by defecating into the flour or other food, and so were a serious menace.

Several museum collections contain smallish Verwood 'bread bins', which have been stained with isinglass, a kind of gelatin obtained from fish. These have been used to store eggs. In the past, chickens laid more eggs in the spring and summer, a natural cycle. Those who had their own hens, or those wanting to take advantage of cheaper prices, stored whole fresh eggs in a mixture of isinglass and water. They kept for six months, but extracting them from the slimy solution was an unpopular job. Pots that have been used for this purpose remain stained with the white isinglass apparently for ever.

Some very large bowls approach the huge size of the bread bins, but they are wider and shorter, with curved sides (*see* photo above).

Bins for storage are often obvious because they are some of the few forms where weight is an advantage rather than a fault. They are seldom moved, so weight does not matter, and thick walls make them more stable and less likely to break. When most things were cooked or baked at home, large quantities of flour or grain were

A big bread bin in a Dorset cottage garden about 1900, perhaps outside for a specific job like washing, but perhaps just parked.

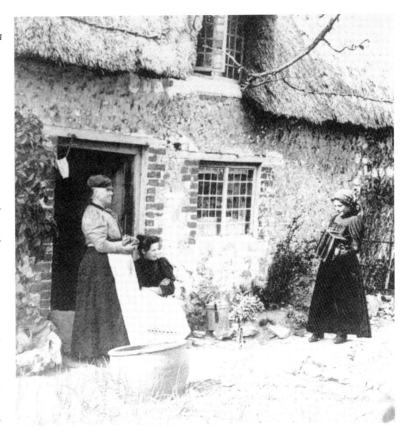

stored, along with other harvests like nuts. In Verwood itself and the surrounding parishes, nuts were an important part of the economy – coppicing hazel for hurdles also produced good crops of hazelnuts. Many of these were sold, but it is likely that some of the storage pots made at Verwood were used to keep home stores of nuts, because these had to be especially carefully protected against mice, who adore them.

Commercial bakers became more common in rural areas from the mid nineteenth century, and by 1895 there were 150 villages with bakers in the Directory. This must have reduced the need for storage somewhat, although nineteenth-century loaves were much larger

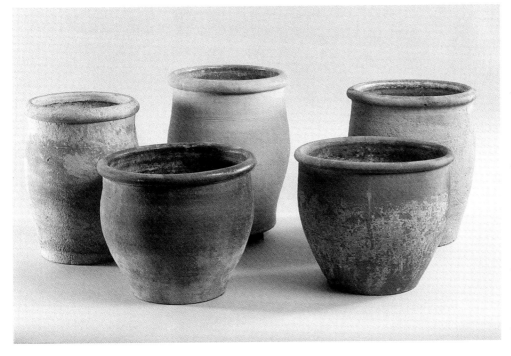

The smallest bins from Verwood are nearly as tall as the big ones, but very narrow. Many show traces of isinglass for egg preservation, and they may also have been used as creampots, as well as general storage. The smaller, wider pots are usually found with isinglass stains (three at the back, VDPT, 285–300mm high; two front, Dorset County Museum).

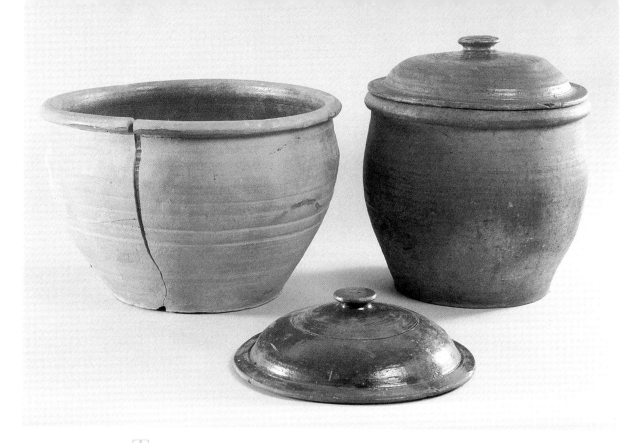

*T*ypical Verwood bread bin, with its matching domed lid (private collection, 316mm high without lid). The lids are rare finds archaeologically, whereas the bins turn up everywhere. This bread bin has a capacity of 5 gallons (19ltr) with space left, i.e., it contains half a bushel and a gallon. The very dark brown glaze on the separate lid is unusual, and it is probably a very late one (Ian Waterfield Collection). Left, bread bin from Bailey's kiln, Blackhill, found during the excavation of the mound in 1985 (see photo on page 65). It must have been thrown out when the kiln was unloaded because of the huge crack that appeared during firing (currently VDPT).

*T*wo marked bread bins, both having the impressed stamp 'Verwood', used only from c.1948–52. The left-hand one belonged to Len Sims, and unusually has glaze on the outside (VDPT). The other would be difficult to distinguish from earlier pots, except for the mark (Martin Green Collection, 274mm high).

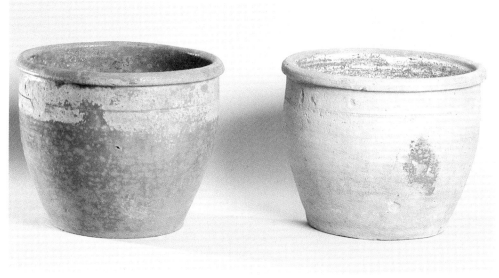

than modern ones. Also, many people were suspicious of the quality of bakers' bread. Mrs Bustle, wife of a farm labourer in Whitchurch, gave evidence to an enquiry in 1843:

> The bread we make at home is better than bakers' bread: I make six loaves out of a bushel of corn [i.e. the finished loaves weighed about 10–12lb/4.5–5.5kg each] we have not quite as much as that every week; but what we have, with a bag of potatoes (240lb), is quite as much as we consume at home. Four bakers' loaves, with the potatoes, are not enough. Bakers' bread does not satisfy the children; it is licked away in no time, and they are hungry all day long with it.

No wonder the Verwood bread bins were so large, with loaves weighing 10–12lb. Mrs Bustle was feeding two adults and five children aged twelve downwards on these massive loaves. She was making them from 'tailing corn', which was the small and poor quality corn often supplied to farm labourers by the farmers as part of their wages.

The Dairy – Butter and Cheese

Before the Second World War, virtually every farm had a dairy where butter and cheese were made. Even farms that did not have a commercial milking herd kept one or two cows to supply milk, butter and cheese for consumption at the farm, often with the surplus being sold in the village. Milking herds were small – when all milking was by hand, one person could only milk about ten to twelve cows. Before the mid nineteenth century there was very little sale of milk because it could not be sent quickly enough to the towns. The railways changed that, but before about 1850 cheese and butter were the main products from a dairy herd.

With every farmhouse having at least a small dairy, huge quantities of vessels for processing milk were needed. Many of them were made of wood or metal – dairies have to be kept very clean because milk goes off so quickly, and can taint everything. Glazed earthenware was a good material for many of the vessels, being easy to clean, but it broke more readily than wood or metal.

West Dorset in 1796 was described as from 'time immemorial, a Dairy District. Formerly its produce was cheese, made from the neat milk … nevertheless of late years its produce has been changed to butter for the London market, to which it is sent in tubs'. This interesting change had been caused by the high price butter fetched in London, and the good reputation of Dorset butter (William Marshall, *Rural Economy of the West of England* (1796)).

Butter-Making

Butter is made from cream, and Verwood made large shallow dishes called milk or cream pans, or sometimes pancheons, in which the milk was stored for twenty-four hours while the cream rose to the top. These Verwood cream pans are distinctive in shape – wider and shallower than those made at other potteries. They are relatively uncommon survivors as whole pots, and can be seen in only one of the photographs of pots drying in the yard at Cross Roads (*see* photo on page 75). They are some of the widest pots made at Verwood, and must have been difficult to throw. Large shallow cream pans, in shape just

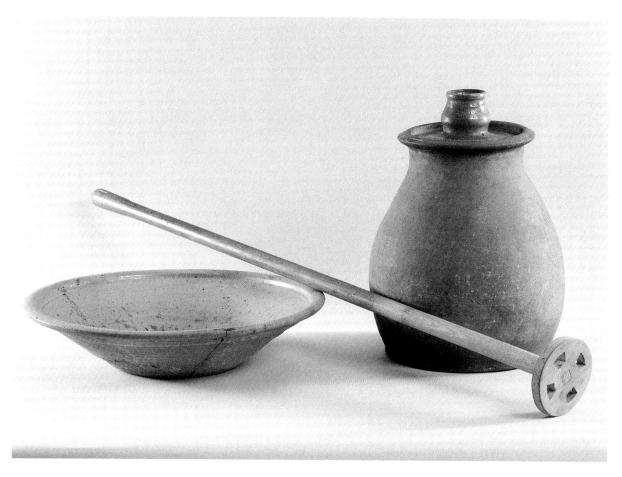

Cream or milkpan, used to separate cream. These Verwood pans are very wide and shallow (Dorset County Museum, 520mm across). On the right is the most complete Dorset plump to survive – still with its wooden handle and disc. This plain type is the most commonly seen – the bases are unglazed (Dorset County Museum, 383mm high).

like surviving examples, are found in many eighteenth- and nineteenth-century groups of pottery. They seem to change very little in style, and can only be dated by their surface finishes and glaze. They are uncommon amongst surviving pots because they were rivalled by wooden pails and big shallow metal dishes, particularly from the mid nineteenth century when butter production in Dorset increased. Freddy Sims' notebook has '3 milkpans 1s 9d' in 1907 – 7d each. Two are known, with a divider up the middle, cutting the useful area in half (Salisbury Museum), one broken from Blackhill, apparently with piercings on one side.

After the milk had been in the milk pan for twenty-four hours, the cream was skimmed off the top with wide, flat pierced metal skimmers, and the cream had to be stored until enough had accumulated to make butter. This could only be spread over two or three days or the cream would go off. Vessels were needed to store the cream, and in the north of England specific pots, like Ali Baba jars with lids, were made for the purpose. The small Verwood bread bins look very suitable for cream storage, and they are occasionally found with the lids that would have made them perfect for the job.

The most spectacular pot used in butter making is the Dorset Plump, a pottery butter churn. John Mowlem published a photograph of one in 1935 because he wanted to preserve their memory:

The plump or butter churn here illustrated would seem to have been in general use a generation or two ago; but already it is so little known as to be worth noting perhaps before it has passed out of remembrance altogether.

The example described was still in actual use in the parish of Corfe Castle about the year 1900. It consists of a pottery vessel 13 inches high and 13 inches in diameter, fitting with a lid, a central orifice which is carried upward forming a cup designed to catch the drippings from the plunger; the latter being a wooden rod attached at its lower end to a perforated disc of elm, operated by being worked up and down through the lid. From this pumping action it was called a plump. Wright's *Dialect Dictionary* 1903 gives: – 'Plumper, a kind of churn which is worked up and down.' Butter made in this way is claimed to have been of superior quality. The lid, except its edge and underside, is glazed with yellow lead glaze; and traces of this glaze still remain on the outside of the vessel.

A slightly larger plump measures 15 inches in height and 13 inches in diameter. Mr Mesech Sims, manager of the Cross Road Pottery, Verwood, Dorset, says that this kind of churn used to be made there.

The tops from the butter churns look very strange when detached from the base – like little pots set on a flat surround. The tops are glazed, sometimes only externally, sometimes overall, and the cup-like top catches the drips. The bases are all unglazed, presumably deliberately so that they could be soaked in water to keep the process cool, a great advantage in butter-making.

Although pretty, these plumps were hard work, so it is therefore inevitable that some people thought that better butter was made in them – old-fashioned traditional hard labour must produce a better product.

Mowlem found out that they had been made at Cross Roads, but they were produced by other kilns too. Freddy Sims' notebook has 'butter churn 1/6d' in January 1903. He sells 'churns' for 1s (1906) and another for 1s 6d in 1905. Presumably these two different prices are for two different sizes. Three out of the four surviving examples are very similar, suggesting perhaps that they were only made over a shortish time span. The sole surviving decorated base may be earlier, perhaps early nineteenth century.

In the seventeenth and eighteenth centuries butter was sent to market in huge pots which look like chimney pots but with a base on them. They were made at virtually every local pottery; Horton made them in the mid-seventeenth century, and a few have been found in excavations at Poole dating from the eighteenth century. No later ones are known, probably because they ceased to be made, butter then being sent to market in wooden or wicker tubs, which seems much more sensible – the pottery butter pots were very heavy.

Dr Robert Plot described the system in Staffordshire in 1677: 'the butter they buy of the pot of a long

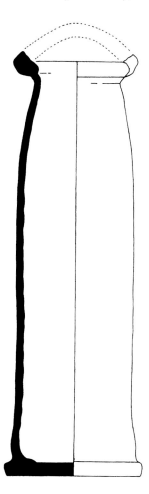

*B*utter pot from the mid seventeenth-century Horton kiln. It is 46cm high, and was glazed externally. Some from the kiln were glazed inside as well. They seem too well made to be simply packaging, but presumably they were used repeatedly by being returned to the dairies and went on being used until they broke.

cylindrical form, made at Burslem in this county of a certain size, so as not to weigh about six pounds at most, and yet to contain at least 14 pound of butter according to an Act of Parliament made about 14 or 16 years ago for regulating the abuses of this trade in the making of pots, and false packing of the butter'.

The 1662 statute suggests that dairymen were not very honest:

… And whereas by Custome time out of mind the Pott of Butter ought to weigh Twenty pounds viz Fourteen pounds of good and Merchantable Butter Neat and the Pott Six pounds And whereas great Complaint hath beene made by the Traders in Butter and Cheese That by

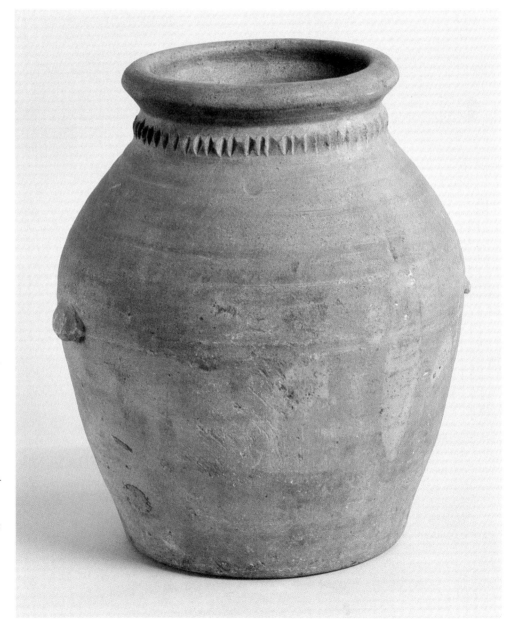

Butter churn base with decorated neck and small handles, the only one seen of this type. There are splashes of glaze externally, probably accidental. The decoration is similar to the 1807 ringer's jug (see photo on page 109), and so is the heavy potting and glaze colour. The churn may well be early nineteenth century (VDPT, 340mm high).

the fraudulent dealing and practice of several Farmers Owners and Packers of Butter and by theire irregular manner of weighing with Stones Iron Wedges Bricks and other unwarrantable Weights the same quantities of Butter are not put up into the respective Cask and Pots aforesaid … The Pots [are] made generally to weigh Seven pounds and some of them Eight pounds or Nine pounds weight and much bad and decayed Butter is mixed and packed up into Kinderkins Firkins and other Caske and Pots with sound and good Butter and immoderate quantities of Salt intermixed to the spoil of the same …

… from and after the First day of June which shall be in the Yeare of our Lord One thousand six hundred sixty and two … every Pot of Butter do and shall contain fourteen pounds Neat or above besides the weight of the Pott of good and merchantable Butter …

… Every Potter shall sett upon every Pott which he shall sell for packing up of Butter the just weight which shall be of every such Pott when it is burnt together with the first Letter of his or theire Christian name and his or theire Sirname at length.

The penalty for not putting his name on a butter pot was one shilling, from the potter, and two shillings for the farmer selling it, but, like so many seventeenth-century laws, this was ignored. If potters had put their names on, it would have helped much with identifying kilns.

The butter was packed into the pots with salt sprinkled between the layers to preserve it. A note of a bill survives from Creech Grange in Purbeck, Dorset for 1741: 'paid the dairyman for 13 doz of butter £4-11s and pots 1s 8d'. The butter pots were probably made at Verwood.

Pots were still used for storage of butter in small dairies after they had stopped putting butter into them for transport, and maybe the Verwood quarts were used for this, as well as for cream.

The inventory of John Gem of Gussage All Saints (5km to the west of Verwood) in 1735 includes: 'In the Dairy' a cheese press, a large trough '17 cheeses 24lb of butter in pot' and 'Earth Ware in the Dairy and Cheese vaults'. Much of the rest of the equipment was metal or even basket ('a butter basket'), or wooden 'three wood trayes & 2 dishes & woodden Cullinder'. He had five milch cows, plus one two-year heifer, two one-year heifers and two weaning calves when he died, supplying the milk to the dairy. Stored in the cheese loft were another eighteen cheeses, value 14s.

Cheese-Making

Marshall notes that the eighteenth-century cheese was made from 'neat', that is, whole milk. After butter production increased, needing the cream from the milk, this skimmed milk was used instead, totally changing the character of the cheese. Hand skimming left more cream in the milk than mechanical separators, which were commonly used from the late nineteenth century.

The skimmed milk was heated, often in a pottery vessel over the open fire along with pieces of calves' stomach, which provided the rennet needed to turn it into cheese. The eighteenth-century cook-pots with feet (pipkins) made at Verwood may have been used for this purpose, as may the small pecks or quart pans, although few of them show any evidence of sooting from fires.

Verwood certainly made pots for the next part of the process – draining the curd. Shallow bowls with holes pierced only in the base (unlike kitchen colanders, which have

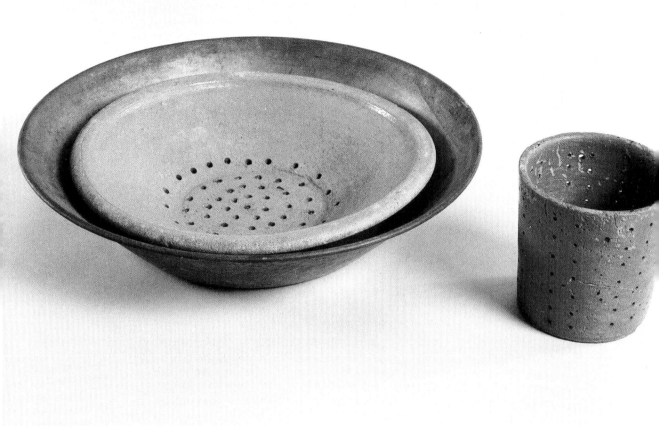

Verwood colander designed for draining the curd during cheese-making, still with its metal outer dish (Dorset County Museum, pot 361mm across). Draining pot for the next stage in the process of cheese-making, probably twentieth century (VDPT).

many more holes up the sides of the pots) are commonly found, and these were used to drain the curd. One example survives with a neat outer dish of metal to catch the whey, a nutritious clear liquid that was fed to pigs.

The rest of the equipment for cheese-making was wooden, including the moulds used to shape the cheeses. A single Verwood drainer for moulding the cheese survives, and it is probably 1930s. Only a small cheese could have been made in it. The famous Dorset Blue Vinney cheese was a by-product of butter-making, made from hand-skimmed milk which still contained enough butterfat to make a palatable cheese. It must have developed after Dorset became famous for its butter, and mechanical separation of cream and milk was its downfall.

10 Bowls, Chamber Pots and Garden Wares

Bowls and Pans

Pots with a wide mouth and short sides – bowls and pans – were produced by earthenware kilns from medieval times. They are divided from the bread bins and big bowls simply by size. These smaller ones tend to be called bowls if they have curved sides, pans if the sides are straight. Some of them, like the large milk pans (*see* 'Butter and Cheese' in the previous chapter), have a single function, but most of them were more generally useful. Larger bowls and pans were used for all sorts of washing – clothes, pots and pans and people. Raising bread dough and many other cooking jobs needed a bowl of some sort. In real life, there must have been much overlap between the bread bins and bowls. In the 1920s and 1930s Cross Roads made a specific jug and basin set for washing (*see* 'Chamber Pots' below), but up until then any bowl or bushel was used. The smaller bowls must have had dozens of uses in the kitchen and dairy, and they were made right up to the end of the industry in 1952.

The mid seventeenth-century kiln at Horton produced a huge variety of bowls and dishes, some with incised wavy lines on the rim and a few with a common seventeenth-century form of decoration, that of applied strips with finger impressions. Almost half the vessels found at Horton were bowls, pans or dishes.

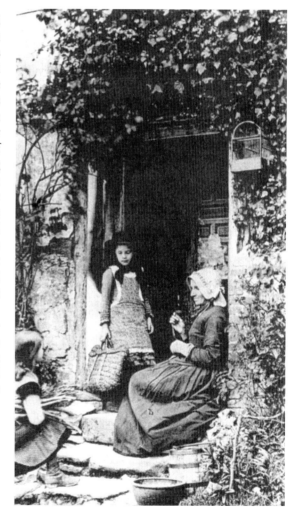

A Dorset cottage doorway about 1890 with an earthenware bowl, centre. The mother is sewing, the useful daughters hold a bundle of firewood and a plaited rush bag. The bowl will probably be needed for vegetable preparation later on.

A variety of bowls from the mid seventeenth-century kiln at Horton. The colander shape was also made without the piercings. Most of the bowls from Horton have straight or angled sides – there are no classic rounded-sided bowls. These seventeenth-century vessels have a distinctive glaze. At one-quarter life size.

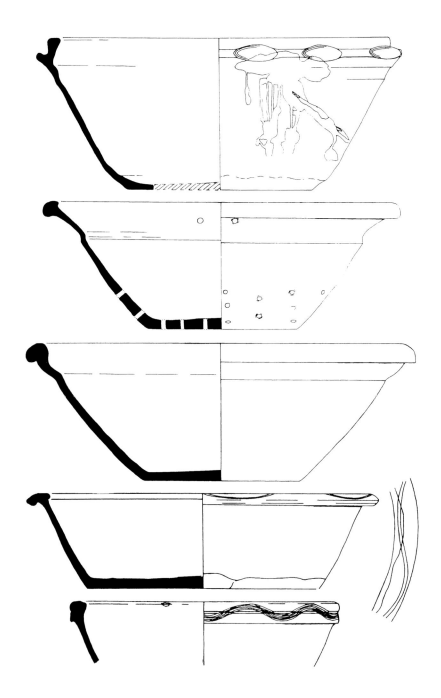

From the late seventeenth century Donyatt (Somerset) and other kilns were using slip extensively, and bowls decorated with slip become common finds in areas that had been supplied by Verwood, who must have been losing a large part of the bowl market to these attractive interlopers. Bowls and dishes, with their wide surfaces, were especially suited to slip decoration.

Archaeologically excavated pottery shows that Verwood went on producing plain bowls, dishes and pans throughout the eighteenth century, but in smaller numbers. One eighteenth-century bowl type from Verwood is very distinctive, looking like a resting octopus. The sides are filled with handles, and these are clearly display pieces rather than useful pots. They were probably for serving punch, if indeed they had any function at all. Only two are known, one with twelve handles (*see* photo below), the other with eight.

Handled bowls of the eighteenth century can be distinguished from chamber pots by their more open shape. Chamber pots are also commonly found in excavated cesspits because they were dropped in while being emptied, so they can be easily identified. Handled bowls must have been useful for shovelling out dry goods like flour from larger containers, and also simply as bowls. One hopes that there was clear distinction in the house between handled kitchen bowls and chamber pots, or perhaps they were simply stored in different places.

The few excavated pit groups of the nineteenth century all contain plain Verwood bowls and dishes, and it is clear from photographs of the kilns in the twentieth century that these continued in production. Alongside the traditional bowls, fancy versions were produced from the early twentieth century. Very pretty little unglazed bowls/vases with a crimped rim were made for Rivers Hill, the local perfumers, for pot-pourri, and these were also produced in larger sizes with glaze (*see* photo on page 159).

Kitchen colanders were made at Cross Roads in the twentieth century, and several survive, being neat bowls which differ from those used for cheese production because they are rounded in shape and pierced further up the sides. They are usually glazed overall, and one in Wimborne Museum has a glaze common from the 1940s. A few in varying shapes have been found in archaeological groups of the eighteenth century.

Shallow dishes were made all through the life of the industry, some looking just like flowerpot saucers, but glazed, while others, especially the later ones, were more complex. The only ones that can be dated are the later ones, distinctive by their glazes and shapes,

A range of bowls from Verwood. Front left, a handled bowl, probably twentieth century (VDPT); centre back, eighteenth-century with twelve decorative handles (Dorset County Museum, 232mm across); the other four were probably made by Herbert Bailey as they were given to the Dorset County Museum by his daughter. Most are robust kitchen bowls, some with more glaze than earlier bowls, and the fluted rimmed one (front right) is even glazed over the base, which has little triple lines left by the supports used in the kiln.

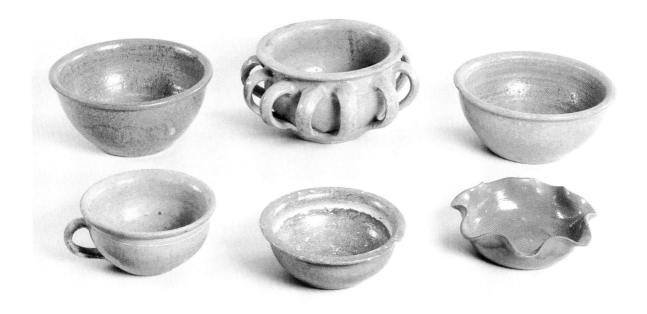

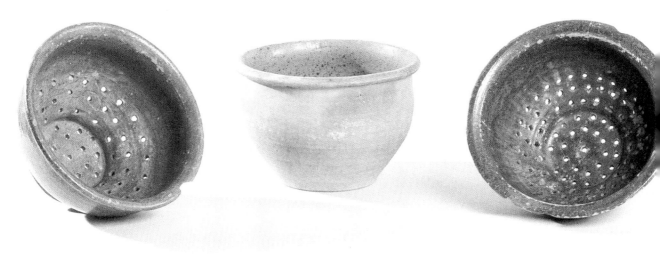

ABOVE:

*T*wo colanders, simply bowls with holes pierced in them. The one on the right belonged to Len Sims (VDPT). The other one and the plain bowl belonged to Marjorie Bailey (Dorset County Museum, colander 230mm across). All probably 1930s to 1952.

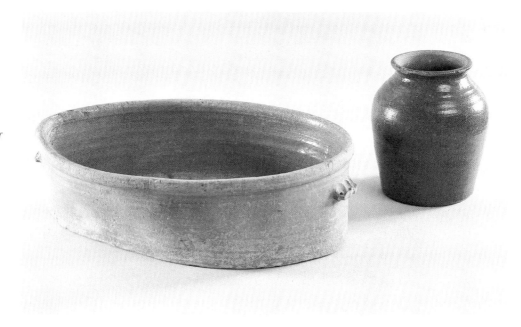

A rare Verwood ham pan, a long oval with a single handle at each end to help empty it. Close examination shows the joint between the sides and the base, which were made separately; probably nineteenth century. Pot for salting runner beans, bought at Cross Roads about 1943–44 (228mm high) (both VDPT).

and sometimes marked. When a reporter visited Cross Roads in 1937 'charming little dishes' were being produced.

One type of pan was very specialized and easy to identify if whole. Ham pans were largish oval pans designed for salting legs of pork to produce bacon or ham. The pork was soaked in brine in these pans for a month or more, and then dried and smoked in the chimney. More commonly, ham pans were made of wood. Earthenware, if not fired high enough, can be too porous for the job, losing much of its glaze through spalling. Ham pans are difficult to identify from fragments unless the oval end part is present. One found in an early nineteenth-century group at Shaftesbury has the corner, but has lost much of its glaze. Surviving whole ham pans are often misidentified as foot baths. These are virtually the only oval pots made at Verwood, and must have been made by throwing a round, bottomless pot on the wheel, and then reshaping it to fit the oval base. It is impossible to throw ovals on the wheel.

It is difficult to be certain exactly when Verwood was producing ham pans – certainly in the early nineteenth century, but probably much later too. These ham pans were specifically designed for salting, but doubtless other pans or bowls were used as well.

Chamber Pots, Stool Pans and Washing

Before main drainage, there were a great many vessels in pottery (and metal) for dealing with human waste. Lavatories consisted of wooden seats over deep pits, and these were out in the yard or garden, not attractive in the middle of the night, or when ill or aged. Every household had a chamber pot, or several, for liquids, and posher households had a commode for more solid waste.

Ceramic chamber pots are known from medieval times, but they become common in the seventeenth century. The mid seventeenth-century Horton pottery was making two different shapes, one of which has the sort of rim that could take a lid, which would be convenient when carrying them out to empty them. Many chamber pots are found in archaeological excavations, often from cesspits. Whole chamber pots are often found in cesspits – presumably they had been dropped in while they were being emptied, and no one wanted to fish them out.

Eighteenth-century Verwood chamber pots come in a great variety of shapes and finish – some are glazed all over, others only internally. Some are slightly conical, straight-sided vessels, others more curvy. Even early nineteenth-century groups show these two types, but it seems that the curved sort, looking like a bowl with a handle, was the only one made from the mid nineteenth century, since all surviving later chamber pots are of that shape.

Cross Roads went on making chamber pots, although they are not to be seen in many of the photographs of the kiln, possibly because they were thought to be indelicate. In the 1920s complete sets of bedroom ware were sold – jug and basin for washing, and matching chamber pot (*see* photo on page 165). The surviving pottery workers enjoyed telling researchers in the 1970s that chamber pots were made to measure, but actual examples are all much the same size. Marjorie Bailey remembered her father making chamber pots during the Second Word War, presumably because they were in short supply.

Chamber pots are easily recognized, but stool pans (commode liners) are less commonly acknowledged. They were used, like modern ones, inside a chair or stool-like

*T*wo mid seventeenth-century chamber pots (1 and 2) from the Horton kiln showing the two shapes made. The lid (3) (also from Horton) is the right size, and the rims are shaped to take a lid, but there is no proof that they go together. A deep and a shallow stool pan (4 and 5) from the Horton kiln, and a late eighteenth-century Verwood deep stool pan from Corfe Castle (6). Verwood earthenware lavatory pan (7) excavated at Abbotsbury, and probably dating from the mid to late nineteenth century. The water inlet pipe is drawn twice to show it in profile and side view. The missing lower part would have tapered to a central hole linked to the drain. All at one-quarter life size.

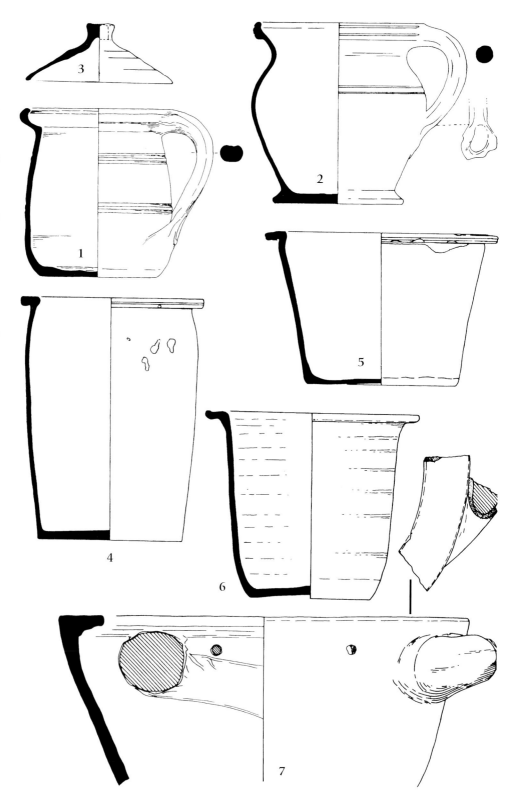

frame, and they have a pro-
truding rim to support them
in the frame. Verwood stool
pans are only known from
excavations, where they are a
common find. Horton made
them in the mid seventeenth
century, and they go on occur-
ring in archaeological groups
all through the eighteenth
century. By the nineteenth
century they seem not to have
been produced at Verwood,
and were probably replaced
by lighter industrial white-
wares. A price list for Brede

ABOVE:

Eighteenth-century chamber pot (left), glazed only inside (158mm high). Many similar vessels have been found at Southampton and Poole in archaeo-logical excavations, a few of them glazed overall. Found at Colliton Park, Dorchester, 1930s. The more rounded shape is common from the late eighteenth century, and twentieth-century examples are all of that shape. This one is probably nineteenth century (both Dorset County Museum).

Pottery, Sussex, of about 1840 lists 'stool pans' and 'chair pans', with the stool pans four times as expensive, and therefore larger. The one surviving commode liner (Verwood His-torical Society) is exactly like mid twentieth-century white earthenware ones, down to the short knobbed handle on either side.

An extraordinary Verwood earthenware lavatory was found in excavations at Abbots-bury. It is exactly like early nineteenth-century lavatory bowls made in Staffordshire, often with blue printed patterns. These go on being made through the nineteenth cen-tury for fitting into wooden lavatories. Like commode liners, these early lavatories were

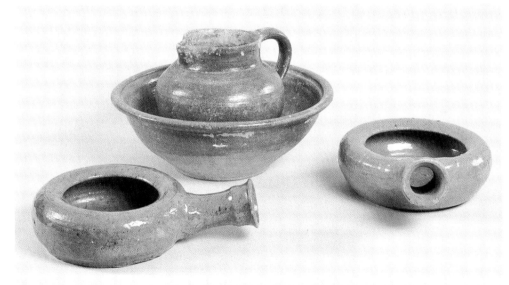

Jug and basin set for washing, both pieces covered with more glaze than usual Verwood jugs and bowls, probably 1920s (VDPT). Two bed pans, both glazed overall, even on the outside of the base. These are a rare form, and perhaps date from the 1940s (left, Peter Irvine Collection; right, Richard Percy Collection, 200mm across circular part).

supported in a wooden frame, so the pan did not take the weight. Earthenware was therefore feasible since it only supplied a waterproof lining. The Abbotsbury example, broken as it is, is the only Verwood lavatory yet discovered.

Bedpans are not common, but were made at Cross Roads from the eighteenth century. Wash bowls with matching jugs seem only to have been made at Verwood in the twentieth century – they have much more glaze than the usual jugs and bowls, and the jugs are a distinctive shape. Only a few survive; Staffordshire and other areas made huge quantities of attractive decorated jug and basin sets which were very cheap. Cross Roads would have found it difficult to compete with these.

One single example of a spittoon survives (Salisbury Museum), rescued from a dump near a pub at East Knowle, Wiltshire. They were commonly used in pubs in the late nineteenth and early twentieth century and Verwood probably made quite a few.

Flowerpots and Other Garden Wares

Pots intended for growing plants are easy to identify because they have holes in the bottom for drainage. Large decorated flowerpots were found in a mid eighteenth-century group at Poole, and seem to come from Verwood as their fabric is similar to known Verwood wares. They are all decorated but unglazed, and have a distinctive collared shape.

Three simple flowerpots from Verwood, the smaller ones cylindrical, the larger one with a pronounced rim. These belonged to Len Sims and must have been made at Cross Roads (VDPT, largest 120mm high).

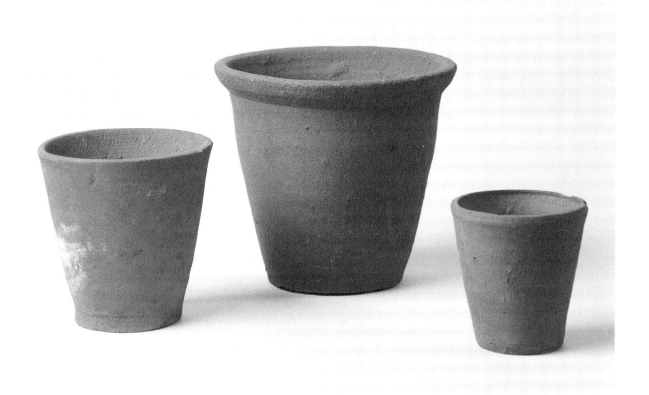

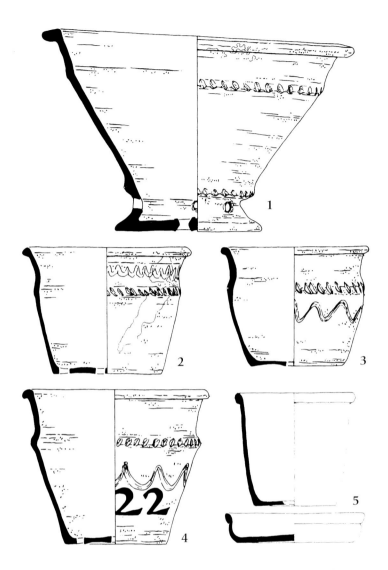

Big unglazed flowerpots from a mid eighteenth-century group excavated at Poole, their fabric matching contemporary glazed pots from Verwood (1–4), and a nineteenth-century flowerpot and saucer (5) from Dorchester, looking very like later ones. At one-quarter life size.

These are the earliest known from the area, but further afield big decorative flowerpots are known from the early seventeenth century.

The earliest simple flowerpots come from a big late eighteenth-century group from Dorchester – five flowerpots and two saucers were included, all unglazed apart from a few flecks and splashes. The pots are rather broader than flowerpots are today, had a small rolled rim and distinct throwing rings. The saucers look just like current plant saucers. A flowerpot and saucer from the Dorchester 1850 group look exactly like modern ones. It is difficult to date flowerpots, and since Verwood never marked them, it is difficult even to identify the local ones. It seems very likely that the excavated examples are from Verwood, and a few have been collected from people who worked there.

Freddy Sims' pottery at Monmouth Ash made many flowerpots in the late nineteenth and early twentieth century, and some are listed in his account books. For example, in March 1909 'Flower pots 6 cast 24 1½ cast 60 1 cast 48'. A cast was a potter's measure, roughly relating to a certain amount of clay, but also to the difficulty of making the pots.

At Fremington, Devon, a cast of small flowerpots (up to 4½in) was sixty pots, whereas for the 12in pots it was only six. If the Verwood sizes relate to those used later at Farnham, the flowerpots listed by Sims are small to medium sized. He charged between 1s 6d and 2s a cast for flowerpots. At Fremington before the First World War they reckoned that a good thrower could produce two casts an hour and would be paid 4½d per cast for the small size pots which were sixty to the cast. A good thrower could produce 1,000 flowerpots in a day.

Freddy Sims was also supplying 'saucers', to go with the flowerpots. For example: '3 doz 7″ saucers' in February 1909, and thirty dozen (no size given) later that year for £1 17s or 1s 3d a dozen.

Plain flowerpots seem to have been in great demand from the late nineteenth century, both for the gardens of big houses and for the increasing number of nurserymen. They went on being made at Cross Roads right to the end, and can be seen in the 1950 unloading photographs (*see* photos on page 79).

Fancy flowerpots were made in the twentieth century, some flattened to hang on a wall with attached watering saucers. A few had applied decoration in a contrasting colour clay (*see* photo on page 172).

Throwing big flowerpots at Cross Roads in 1927 – Harold Churchill turning the wheel for Herbert Bailey. Because they are plain and unglazed, flowerpots are under-appreciated.

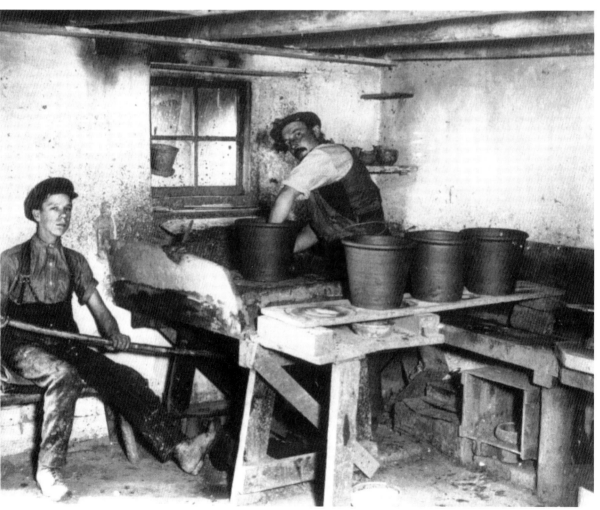

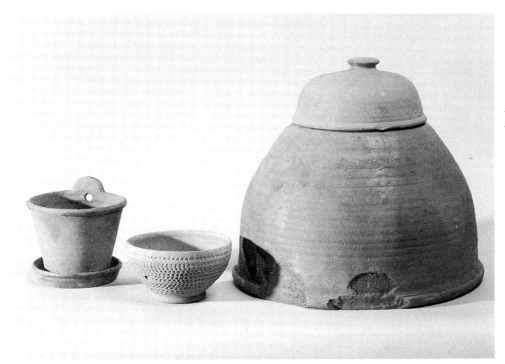

The big open-topped unglazed pots were used for forcing seakale or rhubarb (415mm high). The flowerpot with flattened back and attached saucer was bought from Cross Roads in the late 1950s (both Hampshire County Council Museums Service). Seakale pot lid (VDPT). The heavily rouletted bowl is marked 'Verwood' c.1948–52, and was probably for hyacinths (Dorset County Museum, 171mm across).

'Rustication' is a horrible form of decoration invented in the mid nineteenth century as a type of art ware. The surfaces of the pots were scored to make them look like bark, and in some potteries knobs were added to look like small branches that had been cut off. Mercifully, Verwood made very little rusticated ware – other potteries produced heavy tobacco jars as well as wall and floor pots which go up to very large sizes. At Verwood, they seem to have had too much respect for their beautifully thrown pots to rusticate them, and only a few garden pots and vases (*see* photo on page 168) were made in this style, often with matching stands. A couple of large pots, with several branches for plants, survive in Verwood and were probably made at Cross Roads.

One big rusticated flowerpot, probably from Seth Sims' kiln at Blackhill, has white slip used to make the knots of branches, a rare use of slip at Verwood. A big urn with a double pie-crust rim probably from the same source suggests that these were also made at Blackhill. A base with rouletted decoration also has prunts (applied clay decorations) with embossed flower heads, and was perhaps made at Cross Roads.

One grotesque-face wall pot for flowers comes from Marjorie Bailey's collection, and was probably made by her father, Herbert Bailey, as a one-off at Cross Roads. Another, less ugly, also survives. Most of the rusticated ware was probably made there.

Other Garden Wares

Pottery birdbaths on elegant stands were made in the 1920s (*see* photos on page 165 and overleaf), although one might have thought that pottery was rather breakable for this purpose. The tops look like large dishes; none seems to have survived.

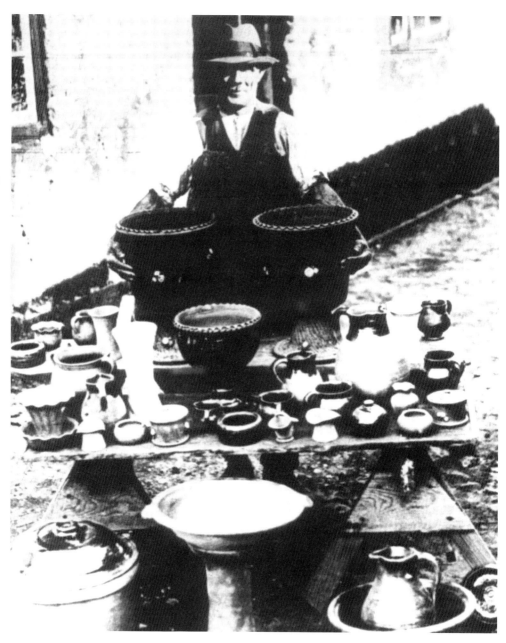

Mesheck Sims with his 'fancy' pots in 1938. The intricate pie-crust rims on the big flowerpots are distinctive. In the centre at the front is a birdbath on its stand, and to the right a jug and basin set. Third from right on the table is a money box.

Large pots for forcing rhubarb or seakale were also produced, as they were at many other potteries. The Verwood ones are unglazed and undecorated, but of an elegant, smooth shape. Those recorded are all the same, except for two large ones seen at Cranborne in the 1970s which had parallel sides and a flat top.

11 Jars, Vases and Decorative Wares

All seventeenth- and eighteenth-century groups of excavated pottery contain pots that archaeologists are reduced to calling 'jars'. These are tallish pots with no handles or lips, too thin or small to be storage jars, and often difficult to give a function to.

The mid seventeenth-century kiln at Horton made several types of jars, some of which have known functions because they are identical to tinglaze examples. The little ointment pots are designed to have a cover of paper or cloth tied over the top. Larger ones sometimes have indented rims to take lids (*see* drawing 5 on page 39).

It is more difficult to say what the larger jars of the seventeenth and eighteenth century were used for. Although they look like earlier cook-pots, they have never been found with sooting outside, which all cook-pots have because of being used on an open fire. They are small for storage jars, but possibly that is what they are.

Although it is tempting to see these jars (and indeed other pots whose function is unclear) as vases, they are not. Those making tin glaze, were producing vases from the seventeenth century, but these are easily identifiable. Earthenware vases do not exist until the nineteenth century, although doubtless any form with a hole in the top was called into service for flowers when required.

Until the mid to late nineteenth century Verwood made only useful pots – 'practical wares' as Lot Brewer, one of the hawkers, described them. All the kilns went on making useful pots until they closed, but probably all of the surviving kilns in the late nineteenth century made fancies too.

Wake Smart, a local historian writing in 1885, noted that at Verwood:

A new branch of the industry has of late years come into fashion requiring a more educated skill, consisting in the production of vases of a finer paste and finish which are sent to London to supply a demand which has sprung up in the Schools of Art for painting artistic designs on porcelain and earthenware. The ware made from this [Crendell] clay is found to be well adapted for the purpose.

A visitor to Bournemouth in 1893 saw 'a great assortment of rough unglazed vessels of quaint and curious shapes', which he was told 'were purchased by ladies for garden ornaments, and for decorating with Aspinall's Enamel and in other ways'. They were made at Verwood.

These quaint and curious vessels were unglazed, and needed to offer wide surfaces on which to paint. Surviving painted vessels of the 1880–1900 period are rare, although the

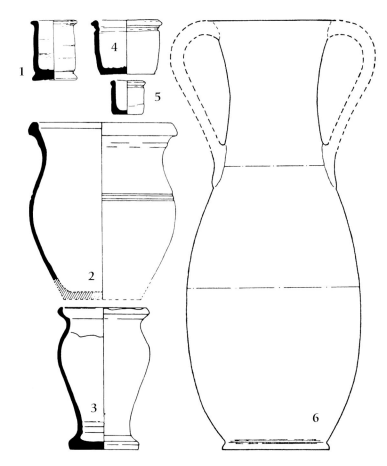

Jars (1–3) from the mid seventeenth-century Horton kiln: (1) tiny ointment pot; (3) lid-seated jar, and (2) a larger jar. Two ointment pots (4 and 5) are from a later seventeenth-century group from Greyhound Yard, Dorchester, and have pronounced grooves under the rim to help with tying a paper or cloth lid. Several of the larger jars have been found in excavated groups at Poole (all at one-quarter life size). The huge vase (6) is the largest ever made at Verwood, produced in the 1940s as a showpiece and is nearly 1m high (Dorset County Museum). One-eighth life size.

BELOW:

Large two-handled jars: right (with one handle broken off), probably late nineteenth century; second right, slightly different form; second left, one with handles with 'VP' below the handle, 1940s, and the 1948–52 equivalent, left, with the impressed 'Verwood' mark, given to Christ-church Museum in 1954 (324mm high). The right-hand jar has an extreme version of the crazed surface seen on several of the unglazed pots and a few glazed ones (left and right, Hampshire County Council Museum Service; second left, John Broomfield; second right, Richard Percy).

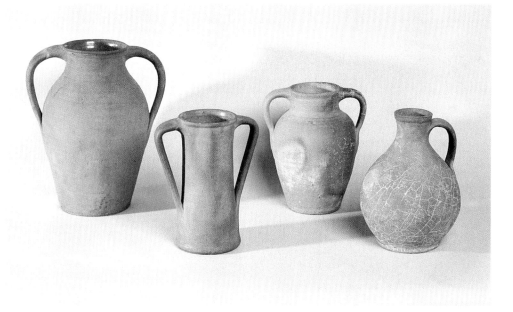

big vase (*see* below) may be of that date. The shape occurs in the 1909 photograph (*see* photo on page 163). Another painted pot which could be late nineteenth century is an extraordinary form – the top is identical to the common round costrels, but the body is elongated, presumably to provide a big surface for painting. Other surviving painted pots include ordinary (glazed) costrels and jugs, but it is possible that the three totally unglazed round costrels known were made to be painted – two of them have no incised lines at all which is uncommon, but would improve the area for painting. One unglazed jug and a strange unglazed jug with no handle may also have been intended for decorating with unfired paint, although it is, of course, possible that the potters just forgot to glaze the odd pot.

It seems very likely that the big two-handled vase was one of these 'fancy' pots in the 1880s. An unglazed one survives, and looks rather like the ones illustrated by 'Grandpa' in 1893 (*see* drawing on page 63). This form went on being made until 1952, but smaller versions are much commoner, both as surviving pots and in the photographs of Cross Roads. They are more appropriate for domestic flowers than the huge jars. In 1935, Herbert Fry can be seen fixing handles to these small vases (*see* photo on page 76). A photograph (Verwood Historical Society) of the late 1920s or early 1930s illustrates three or four sizes of the larger two-handled vases, all the same shape as those on the photograph opposite, second from right.

Left, a painted pair, with very similar decoration, purchased together. The jug is a normal one, but the costrel is unique, with an elongated body (Penny Copland-Griffiths Collection). The elegant shape of the jar (right) can be seen in 1909 (see photo on page 163). The painting could date from the 1890s (Graham Zebedee Collection, 413mm high).

Big earthenware jugs are commonly found in churches because their size and weight makes them perfect for large flower arrangements. The Cross Roads big two-handled vases were even better, and one of these was given to Christchurch Museum in 1954, having been bought at Cross Roads that year. The accession is annotated 'of the type that used to be made for the Priory Church' Christchurch. They must have been purchased by many churches, and one appears on the 1950 advertisement photograph (*see* page 172). Len Sims remembered that they cost three shillings.

Scented Pots – Costrels and Bricks

Miniature costrels made at Verwood from 1907 to hold lavender water or oil. The two unglazed ones, left, have the Liberty mark (see page 180). The glazed one, second right, is unusual. The perfume brick, firmly stating its purpose, was made at Cross Roads, 1920s (all VDPT except second from left, Richard Percy Collection, 100mm high).

In the early twentieth century, Cross Roads and other kilns were still making the rounded costrels which looked just like medieval ones, but from 1907 they also made a tiny 'toy' version.

In about 1906 a lavender farm was established at Corfe Mullen, to the south-west of Verwood, where the clay came from later in the century. The 65 acres (26ha) of lavender were grown by Rivers Hill and Company Limited of Broadstone, Dorset, Manufacturing Perfumers and Chemists. They were processed to make lavender oil and lavender water. Large areas of roses were grown for pot-pourri, and the disused church at Corfe Mullen served as a distillery. The company retailed much of its lavender water and employed local girls to weave raffia around glass bottles to contain it. Novelty perfume containers were very fashionable from about 1900. Rivers Hill also worked with Verwood potteries, and in 1907 a miniature costrel was registered as a design for a perfume container. Small bowls were also made, probably for pot-pourri, and both these forms are found with the registration number for the miniature costrel impressed on the base – the pottery does not seem to have appreciated that it was only legal on the costrel.

The registration number was 517683, 16 December 1907, submitted not by Cross Roads but by Rivers Hill. The miniature costrel was described as 'Scent Vase (for

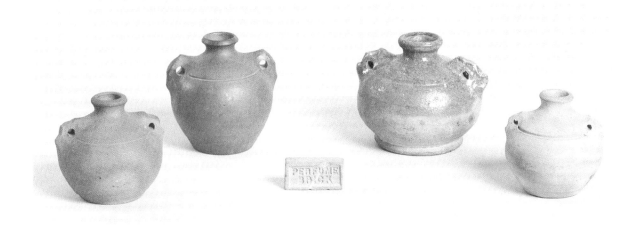

Suspending)', and it is a shock to see the drawing attached to the registration – two-thirds of it is taken up by a quadruple strand of cord, with a tassel one side, and only one-third by a rather odd-looking little costrel whose lugs have been finished as facets rather than pie-crust. The dozen perfume costrels surviving in collections do all have these facetted lugs, quite unlike those of the real costrels. Only three of the twelve are glazed; presumably it was intended that the lavender water should slowly evaporate through the porous sides of the unglazed ones.

They vary from 60–100mm high, with the extremes most likely representing two different sizes, but possibly three. One glazed miniature and five others are marked on the base with the circular stamp (*see* photo on page 180), showing that they were to be sold at Liberty in London. Four are unmarked, and one has 'Rivers, Hill & Co. Ltd Broadstone Dorset' incised on the base, handwritten. It perhaps dates from before the design was registered in 1907, as it would have been a lot easier and quicker to use the stamp. Two are known only from photographs and one of these is from Seth Sims' kiln at Blackhill, so it seems likely that the perfume costrels were made there, as well as at Cross Roads.

Cross Roads also produced many perfume bricks – tiny bricks that were impregnated with perfume to put in linen cupboards or wardrobes. They were probably produced from about 1906, when the Rivers Hill perfumery opened up. Marjorie Bailey remembered that her grandfather, Samuel Bailey, had made them at Cross Roads, and he retired in 1911.

George Brewer, who worked at Cross Roads from about 1911, remembered that it was Fred Fry who started production of the perfume bricks, which were made in a brass mould. George Sims recalled them being taken to Broadstone, presumably to be impregnated with perfume. According to Harold Ferret, they were made of fine clay, and many were sold in a china shop at Swanage; however, Len Sims claimed they were made from the same clay as the pots.

Len Sims remembered the brass mould used to make them, and that lots were produced, being fired inside pots. He recollected some going to Broadstone to be perfumed, and that they were still made in the 1920s. They are virtually indestructible, being well-

S mall bowls/vases with neat pie-crust rims. The one on the right has the Rivers Hills Co. Broadstone mark with the same registration number as the costrels (Richard Percy Collection, 60mm high). They were probably for pot-pourri. The one on the left has a late-looking glaze inside (John Broomfield Collection), and the one in the centre is the latest dated piece of Verwood pottery – with on the base the 'Verwood' stamp impressed and followed by 'Pottery/ School Visit/March 12 1951' incised (Mrs Fox).

fired, solid little rectangles. They are occasionally dug up in gardens, and a few have survived at Verwood and in museum collections.

Neat little bowls with a pie-crust rim were probably made for pot-pourri originally. Two have a similar stamp to the little perfume costrel, but with 'Rivers Hill & Co. Ltd Broadstone', quite wrongly as the registration number is specific to that form. They went on being produced right to the end – there is one on the 1950 advertisement (*see* photo on page 172), but the later ones are glazed.

Cross Roads was not the only pottery supplying Rivers Hill with pottery for their perfumes. Crown Dorset pottery at Poole made little conical bottles for perfume, as well as small discs and bricks to be impregnated with perfume. The Crown Dorset pottery moved to Honiton in 1918, but the Wessex Perfumery and Potteries continued making scented wares at Poole through the 1920s. They were at their most popular in the early 1920s as cheap souvenirs for the seaside resorts. The survey *The Rural Industries of England and Wales* (1927) disapproved of them:

> The scented ware which was being produced in considerably quantities in some of the Dorset potteries in 1921 was baked only once and not glazed. The vases were therefore porous and quite useless for holding water. Some were decorated with 'slip', others with oil-paint or transfers, and handles of plaited raffia were added. These ornaments could be produced very cheaply. The shapes were of a kind which a boy could quickly learn to throw and the single firing was a great economy. The ware achieved popularity not because of its hand-thrown character, nor, indeed, on account of any artistic merit, but because it was inexpensive and novel.

Verwood's scented wares were not of this cheap type – the little costrels were beautifully made, and as the marks on some of them demonstrate, they were intended for sale at Liberty in London, not as cheap seaside souvenirs.

Money Boxes

Very few Verwood pots have inscriptions or dates, but money boxes are the exceptions to this rule. Twenty-one have been recorded, and only eight of these are plain. The other thirteen all have inscriptions of some sort, and ten money pots have associations with named potters. Money boxes seem to have been the special pot chosen by the potters themselves to give as presents. Pans Brewer, one of the hawkers, was given one as a wedding present by Fred Sims. Inscribed ones were made for other people too. Len Sims remembered that they cost 9d, presumably for the usual small one.

Although they look just like money boxes made in the Farnham area in the seventeenth century, Verwood seems not to have made money boxes until the late nineteenth century. All surviving examples date from the late nineteenth century up to the 1940s. Only one money box occurs in photographs of Cross Roads (*see* photo on page 154, third from right on the table).

The commonest shape is the onion, with a fairly simple knob on top, and a horizontal slit for the money. Apart from the glaze, these are difficult to date. One with a band of slip on the knob and around the top of the body was made by Mesheck Sims about 1900 at Blackhill, and given to his wife as a present. It is very like the photograph opposite, right, but has '£ S d' incised under the slot, as well as the unusual slip.

One of the three-tier money boxes with '£ S d' hopefully inscribed beneath the three slots is also associated with Mesheck Sims, and is said to have been made by him about 1910 and given to his wife. An almost identical three-tier box was photographed in the 1970s, and is inscribed on the base 'B.P. Ferrett maker'. Benjamin Paul Ferrett was born in 1877 and is described as a potter aged fourteen in the 1891 census. Three plain three-tier money boxes are known, larger than these, one with a simple knob top (Wimborne Museum), one with a stepped conical finial (Verwood and District Potteries Trust), and fragments of another excavated at Mannington near Holt. These all have vertical slots. Three money boxes made by Mesheck Sims for three of his children survive. The most elaborate is for Eric V. Sims, who died when he was only eight months old. Owen Sims' was made the very day he was born, as the inscription on the base shows.

One onion-shaped money box was probably made at Fred Sims' pottery, Monmouth Ash (*see* photo on page 73), and it is possible that the rather squat ones with a vertical slot (*see* overleaf, top middle) were not made at Cross Roads, but at one of the other kilns still working in the late nineteenth/early twentieth century. Two of them have very rough surfaces not like any pots known from Cross Roads. A similar shape money box recorded in the 1960s is inscribed 'Albert Andrews' around the top. Albert Cecil Andrews (born 1866) was a ware dealer, not a potter, and was the son of Joseph Andrews, a potter in Verwood. It is not clear which kiln he worked at. It could have been made anywhere at Verwood. The money box made for Elenor Letitia Porter in 1899 is unusual for Verwood because the whole pot, even the bottom of the base, is glazed. It is surprisingly roughly made for a specially ordered piece, and again could have been made at any of the seven potteries still working in 1899. Another, very similar even down to the hole pierced in the knob, is inscribed 'Sept sixteenth 1898 Laur [ie or a] Fry' (Verwood Historical Society).

All the boxes mentioned so far are glazed, and have characteristics in common. The unglazed money boxes vary wildly, with only one pair matching. These two are the most

*L*eft, with a late glaze, probably 1940s, rouletted decoration. Centre, squat money box with a vertical slot, purchased second-hand in 1922. Two of this type are known, both with very rough, pimply glaze. They may be earlier than the other money boxes. Right, onion-shaped box inscribed 'Elenor Letitia Porter/Born April 24th 1887/ Made Verwood 24/8/89' (all Hampshire County Council Museums Service, small one, 64mm high).

elaborate, rusticated and with prunts (applied clay decorations). One simply says 'A Present from Verwood'; the other was made by Herbert Bailey at Cross Roads for his daughter Marjorie, and has her date of birth. Both probably date from the 1920s. Another is superficially similar, but in fact varies in all detail. The most complex money box has every type of decoration used at Cross Roads, and must have been made there. The sides are rusticated, the top a stepped cone, and the joint has neat pie crust. On top of this, it

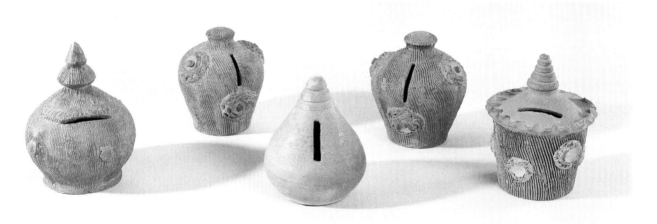

*U*nglazed money boxes. Left, with rustication and small prunts inscribed 'Hilda Mary Longman' on the base (Richard Percy Collection, 140mm high); second left and fourth left, two nearly identical boxes, one inscribed 'A Present from Verwood' on the shoulder (VDPT), and the other 'M.H.D. Bailey born 10.1.21' for Marjorie Bailey (Dorset County Museum). Third left, inscribed across the slot 'Herbert Bailey / Coronation / 1902' and on the base 'Verwood/Salisbury'. Herbert Bailey was the last potter at Cross Roads (Dorset County Museum). Right, an unusual shape, with rustication, pie-crust rim and white prunts (VDPT).

has prunts of white clay, an unusually sophisticated form of decoration used occasionally at Cross Roads. A wall flowerpot with these white prunts can be seen in the photograph below, second tier from the bottom, left. They are more effective when glazed.

One of the most elegant money boxes is an unusual conical shape, beautifully made and inscribed 'Herbert Bailey', one of several potters at Cross Roads when he made it in 1902, and the last potter, working alone from 1942–52. It is curious that the bottom of the box is inscribed 'Verwood, Salisbury', the only time this occurs. Salisbury is 23km from Verwood, and there are several towns closer.

Verwood's money boxes are quite restrained compared with those being made in Devon and at Donyatt in the late nineteenth century. Many of the Donyatt ones had little modelled birds on them, and the Devon ones had slip decoration and sometimes modelled figures too.

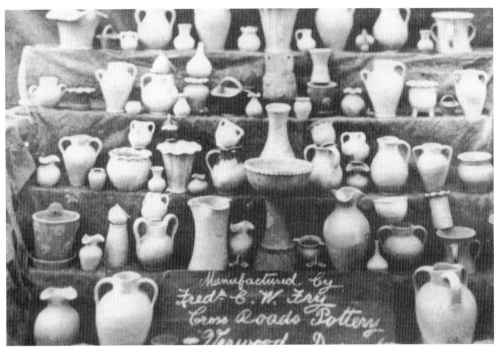

*F*red Fry's fancy pots in 1909, displayed at a fête in Cranborne. A couple of jugs (third rank from the top) are the only traditional forms, with the rest virtually all vases in innumerable shapes. The wall flowerpots left and right, second rank from the bottom, are elaborate and attractive. It is surprising that there are no money boxes.

Other Fancy Lines

Fred Fry, who took over Cross Roads about 1908, seems to have expanded the range of ornamental wares while still making the traditional ones. 'Fred Fry's Fancies' has irresistible alliteration, and it is clear that he made a good many ornamental wares. Very luckily, two photographs of these wares survive, and whilst these perhaps do not cover everything he made, an amazingly wide selection is shown.

The 1909 photograph (*see* above) shows seventy-five pots set up on a stand at a garden fête in Cranborne in 1909. With the exception of a couple of normal Verwood jugs, all the pots are decorative, with the vases ranging in size from massive two- or three-handled urns down to tinies. Some, like the vases and the posy baskets, are familiar from surviving pots, but others, such as the fluted vases and some with deliberately non-symmetrical handles, are not.

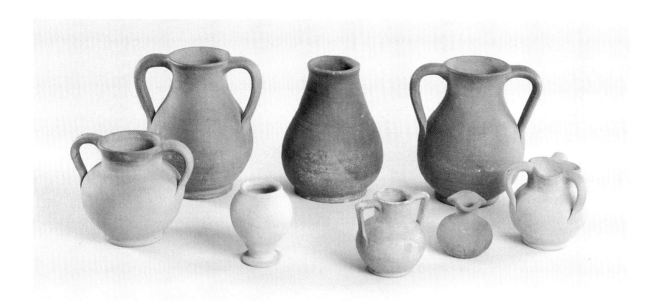

Small vases made at Cross Roads about 1908–25, when Fred Fry was master potter. Most of them have a vaguely classical look, especially the ones with two handles (all VDPT except second left front, Martin Green Collection; second and third right (front) and centre back (an unusual shape, 195mm high), which are Richard Percy Collection).

The 1912 photograph of Fred actually standing with his pots (*see* below) has only thirteen of them, but two forms are present which are not on the 1909 photograph – a rounded posy basket and a really strange pot with feet and handles which looks like a revival of a seventeenth-century type. A jug with unnecessary feet is the only pot to survive in this style.

Fred Fry sold Cross Roads in 1925, and the many photographs taken in the later 1920s and 1930s suggest that the range of fancies changed after that time. Big spill-shaped vases, ornamental flowerpots and the two-handled vases continued to be made (*see* photo opposite), but there seem to be fewer small vases, and less variety amongst them. The posy baskets went on being made, and candlesticks were produced possibly for the first time. Only four candlesticks are known, three identical to each other, and all like the common enamelled iron ones in shape. One has a little handle and no indents in the rim. They were being produced in 1937 when a reporter visited.

Fred Fry in 1912, with some of his fancy pots. All of them are vases, except the strange pot with feet that he is holding and a small jug on the left. The baskets (left) continued to be made until the end, as did the large and small two-handled vases. No example survives of the fluted vase on the right; two occur on the 1909 photograph.

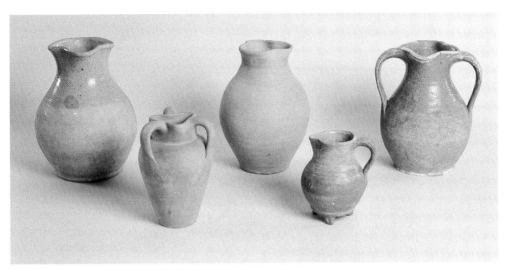

*S*econd from right, an extraordinary jug with feet, the only pot which is anything like the pot held by Fred Fry opposite. It may have been made by him (Julian Richards Collection). Large vases with triangular or four-lobed mouths: second left, unglazed triangular mouth, perhaps late nineteenth century (Graham Zebedee Collection); left, four-lobed and glazed, perhaps 1920s or 1930s (Michael & Polly Legg Collection, 265mm high); third left, unglazed but similar, late nineteenth or early twentieth century (Richard Percy Collection); right, four-lobed and handled, an unusual vessel, perhaps early twentieth-century (VDPT).

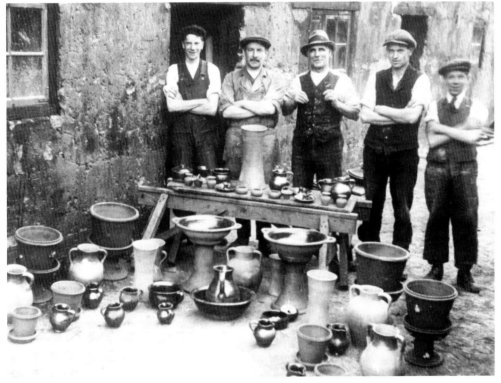

*T*he workers at Cross Roads in 1927, with their fancy wares. Left to right, R.J. (Jim) Scammell, Herbert Bailey, Mesheck Sims, Len Sims and Harold Churchill. The range of wares is different from Fred Fry's – more large pots, and most of them glazed. The jug and basin set (centre) with matching chamber pot may be a new venture. There are several big two-handled vases, and big spill-shaped ones. On the table are candlesticks, posy baskets, simple vases, a covered pot and several different jugs which seem to be glazed overall. The birdbaths (centre in front of the table) are only known from the 1927 photographs. This only shows the fancies – pans, pitchers and useful wares were still being made.

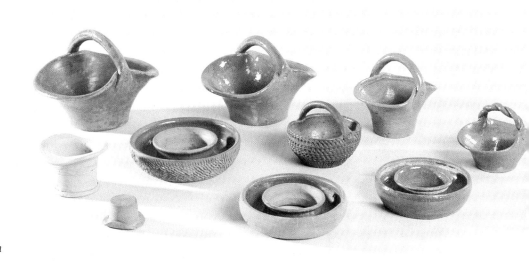

*N*ovelty pieces –
front left, two top
hats, which were
being made in 1917
because they are
shown on the film
(VDPT & Dorset
County Museum).
Back row: posy
baskets left and
second from left
marked 'Verwood'
c.1948–52; third
left, with rouletting
inside (all three
VDPT); right, a
unique example with
twisted handle, also
marked 'Verwood'
(Richard Percy
Collection); and in
the middle, painted
blue with rouletting
outside (VDPT,
78mm high
including handle).
Posy rings: centre
and right, marked
'Verwood' and
glazed overall (both
Dorset County
Museum, belonged
to Marjorie Bailey);
and left, rusticated
externally (VDPT).

Posy rings and posy baskets are some of the prettiest vases made at Verwood. The baskets were made from at least as early as 1909, as they are on the photograph of that date (*see* photo on page 163, second row from the top), and they went on being made into the 1950s (*see* photo on page 172, middle top). They had been made by industrial potteries in Staffordshire and elsewhere from the 1860s, and are an ideal shape for easy flower arranging. Several have the impressed 'Verwood' mark, and so date from after *c.*1948. All of them have little impressed circles with crosses inside on the handles where they join the pots, possibly imitating screwheads. A few have rouletted decoration inside the rim and one has a rope-twist handle.

A variant basket is only known from one example, and from the 1912 photograph. It actually looks more like a basket, with rouletting imitating the basketwork.

Posy rings are a classic 1920s' and 1930s' form, made by many of the Staffordshire potteries, and by earthenware kilns. Verwood produced a simple one that is sometimes only glazed inside, sometimes over the whole pot including the base, and is occasionally rusticated. Marked examples are known, and one is shown in the 1950 photograph (*see* page 172, leftish bottom row). They do not appear in the 1909 and 1912 photographs, and were probably made at Cross Roads from the 1920s.

Small covered pots may have been made to serve butter. Judging from that fact that there are only a few surviving, they were not made very often, and they only appear on one of the photographs (1927; *see* page 165). Only four are known, and three of them have the strangest decoration – chips of coloured industrial pottery embedded in the body and fired with the pot. One dates to 1902, as it commemorates the coronation of King Edward. Both have 'A Present from Verwood', but are rather different shapes. The only other pot known with inserted chips of pottery is a huge chimney-pot like object possibly intended as an umbrella stand, although there is no bottom inside; it may have been the base for a birdbath, as in the photograph on page 165. Behind each chip of pottery on the inside of this pot is the little bulge reflecting the push needed to set the chips. Although the five pots with this type of decoration are all rather different, they probably date from the same sort of time, most likely 1900–10.

*P*robably the most elaborate Verwood pot ever made, with chips of industrial china in bands, prunts of white clay with simple portraits of King and Queen and inscribed 'A Present from Verwood', 'God Save our King and Queen', 'Long live their Majesties King Edward and Queen Alexandra'. Presumably a coronation piece, 1902 (the Shearing family, 155mm across).

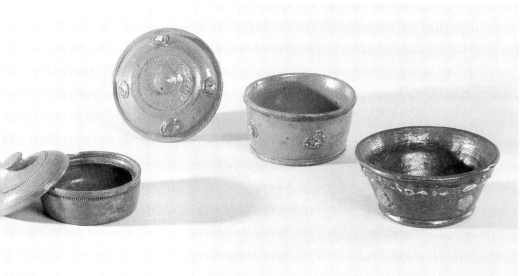

*C*overed pots, probably for butter. Left, plain, probably 1920s (private collection, 118mm across with lid); centre with rouletting and moulded prunts of clay with small sherds of industrial wares in each. Inscribed around the top 'Present from Verwood', perhaps 1900–1910 (VDPT); right, also with chips of industrial pottery; belonging to Maud Brewer, Len Sims' sister.

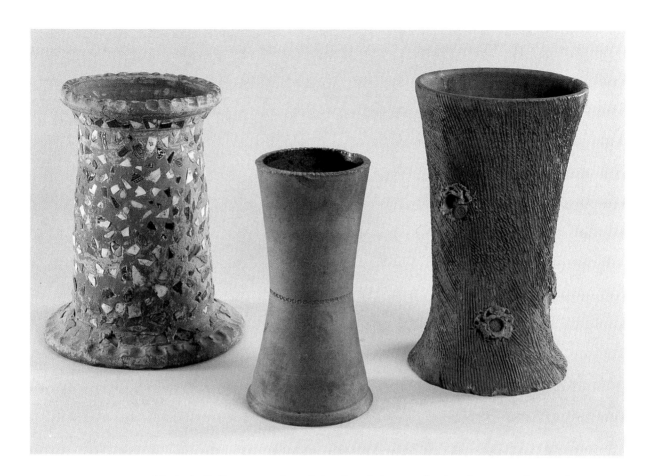

Big pot with chips of industrial pots and thumbed base and rim. It is hollow with no base (VDPT). Huge spill-shaped vases: centre, glazed inside and impressed lines on the rim (VDPT); right, unglazed with pale prunts and rustication (Dorset County Museum, 386mm high). These big vases are on the 1927 photograph (see photo on page 165).

Marjorie Bailey remembered that her father made chamber pots during the Second World War, presumably because there was a shortage. It is possible that most of the ashtrays, egg cups and mugs were also made in the war, again because they were in short supply. The surviving ashtrays all have four folds in the rim, and all are in late-looking glazes. Two are marked, and must have been made after about 1948. A single unmarked ashtray has rustication (unglazed) outside and another unfired painted flowers. The egg cups all look late as well.

Two styles of mugs were made at Cross Roads. The simpler ones (*see* photo on page 170, right) were certainly being made during the Second World War because three survive with inscriptions. One has '41st ANTI-TANK BATTERY R.A.' and the other two 'THE DIRTY DUCK/WASHFORD', one with 'BILL BATES' as well. Washford is near Watchet on the north Somerset coast, which seems a very long way for Verwood pottery to travel during the War, but perhaps the men of the Gun battery had been stationed in Dorset, or one of them came from Verwood. The mugs are just the same as plain ones known to come from Cross Roads.

A more elegant shape was made from the middle 1940s, and three of these mugs are known with the rare 'VP' mark that was occasionally used from about 1943. The same shape is illustrated in the advertisement of 1950 (*see* photo on page 172, top left).

In 1948 Gertie Gilham was asked to come to Cross Roads to set up a studio pottery, and although she worked separately using an electric wheel and electric kiln, her ideas

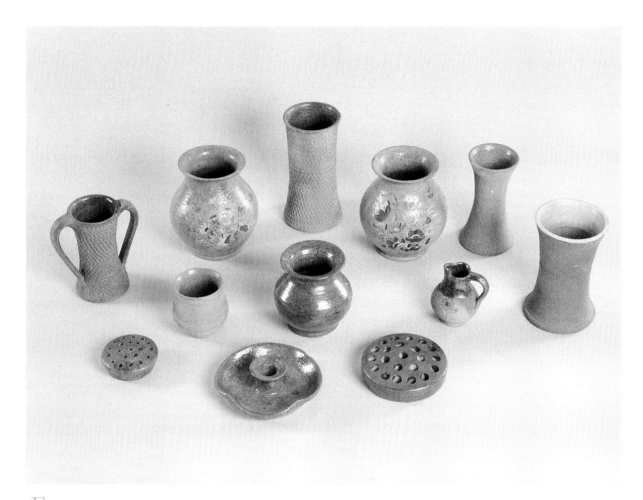

*F*ancy wares, 1920s to 1940s. Front: candlestick holder, probably 1930s (VDPT), flanked by two flower roses, perhaps 1940s (Dorset County Museum). Back row: handled vase, left, conical vase, third from left, and middle row, second from left, all glazed inside and rouletted over the whole outside, 1930s or 1940s (left, VDPT, belonged to Len Sims, other two Julian Richards Collection); vase, right, with odd white in the glaze probably 1940s (Richard Percy Collection, 166mm high); second right, vase (VDPT); plain vase, centre, probably 1940s (Graham Zebedee Collection). Back row: two vases painted with unfired colours, left, belonging to Mrs Maud Brewer, Len Sims' sister, and, right, belonged to Marjorie Bailey, Herbert Bailey's daughter. Both probably 1940s (150mm high). Second right, middle row, a small jug with a flower incised on one side, and on the base 'JS may 26 1926' probably referring to Jim Scammell who worked at Cross Roads as a boy. It may record the date he started work (Dorset County Museum).

and especially shapes may have influenced those made by Herbert Bailey, the last potter. Only one pot survives which was clearly made by Gertie Gilham – a beautifully thrown small jug, less than half the thickness of other Verwood pots, but marked with the Verwood stamp. It is black, and may have been fired in the main kiln when she persuaded the potters to fire to a higher temperature than usual (*see* page 100). A tiny replica of the usual Verwood jug is likely to be by Miss Gilham. It is only 78mm high and amazingly finely thrown. A tall coffee pot, slightly conical, with a big handle, simple lip and domed

Late useful wares, probably all 1940s. Front, two ashtrays: left, glazed overall and marked 'Verwood' (Dorset County Museum); right, glazed inside only (VDPT). Centre, two egg cups (VDPT & Ian Waterfield Collection); back left, mug (Dorset County Museum, belonged to Marjorie Bailey, 90mm high); casserole and lid which belonged to Len Sims (VDPT); third left, mug with 'VP' mark c.1943–8 (Dorset County Museum); and right, mug which belonged to Len Sims (VDPT).

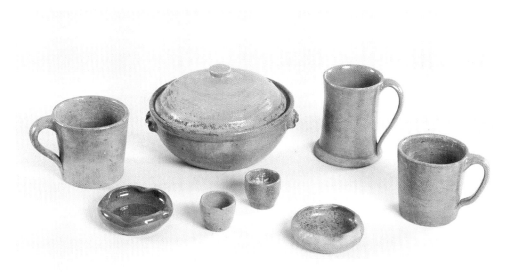

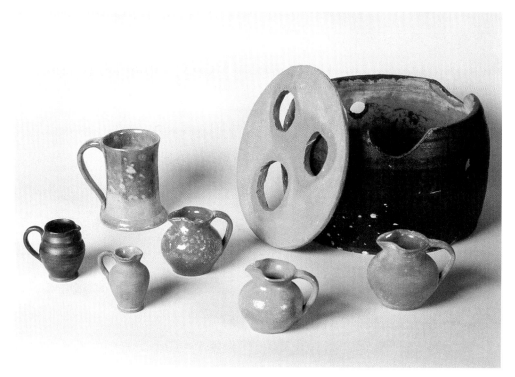

Late wares, all probably 1940s to 1952. Left, a very fine jug with black glaze marked 'Verwood' (Mr & Mrs Pope), and a tiny replica of a classic Verwood jug (Verwood Historical Society), both probably made by Miss Gilham, one of whose saggars (with lid) can be seen back right (Ian Waterfield Collection). The large mug (128mm high) is marked 'Verwood' (VDPT). The three low jugs: right, marked 'VP' and glazed inside only (Peter Irvine Collection); the other two glazed overall and marked 'Verwood', one with random white decoration, possibly slip (Verwood Historical Society, the other, Dorset County Museum).

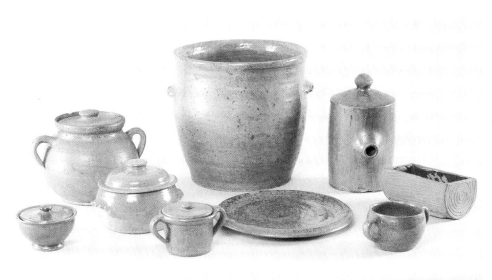

lid, was recorded in the 1970s by the Verwood & District Potteries Trust, and was then said to have been made by Miss Gilham. It has a dark tan glaze. Most of her output was sold to Heal's in London, so it is not surprising that so few have been found locally.

A type of elegant small jug in the usual earthenware fabric and glaze has been associated with Miss Gilham, but it seems likely that this was already being made before she came to Verwood, as one has the 'VP' mark used from *c*.1943. That one has no glaze externally (*see* photo opposite) and the handle merges into the body. All the rest of these jugs are marked 'Verwood' and have glaze externally, and mostly the tail of the handle is cut to a neat point. One is shown on the 1950 advertisement (*see* photo on page 172). Although many types of small jug were made from the 1920s, it seems that this one was only made from the 1940s. The shape is very like jugs made by the Fishley Hollands pottery at Clevedon, Somerset, from the 1920s.

Small bowls with handles seem to have been made from the 1940s, and although none are known with a mark, one is shown on the 1950 photograph (*see* photo on page 172, bottom right) sitting on a saucer. Two have lid-seating, and still have their lids. Two very unusual casseroles with lids belonged to Len Sims and another member of the Sims' family. A couple of the double-handled bowls are so high-fired that they almost look like stoneware.

Cross Roads also made flower roses, supports for flower stems to be put in vases or saucers. These are much more common in glass, and the Verwood ones probably date from the 1930s onwards, and were perhaps, like mugs and chamber pots, made because of wartime shortages.

Some forms that can be identified by their glazes as dating from the 1940s to 1952 survive as only single examples. A goblet, a big, glazed bell-shaped cheese-dish cover and a simple conical beaker are all in Christchurch Museum and were collected directly from Cross Roads. Various plates have survived. A jam pot, bread bin glazed inside and out, and a hot water bottle that belonged to Marjorie Bailey, may have been one-offs. The odd rusticated log (*see* photo above) is the only one known, although a big plain rectangular container was recorded in the 1970s.

The last advertisement for Verwood Pottery, published in May 1950, and showing only jugs from the traditional range of wares, although pans were still being produced. The two-handled jar, posy ring and basket, and the small vases were of types made from the 1920s. The mug is a new shape, as are the bowls and dishes. Although Cross Roads was using the Verwood mark by 1950, only a few of the pots made were marked, as there are many surviving examples of the pots shown here and only very few of them have marks.

Tea wares are the rarest types in Verwood earthenware, probably because their robust making methods were not really suitable for complex pots like teapots. Two teapots have been recorded in photographs, one rounded, one more necked. Both have handsome handles and horrible spouts. The rounded one has typical Verwood glaze inside, the other is glazed overall in the shiny brown glaze only found after *c.*1930. Seven tea cups and one saucer (Hampshire Museums Service) are known, probably dating from the 1940s. The cups are very clumsy, short things, with badly made handles.

Cross Roads was diversifying wildly towards the end, and some of the pots produced are frankly ugly, but these fancies were only a small proportion of the wares made even after 1945. Bread bins and jugs were still the staple products, and it is the diversity of the later fancies which leads to undue emphasis on them.

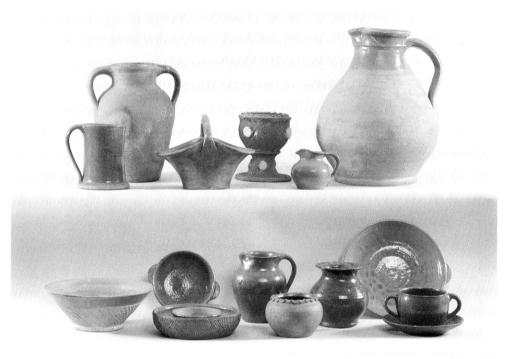

An attempt at reproducing the 1950 advertisement with surviving pots. Only the wall vase (top centre) is unknown, but some of the others are the wrong sizes. Front row: left, bowl with very stylish oblique lines (Mrs Maud Brewer); small dish and jug bought at Cross Roads 1943–4 (VDPT); posy ring marked 'Verwood' (Dorset County Museum); bowl/jar with pie-crust rim (John Broomfield Collection); glazed vase (Graham Zebedee Collection); right front row, dish marked 'Verwood' (VDPT); handled bowl (Julian Richards Collection), and saucer marked 'Verwood' (Mr & Mrs Pope Collection). Back row: mug marked 'VP' (Dorset County Museum); two-handled vase (Richard Percy Collection); posy basket marked 'Verwood' (VDPT); tiny flowerpot and stand which belonged to Len Sims (VDPT); small jug marked 'Verwood' (Dorset County Museum); and large jug (Graham Zebedee Collection).

12 The End of the Potteries

Enamel baths and that came in. Put a finish to the pottery.
Interview with Len Sims, 1993

The Verwood and district potteries were a surprisingly large industry. From the early eighteenth century up to the 1840s there were between twelve and seventeen different kilns working. In 1832, an estimate of how many people were employed in the potteries was made – the thirteen firms kept 325 people in work, not just potting but digging clay, cutting wood and selling the pots. It must have been one of the largest industries in Dorset in 1832, and indeed in the eighteenth century. Because the trade was spread over so many kilns and several parishes, it can never have been easy to see the full extent of it.

The kilns of the Verwood area went on producing plain but beautiful earthenwares all through the nineteenth century, with nobody noticing they were there. When people started collecting earthenwares in the late nineteenth century, they bought Verwood costrels thinking they were medieval, and no collector bothered to investigate their source.

In the twentieth century the surviving potteries, especially Cross Roads, the very last one, tried hard to attract visitors and customers, widening the range of forms made, welcoming groups and even advertising. Alongside these 'fancy' wares they still made age-old jugs and bread bins, using only ancient traditional methods and tools. The kiln was still fired with wood right to the end in 1952.

In 1902 Lawrence Binyon wrote:

Alas! The fine shapes that marked our old handicrafts have long ago disappeared; the domestic utensils and furniture that gave dignity by their fine simplicity of form and careful workmanship to country cottages have been driven out by dull products of cheapening commerce, things whose making gave no pleasure to those who made them, and whose use gives none to those who use them. Admirable specimens of our old crafts exist, but scattered about, and in remote places for the most part. It is to the old models that those who are now trying to reawaken beauty in the homely arts should turn for guidance. We need not reproduce old forms with servility, but if we wish to preserve an English character, we should look long and carefully at those works which bring down to us the tradition of those who wrought so well for our ancestors.

Binyon was writing about metalwork, but it was just as true for pottery. Happily, when studio potters started to show an interest in English earthenwares, they discovered Verwood still surviving as a real craft pottery, a living traditional kiln. Bernard Leach wrote:

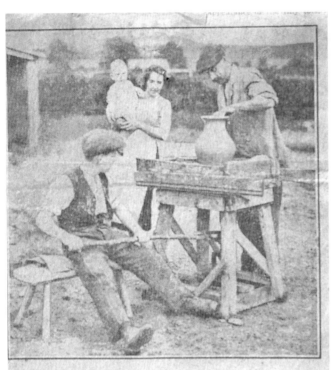

WHERE TIME HALTS.—No modern inventions are used by this potter on the eastern borders of Dorset; he plies his trade in the same crude way as his ancestors have done for 200 years.

*N*ewspaper cutting found in Bernard Leach's papers: Fred Fry throwing at Cross Roads, Verwood. The cutting probably dates from the early 1920s.

*O*ne of the earliest photographs of Cross Roads, in 1911, looking across the yard, with two lady visitors, left, Fred Fry, right, and five other pottery workers. Drying on boards are big bread bins and upside-down jugs with no handles.

When I returned to England [from Japan], in 1920 accompanied by Shoji Hamada our first endeavour was to search for what remained of the English tradition. Books, museums and surviving country potteries, such as Truro, Verwood and Fremington were our chief sources of material, and gradually by adapting our previous knowledge of Eastern methods to those of the English slip-ware potters and through many experiments, one difficulty after another was surmounted.

Len Sims, one of the last two workers at Cross Roads, remembered a potter, a gentleman, from Cornwall visiting Cross Roads in the early 1920s, but this may have been Michael Cardew, then working as an apprentice with Bernard Leach at St Ives in Cornwall. Cardew spent several days at Cross Roads, so is more likely to be remembered.

Cardew visited in the mid-1920s and realized that Verwood was 'one of the most primitive potteries to survive into the twentieth century'. He was astonished to see the clay still being 'tempered by a boy with bare feet

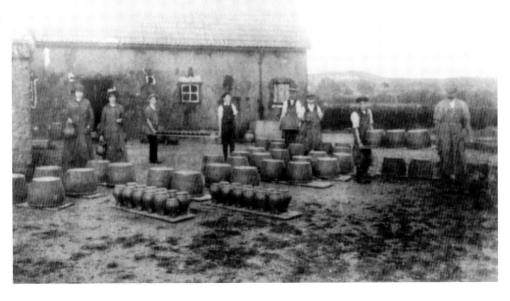

treading it out on a stone or cement floor', and to find them still using a single-flue, top-loaded kiln fired only with wood. 'Here they made the usual flowerpots and washing pans and also – this was its special recommendation in my eyes – pitchers of a very fine shape, much fatter than the Truro and Fremington pitchers, but, like them, free and generous in feeling.'

Cardew not only understood the methods being used, he admired their wares, and considered moving to Verwood to work alongside the Cross Roads' potters. He did not because he could not face firing his pots without the protection of saggars, and he felt he would have been 'a sort of cuckoo in this ancient nest'.

So Cross Roads, quietly working on in the traditional ways, had an effect on the two most important pioneer studio potters of the 1920s, and many other potters visited because Cardew or Leach told them about Verwood. Sadly, this appreciation by potters was not enough to preserve the industry.

Verwood did not make every earthenware form. In the late nineteenth and early twentieth century many kilns, especially those in the north, were making decorative lidded jars, sometimes with a big outer lid and an inner stopper-like lid for tobacco. These were made at Donyatt, Somerset, too, but Verwood never made them. Models, ranging from little cradles through rough figures, to whistles made in the shapes of

One of the seventeenth-century jugs from Horton, one of the earlier Verwood pots and one of the last, made by Herbert Bailey for his dog, Bonzo (Dorset County Museum).

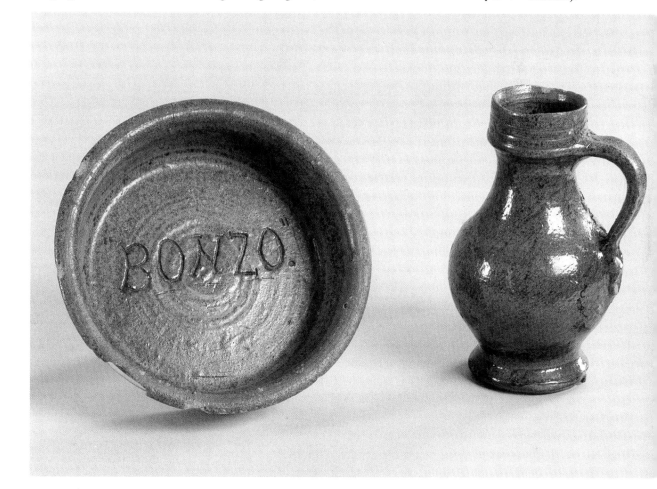

The throwing corner at Cross Roads about 1950, with Herbert Bailey throwing a jug and Len Sims providing the power.

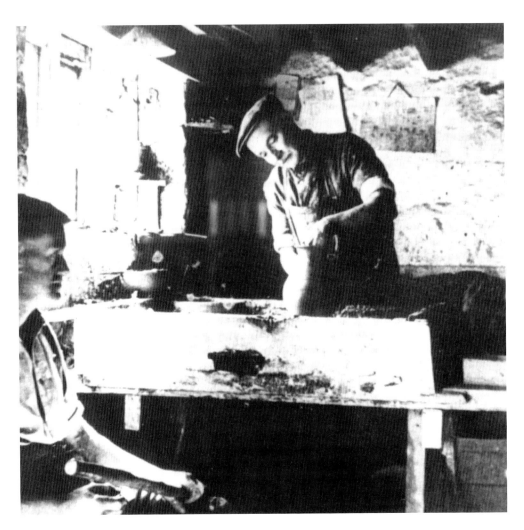

birds were produced at many earthenware kilns, but not at Verwood. Salt kits, hooded storage jars for salt, were made in the Midlands and North, but were not produced in the south of England.

Open dishes for baking were made at Fremington, Devon, and many other earthenware kilns, but those commonly found in Hampshire, Wiltshire and Dorset were made in the north-east of England, with simple slip decoration. Stew pots, barm pots for yeast (like jam jars), knife boxes (open trays like wooden ones) and tea canisters were not produced by Verwood. The big mugs known as paint pots or dipping pots were used in the area for holding paint (household paint) and probably for dipping flour and so on from bulk storage, but the pots were all produced in the Midlands or Devon. Shallow rounded bowls with a single handle like that shown on page 145 were made at Verwood and may have been used for paint but the taller, mug-like ones were not made at Verwood. Fareham (Hampshire) and other kilns made big strawberry pots, but Verwood did not. Generally, Verwood made fewer lids for pots than, for example, the Devon kilns or the Welsh ones.

From the nineteenth century onwards, it is not difficult to identify Verwood pots, with their distinctive shapes, fabric and glazes. What is more difficult is identifying accurately

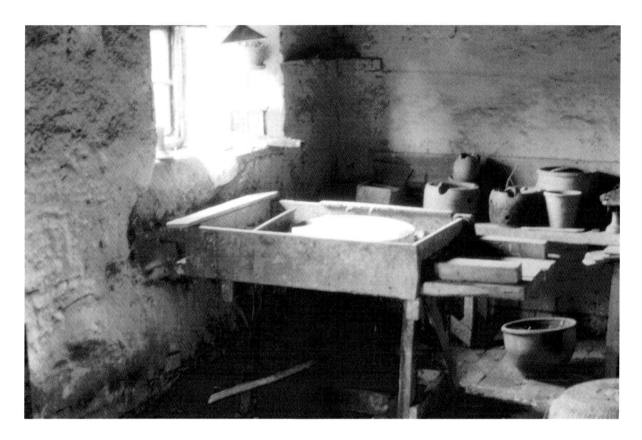

the other pots from kilns such as Fareham (Hants), the many Welsh kilns which supplied the south-west, or the Oxfordshire bread bins which are also commonly found in Hampshire, Dorset and Wiltshire. The many pots from the Donyatt, Somerset, kilns are easier to identify, partly because many of them have slip decoration and partly because so much has been published about them.

Further study of the pots, the kilns and the huge range of documentary evidence will improve our knowledge of Verwood and district potteries – this book is just the first attempt to draw some of the material together, and some conclusions here may well be proved wrong by further studies.

Where to See Verwood Pottery

The largest display currently is at The Curtis Museum, which has extensive ceramic galleries. Somerset County Museum has a huge collection of earthenwares, some of which can usually be found on display. The Dorset County Museum has some Verwood on display, as do the Salisbury and South Wiltshire Museum, The Priest's House Museum, Poole Museums, and Red House Museum. *See* the Useful Addresses section for details of these museums. The museum at Corfe, Dorset, and other museums, have small numbers of pots. The Verwood Historical Society Collection is held by Verwood Town Council.

The same corner in the mid 1960s, photographed by David Algar. The wheel looks usable even though deserted for more than ten years, the crank handle lying idle. Right foreground is the iron stove, and right background the weighing scales. Several pots are on the floor or shelf, along with two big saggars (the pierced pots), which had been used by Gertie Gilham. The black one is probably the one in the photograph on page 170.

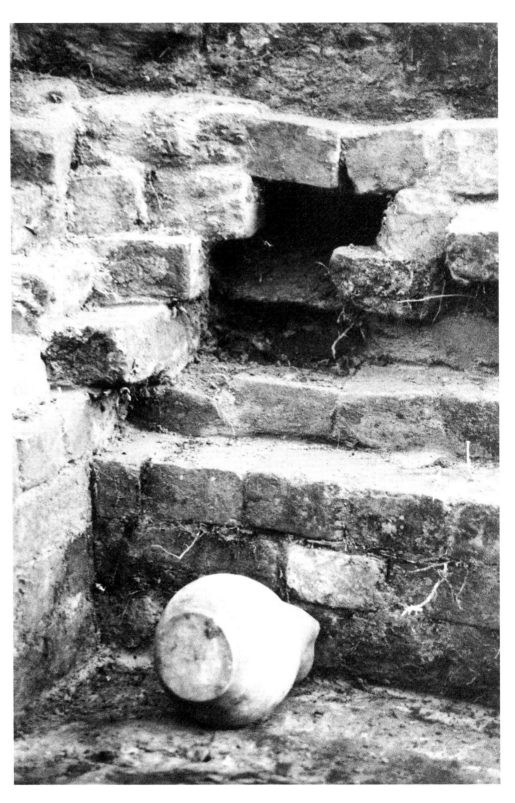

The excavated kiln at Bailey's, Blackhill, Verwood, with one of its products, a jug, lying on the brickwork. This was found underneath the oven where the lead was melted, possibly a deliberate ceremonial burial.

Pots Recorded

This book is based on the recording of 1,000 Verwood pots held in museum and private collections. They have all been examined, measured and photographed, with the information processed on a dedicated recording sheet. Copies of all these records are with the Verwood and District Potteries Trust and the Dorset County Museum. This sample is probably skewed in several ways – collectors have only acquired what they know to be made at Verwood, and most prefer the traditional pots. The 'fancies', judging from the photographs taken at Cross Roads, are under-represented. Most of the earlier pots are in museums, partly because they were collecting earlier, and partly because of their archaeological material. No museum has set out deliberately to collect Verwood: this has been done by the Verwood and District Potteries Trust since 1985, and it currently has 200 pots in its collection, the largest in existence. This collection can be seen by appointment.

About 450 of the pots recorded are in museums, 200 belong to Verwood & District Potteries Trust and the remaining 350 are in private collections.

Two hundred and sixty-two pots are jugs, 210 of them 'classic' Verwood jugs, while the others mostly twentieth-century fancy shapes, ranging from small glazed jugs to large glazed ones for jug and basin sets. One hundred and seven costrels include nine in uncommon shapes, and ninety-eight Verwood owls or pills. Eighty-two bread bins include large down to the smallest size, the quart. Only one lid for a quart has been recorded, and only nine for other sizes. No lid large enough for the full bushel bread bin has been seen. There are thirty-three flagons and thirteen chamber pots.

Bowls, dishes, colanders and cream pans total 117, including eleven colanders and nine cream pans. The fifty-six vases are mostly twentieth century, and there are sixteen posy baskets, twelve posy rings, twenty-one money boxes, eleven ashtrays, twelve mugs and fourteen egg cups.

Types of pottery where there are fewer than ten examples are not listed here, but are generally mentioned in the main text. Sixty-nine pots that were not made at Verwood have been recorded.

Marks

Only a tiny percentage of Verwood pottery was marked, and most of this dates from the 1940s to 1952. The difficult-to-spot 'VP', for Verwood Potteries, seems to have been introduced about 1943 when Cross Roads reopened after a short closure. Apart from the few pots with this mark, the only reference to it is in a newspaper article of 1950, which winsomely asks: 'Have you any Verwood pottery in your home? It would be difficult to say, for unfortunately it is only recently that the distinguishing words have been stamped on the base of the craftsman's produce [he means the Verwood stamp]. For a few years previously, however, the letters were only stamped. Perhaps you may be in luck and find the inscription – VP' (*Wimborne and District News*, 27 May 1950).

The article confirms the date suggested by Len Sims and Marjorie Bailey for the Verwood stamp, which they said was used from about 1948. No one asked them about the VP mark. Only four forms have been recorded with the VP stamp: a single 'classic' jug (*see* photo on page 106); a small milk jug (*see* photo on page 170); a two-handled vase,

with the mark below one handle (*see* photo on page 156); and the waisted mug (*see* photo on page 170, top). Three of the mugs have been recorded with the mark, but only single examples of the others, six pots in all.

The Verwood stamp is found on many more pots, and on a much wider range of forms, from bread bins to small jugs. In all, forty-seven pots with this mark have been recorded: nine small milk jugs (*see* photo on page 170, bottom); eight posy baskets (*see* photo on page 166); four large jugs (*see* photo on page 108); four ashtrays (*see* photo on page 170, top);

M arks, here and opposite page: small costrel with impressed mark 'LIBERTY LONDON Rd No 517686' (Richard Percy Collection, c.37mm across).

three small jugs; two posy rings (*see* photo on page 166); two bread bins (*see* photo on page 136); two wall vases; one large two-handled vase (*see* photo on page 156); a small vase (as photo on page 169); a bowl with rouletting over the outside (*see* photo on page 153); a tiny and fine black jug (*see* photo on page 170); a classic jug (*see* photo on page 106); a large jug (*see* photo on page 108); a small pot dated 1951 (*see* photo on page 159); one dish and one saucer (*see* photo on page 172); a little rustic log container (*see* photo on page 171); and three mugs like the ones marked 'VP' (*see* photo on page 170, top).

*Vase/bowl
impressed mark
'RIVERS HILL & Co
Ltd BROADSTONE
Rd No 517683'
(Richard Percy
Collection, c.37mm
across).*

*Very clear 'VP'
(13mm across),
1943–48, on a
classic jug (Julian
Richards Collection).*

Marks: 'Verwood' (33mm across), c.1948–52, on a dish (VDPT).

Two types of jug and the mug are the only forms found which are identical with either the VP or the Verwood mark. The two-handled vases with the two marks are of very different shapes. Conversely, many forms which are known to be late either because of their glaze, or because they appear in the 1950 advertisement, have been recorded but are not marked.

Some earlier twentieth-century pots were marked, not with the name of the pottery but Rivers Hill, the name of the perfume manufacturers, or Liberty, the London shop where the pots, full of lavender water or pot-pourri, were sold. Five tiny costrels (*see* photo on page 158) have the impressed mark 'LIBERTY LONDON Rd No 517683'. The registration number was issued on 16 December 1907, 'a scent vase for suspending'. Two small pots, probably for pot-pourri (*see* photo on page 159) have RIVERS HILL & Co LTD BROADSTONE around the same registration number, which should only have been used for the costrel, as that was the registered shape. The Rivers Hill mark has not yet been recorded on a costrel, but it is likely that it was used on them.

The only nineteenth-century mark is the rouletted band with 'R Shering' found on several bread bins and a storage jar (*see* page 60). Inscriptions occur on pots ranging from the 1807 ringer's jug (*see* page 109) up to a little pot of 1951 (*see* page 159). These sometimes include the place name Verwood, or the name of the potter. Most of the inscriptions are people's names, especially on money boxes, and some are national celebrations like the 1902 coronation. Seven pots, ranging in date from 1805 to 1926, have potters' names inscribed on them, sometimes with 'maker' included.

Bibliography

CHAPTER 1 – INTRODUCTION

Evening Standard, 12 May 1938

The Graphic, 4 September 1926

David Algar, Anthony Light and Penny Copland-Griffiths, *Verwood and District Potteries* (1979, new edition 1987)

Michael Cardew, *A Pioneer Potter* (1988)

T.P. Kendrick, 'The Verwood Pottery', *Pottery Quarterly* (1979), pp. 127–31, pls 4–6

John Musty, 'Note on Post-Medieval kiln sites supplying the Salisbury Area' in *Wiltshire Archaeological and Natural History Magazine*, vol. 63 (1968), pp. 51–3

J. Sims' thesis *Heath Potters in the Cranborne District*, has never been published, but there is a typescript in the Dorset Record Office

Donald Young, 'The Verwood Potteries' in *Proceedings of the Dorset Natural History & Archaeological Society*, vol. 101 (1979), pp. 103–20

CHAPTER 2 – THE PLACE – HEATHLANDS AND WOODS

The Inquisition of 1698 is Dorset Record Office reference D/BKC/CF/1/3/1/46

Pam Bailey, *Grampy: Sidney Frampton of Holtwood* (1983) (cob building)

William Chafyn, *Anecdotes of Cranborne Chase* (1818)

W. Densham and J. Ogle, *The Story of the Congregational Churches of Dorset* (1899) (Cripplestyle and Three Legged Cross)

Copy of H.C. Fryer letter (1920) in Verwood and District Potteries Trust archives

Desmond Hawkins, *Cranborne Chase* (1980)

Myldride Humble-Smith, 'Making Brooms by Hand', *Bournemouth Echo* (undated cutting in Dorset County Library *c.*1937)

John Hutchins, *History … of Dorset* (1774)

Helen Jones, 'Hand Made Brooms', *Dorset Yearbook* (1938), p. 98

Oliver Rackham, *The History of the Countryside* (1986) (parks, forests, trees etc.)

William Stevenson, *General View of the Agriculture in the County of Dorset* (1815) (Uddens Park reclamation)

Heywood Sumner, *The New Forest* (1924), pp. 66–8 (cob building)

T.W. Wake Smart, *Chronicle of Cranborne Chase* (1841) annotated copy in Dorset County Museum (Daniel Sims, smuggler)

P.J.K. Warren, 'The story of Holt Church and Holt Forest, Wimborne', *Proceedings of the Dorset Natural History & Archaeological Society*, vol. 88 (1966), pp.188–202

Ralph Wightman, *The Wessex Heathland* (1953)

J.D. Wilson, 'The Medieval deer-parks of Dorset X III', *Proceedings of the Dorset Natural History & Archaeological Society*, vol. 96 (1974), pp. 48–9 (Alderholt deer park)

CHAPTER 3 – THE START OF THE KILNS

The Cranborne Court records are at Hatfield, and give all the clay digging and lease references. Elias Talbot's will is preserved in a copy at the Public Record Office; all the other wills and inventories mentioned are in the Dorset Record Office.

Excavations in Dorchester Volume 1 (DNHAS monograph 2, 1982) (medieval pots)

Excavations at Greyhound Yard, Dorchester 1981–4 (DNHAS monograph 12, 1993) (the Dorchester groups)

Proceedings of the Dorset Natural History & Archaeological Society, vol. 114 (1992), p. 141 (the Wimborne pot)

R. Coleman-Smith and T. Pearson, *Excavations in the Donyatt Potteries* (1988)

Penny Copland-Griffiths, 'Excavation near a seventeenth century kiln at Horton Dorset', *Proceedings of the Dorset Natural History & Archaeological Society*, vol. 111 (1989), pp. 71–85

Penny Copland-Griffiths and Christine Butterworth, 'Excavation of the seventeenth century Kiln at Horton, Dorset', *Proceedings of the Dorset Natural History & Archaeological Society*, vol. 112 (1990), pp. 23–32

Jo Draper and Christopher Chaplin, *Dorchester Excavations Volume 1* (DNHAS monograph 2, 1982) (Dorchester pots)

Norman Field, 'A thirteenth century kiln at Hermitage, Dorset', *Proceedings of the Dorset Natural History & Archaeological Society*, vol. 88 (1966), pp. 161–75

M.G. Fulford, *New Forest Roman Pottery* (1975) (British Archaeological Reports 17)

B.P. Harrison and D.F. Williams, 'Sherborne Old Castle, Dorset: Medieval Pottery Fabrics', *Proceedings of the Dorset Natural History & Archaeological Society*, vol. 101 (1979), pp. 91–102

Jeremy Haslam, *Medieval Pottery* (1978)

David A. Hinton and Richard Hodges, 'Excavations in Wareham 1974–5', *Proceedings of the Dorset Natural History & Archaeological Society*, vol. 99 (1977), pp. 42–83 (medieval pots)

Keith S. Jarvis, *Excavations in Christchurch 1969–1980* (DNHAS monograph 50, 1983) (sixteenth-century pots from Christchurch)

A.D. Mills, *The Place-Names of Dorset* Part II (1980)

John Musty, D. J. Algar & P.F. Ewence, 'The Medieval Pottery Kilns at Laverstock, near Salisbury, Wiltshire', *Archaeologia*, vol. CII (1969), pp. 83–148 (the jugs are in Salisbury and South Wiltshire Museum)

CHAPTER 4 – THE EIGHTEENTH CENTURY

All the clay digging and other court records are in Cranborne Manor Court, Hatfield House. The potters' inventories are at the Dorset Record Office. The Kingston Lacy bill is in Dorset Record Office, D/BLK vouchers 1782–4.

'A coarseware bellarmine from Dorset', *Proceedings of the Dorset Natural History & Archaeological Society* , vol. 100 (1978), pp. 120–21 (flagon, *see* photo on page 50)

'An earthenware "bellarmine" shaped jug from Poole Harbour', *Proceedings of the Dorset Natural History & Archaeological Society*, vol. 103 (1981), p. 138 (flagon, *see* photo on page 50)

R. Coleman-Smith and T. Pearson, *Excavations in the Donyatt Potteries* (1988)

Jo Draper, 'An eighteenth-century kiln at Hole Common, Lyme Regis', *Proceedings of the Dorset Natural History & Archaeological Society*, vol.104 (1982), pp. 137–42.

Jo Draper, 'Inventory of Ann Shergold, ceramic dealer in Blandford, Dorset', *Post-Medieval Archaeology*, 16 (1982), pp. 85–91 (1759 shop inventory)

Ian P. Horsey, *Excavations in Poole 1973–1983* (DNHAS monograph 10, 1992) (Poole pots)

John Hutchins *History … of Dorset* (first edn 1772) (the Crendell and Ebblake kilns)

J.F. James and J.H. Bettey (eds), *Farming in Dorset Diary of James Warne, 1758, Letters of George Boswell, 1787–1805*, (Dorset Record Society, vol.13 (1993), pp. 51, 84)

Peter J. Woodward, Susan M. Davies and Alan H. Graham, *Excavations at Greyhound Yard, Dorchester 1981–84* (DNHAS monograph 12, 1993) (Dorchester pots)

CHAPTER 5 – THE NINETEENTH CENTURY

The letter to Lord Salisbury is at Hatfield House.

Excavations at Greyhound Yard Dorchester 1981–84 (DNHAS monograph 12, 1993), pp. 308–12 (Dorchester groups of 1800–10 and 1830)

William Cobbett, *Cottage Economy* (1824)

Jo Draper, article on the mid-nineteenth century group from Dorchester, *Proceedings of the Dorset Natural History & Archaeological Society*, vol. 100 (1978), pp.120–22

Jo Draper, article on Christchurch group of the later nineteenth century, *Proceedings of the Dorset Natural History & Archaeological Society*, vol. 105 (1983), pp. 51–2

Jo Draper, article on the Shaftesbury group, *Proceedings of the Dorset Natural History & Archaeological Society*, vol. 109 (1987), pp. 35–8

John Hutchins, *History … of Dorset*, third edn, vol. 3 (1868), pp. 388, 386

Keith S. Jarvis, *Excavations in Christchurch 1969–1980* (DNHAS monograph 5, 1983) pp. 60–63 (Christchurch material of about 1800)

T.W. Wake Smart, *A Chronicle of Cranborne and the Cranborne Chase* (1841) annotated copy in Dorset County Museum

CHAPTER 6 – THE TWENTIETH CENTURY

For all the interviews, see Verwood Potteries Trust archives.

Fred Sims' notebooks and correspondence copies are in Dorset Record Office.

Interview with letters from Gertrude Gilham in Don Young archive, Dorset County Museum.

Excavations at Cross Roads in 2000 were by A C Archaeology.

Wimborne & District News, 27 May 1950 (1950 press interview)

T.P. Kendrick, 'The Verwood Potteries', *Pottery Quarterly* (1979), pp. 127–31

John Musty, 'A note on post-medieval kilns supply in the Salisbury Area', *Wiltshire Archaeological and Natural History Magazine*, vol. 63 (1968), pp. 51–3

Lot Oxford, 'The Seven Daniels of Verwood', *Dorset Yearbook* (1929), pp. 60–66

CHAPTER 7 – MAKING AND SELLING THE POTTERY

The sand, clay and turf references for the sixteenth–eighteenth centuries are all from Cranborne Manor Courts.

Interviews with Harold Churchill, Harold Ferrett, Alfie Sims, Gertie Sims, Len Sims, 'Pans' Brewer and Rose Vine are in the Verwood and District Potteries Trust archive (copy in Dorset County Museum).

Michael Cardew, *A Pioneer Potter* (1988)

Helen E. FitzRandolph and M. Doriel Hay, *The Rural Industries of England and Wales*, vol. III (1927), republished 1978

T.P. Kendrick, 'The Verwood Pottery', *Pottery Quarterly* (1959)

Olive Philpott, 'The Well', *Dorset Year Book* (1974/5), pp. 13–17.

Mrs Mescheck Sims was interviewed by John Musty for his article in *Wiltshire Archaeology & Natural History Magazine*, vol. 63 (1968), pp. 51–3

T.W. Wake Smart, *A Chronicle of Cranborne and the Cranborne Chase* (1841); descriptions of glazing and firing are from his manuscript notes in a copy of this book in the Dorset County Museum

CHAPTER 8 – JUGS AND COSTRELS
Jugs, Cisterns and Bucket Pots
For the Horton jugs, *see* Chapter 3, Bibliography.

Excavations in Poole 1973–1983 (DNHAS monograph 10, 1992) (Poole pots)

Excavations at Greyhound Yard Dorchester 1981–4 (DNHAS monograph 12, 1993) (Dorchester jug)

Proceedings of the Dorset Natural History & Archaeological Society, vol. 118, p. 75 (big Corfe jug)

Verwood & District Potteries Trust Newsletter, no.35, December 1993, p. 2 (jugs from the well)

Peter C.D. Brears, *The Collector's Book of English Country Pottery* (1974) (for all inscriptions from Devon and Donyatt jugs)

Michael Cardew, *A Pioneer Potter* (1988)

R. Coleman-Smith and T. Pearson, *Excavations in the Donyatt Potteries* (1988) (bucket pots)

Costrels and Flagons
The Poole costrel is not published.

Excavations at Poole 1973–1983 (DNHAS monograph 10, 1992), p. 99, no. 485 (flagon excavated at Poole)

'Lodge Farm, Kingston Lacy Estate, Dorset', *Journal of the British Archaeological Association*, CXLVII (1994), p. 96 (Kingston Lacy costrel)

R. Coleman-Smith and T. Pearson, *Excavations in the Donyatt Potteries* (1988), pp. 120–23 (Donyatt barrel costrels)

Penny Copland-Griffiths, 'Excavation near a seventeenth century kiln at Horton', *Proceedings of the Dorset Natural History & Archaeological Society*, vol. 3 (1989), pp. 71–85

Keith S. Jarvis, *Excavations in Christchurch 1969–1980* (DNHAS monograph 5, 1983), p. 63, no.107 (Christchurch costrel)

John Manwaring Baines, *Sussex Pottery* (1980) (barrel costrels and the Stepney flagon)

L.F. Pitt Rivers, *Excavations in Cranborne Chase*, vol. 1 (1887), p. 100 (the engraving of a costrel)

Colin Platt and Richard Coleman-Smith, *Excavations in Medieval Southampton*, vol. 2 (1975), p. 120, no. 825 (Southampton costrel)

CHAPTER 9 – BREAD BINS, PANS AND DAIRY WORK
Bread Bins or Bushels
I am grateful to Richard Percy for pointing out the role bread bins played in the firing of the kiln and in acting as saggars.
Interviews with the potters and their relatives in the 1970s are in the Dorset County Museum, Dorchester.
Notes on interviews with Marjorie Bailey in Don Young's papers, Dorset County Museum.

Excavations at County Hall, Dorchester, Dorset (Wessex Archaeology Report no. 4, 1993), p. 63 (Colliton Park bread bin)
Proceedings of the Dorset Natural History & Archaeological Society, vol. 109 (1987), p. 37 (early nineteenth-century Shaftesbury bread bins)
Proceedings of the Dorset Natural History & Archaeological Society, vol. 112 (1990), p. 150 (Robert Shering bread bin)
Report of Special Assistant Poor Law Commissioners on the Employment of Women & Children in Agriculture, Wilts, Dorset, Devon & Somerset volume by Mr A. Austin (1843), p. 90 (interview with Mrs Bustle)
Winifred Legg, *Dorset*, no. 85, n.d. (*c*.1981)
Olive Philpott remembered Semley in 'The Well', *Dorset Yearbook 1974/5*, pp. 13–17.

The Dairy – Butter and Cheese
'West Country Cheeses', *Journal of the Royal Agricultural Society of England*, vol. 73 (1912), pp. 32–3 (cheese-making in nineteenth-century Dorset)
John Arlott, *English Cheeses of the South and West* (1958) (Blue Vinney cheese)
A.R. Mountford and F. Celoria, 'Some Examples of sources in the history of seventeenth century ceramics', *Journal of Ceramic History*, no.1 (1968) (1662 butter statute)
John Mowlem, *Somerset & Dorset Notes & Queries*, vol. 21 (1935), p. 169 (Dorset plump)

CHAPTER 10 – BOWLS, CHAMBER POTS AND GARDEN WARES
Copies of Freddy Sims' notebooks are in the Dorset Record Office.

Excavations at Greyhound Yard Dorchester (1981–4), p. 307 (Dorchester late eighteenth-century flowerpots)
Proceedings of the Dorset Natural History and Archaeological Society, vol. 100 (1978), pp. 120–22 (1850 group of pottery)
Proceedings of the Dorset Natural History & Archaeological Society vol. 111 (1989), pp. 68–85 (Horton pots)
Proceedings of the Dorset Natural History & Archaeological Society, vol. 118 (1996), pp. 71–8 (Corfe stool pan)
'The Old Malthouse, Abbotsbury', *Proceedings of the Dorset Natural History & Archaeological Society*, vol. 108 (1986), pp. 103–25 (Abbotsbury lavatory pan)
Munroe Blair, *Ceramic Water Closets* (2000) (close stools, lavatories etc.)
Peter C.D. Brears, *Farnham Potteries* (1971)
W. Fishley Holland, *Fifty Years a Potter* (1958) (Fremington)
Ian P. Horsey, *Excavations in Poole 1973–83*, (1992), pp. 85, 104 (Poole pots)
Lucinda Lambton, *Temples of Convenience* (1978) (close stools, lavatories etc.)
John Manwaring Baines, *Sussex Pottery* (1980), p. 64 (Brede price list)

CHAPTER 11 – JARS, VASES AND DECORATIVE WARES

Corfe Mullen Afternoon WL, *History of Corfe Mullen* (1984) (copy in Dorset County Library) (lavender farm)

Carol and Chris Cashmore, *Collard the Honiton & Dorset Potter* (1983) (Crown Dorset pottery and perfume wares)

Olive Knott, 'The Lavender Farm', *Dorset Year Book* (1956/7), pp. 60–62

Christie Mayer Lefkowith, *The Art of Perfume* (1994) (perfume containers)

CHAPTER 12 – THE END OF THE POTTERIES

Mostyn Art Gallery, Llandudno, *Buckley Pottery* (1983) (Welsh pottery)

Lawrence Binyon, introduction to *Old English Metalwork* by W. Twopeny (1904), quoted in G. Jekyll and S.R. Jones, *Old English Household Life*, 2nd edn (1944/5), p. 4

Peter C.D. Brears, *The English Country Pottery* (1971) (other earthenware kilns)

Peter C.D. Brears, *The Collector's Book of English Country Pottery* (1974) (other earthenware kilns)

Michael Cardew, *A Pioneer Potter* (1988), pp. 57–8

R. Coleman-Smith and T. Pearson, *Excavations in the Donyatt Potteries* (1988)

Peter Davey, *Buckley Pottery* (1975) (Welsh pottery)

W. Fishley Holland, *Fifty Years a Potter* (1958) (for a wonderful picture of the north Devon kilns)

Bernard Leach, *A Potter's Book*, 3rd edn (1976), p. 33

J.M. Lewis, *The Ewenny Potteries* (1982) (Welsh pottery)

J. Manwaring Baines, *Sussex Pottery* (1980)

Andrew McGarva, *Country Pottery Traditional Earthenware of Britain* (2000) (other earthenware kilns)

Nancy Stebbing, John Rhodes and Maureen Mellor, *Oxfordshire Potters* (1980)

Useful Addresses

The Curtis Museum
Church Street
Alton
Hampshire
GU34 1BA

Tel: 01420 82802

**The Dorset County
Museum**
High West Street
Dorchester
Dorset
DT1 1XA

Tel: 01305 262735

Poole Museums
High Street, Poole
Dorset
BH15 1BW

Tel: 01202 683138

**The Priest's House
Museum**
High Street
Wimborne
Dorset
BH21 1HR

Tel: 01202 882533

Red House Museum
Quay Road
Christchurch
Dorset
BH23 1BU

Tel: 01202 482060

**Salisbury and
South Wiltshire Museum**
The King's House
The Close
Salisbury
Wiltshire
SP1 2EN

Tel: 0172 332151

**Somerset County
Museum**
The Castle
Taunton
Somerset
TA1 4AA

Tel: 01823 320200

**Verwood and District
Potteries Trust**
Trowle House
Wingfield
Trowbridge
Wiltshire
BA14 9LE

website: www.verwoodpot-
teries.co.uk

**Verwood Historical
Society Collection**
Verwood Town Council
28 Vicarage Road
Verwood
Dorset
BH31 6DR

Index